D-Day

Normandy Revisited

For London Nan, Mum, Dad,
Nan, Grandad and Nathalie

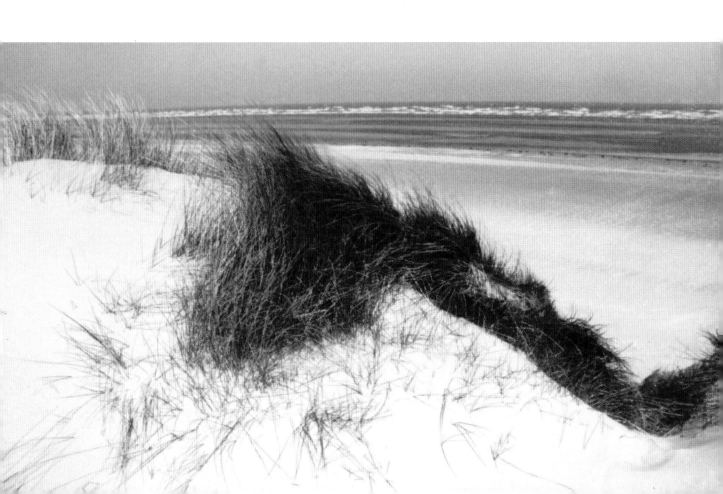

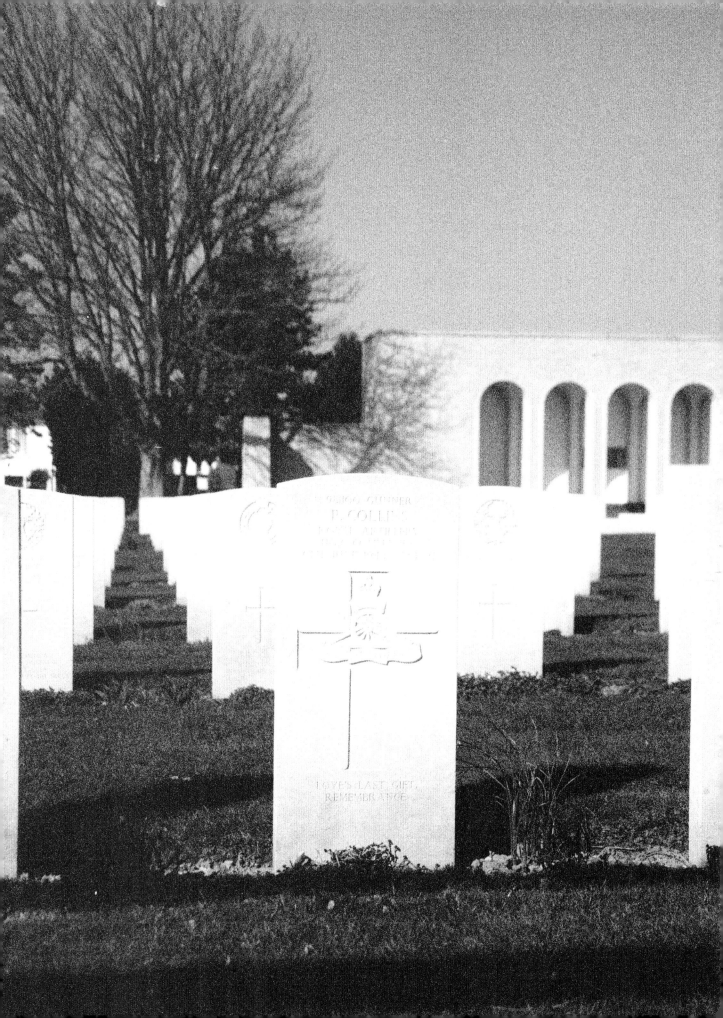

D-Day
Normandy Revisited

A Photographic Pilgrimage by
Richard Bougaardt

CHAUCER PRESS
LONDON

Published by Chaucer Press
20 Bloomsbury Street
London WC1B 3JH

A CIP catalogue record for this book is available from the British Library

ISBN 1-904449-29-8

Designed and produced for Chaucer Press
by Savitri Books Ltd
25 Lisle Lane
Ely CB7 4AS

Edited by Caroline Taggart
Printed by

The author, the producers and publishers of this book would like to express
their sincere thanks to the children of Frank and Peggie Holden: Susan, Judy,
Jennie and David, for allowing extracts of the unpublished letters of their
father, Captain – later Major – Frank Holden to appear in this book.
(See Credits and Permissions, page 188.)

Thanks are also due to R J Bettiss and others who kindly gave their
permission for extracts of their memories of the D-Day landings to be quoted
in this book. Every effort has been made to trace the copyright holders. The
author and publishers of this book apologize for any omission
which may have occurred.

Endpapers: Dragon's teeth on the beach at Riva-Bella are a stark reminder of
the fierce battles that took place along the Normandy coastline.

Half-title page: A deserted stretch of beach at Tare Green Sector.

Frontispiece: Ranville British Cemetery.

CONTENTS

FOREWORD

There is a haunting quality to battlefields. I know, because I spend so much
of my life walking over them. War walks are indispensable to military history,
for painstaking map study never quite summons up the right image. And there
are fragments of 'microterrain' which spring out of the ground itself. The Duke
of Marlborough's attack at Ramillies worked because a gully enabled him to shift
troops, unseen, from one flank to another. Failure to take the dominant Hawthorn
Ridge Redoubt crippled the British attack on Beaumont Hamel on the Somme
on 1st July 1916. The bunker at Vierville-sur-Mer, on Omaha Beach, shows what
'flanking fire' really means. The little River Merderet would stop a tank, and so
its tiny bridges briefly became as important as the disputed Round Tops
at Gettysburg.

Visiting battlefields touches heart as well as head. Men fight out under the sky
in all weathers, and we can empathise with them so much better when we see,
for instance, what heavy surf on a Normandy beach would have meant to a heavily
laden man. For some combatants that short stretch of sand from tide-line to sea-wall
seemed a boundless desert, its gentle gradient like Everest. And soon the invaders
met civilians, for this battlefield was their home. Seaside villas with their fussy
gables link past with present, and remind us that real people lived on phase lines
and in objectives. Their ancestors had worshipped in those confident Gothic
churches for a thousand years: the double spire of Douvres-la-Délivrande still
watches over Juno Beach.

The battlefields of D-Day are well commemorated, from the bronze parachutist
surveying the American drop zones on their western flank, to the bust of Major John
Howard, whose company secured Pegasus Bridge, to the east. They are still littered
with the debris of defence, like the Tobruk bunkers above Utah Beach and the squat
concrete of the Merville battery, in the British airborne sector. But they are above
all a living landscape, This inspired and inspiring collection of photographs catches
these battlefields in sunshine and shadow. It is an invaluable aid to understanding
them if you have never been there, and a fitting remembrance if you have. It enfolds
time and place, past and present, seizing this little piece of France which still means
so much to so many.

RICHARD HOLMES, JANUARY 2004

Opposite: Chateau Ste Marie at Ste Marie-du-Mont.

Overleaf: View from a German machine-gun post, showing the entire length of Omaha Beach. The stretch of beach nearest to the aperture of the bunker is the area that was known as Charlie Sector for the purpose of the D-Day landings. On the other side of the new fishing pier lies Dog Green Sector.

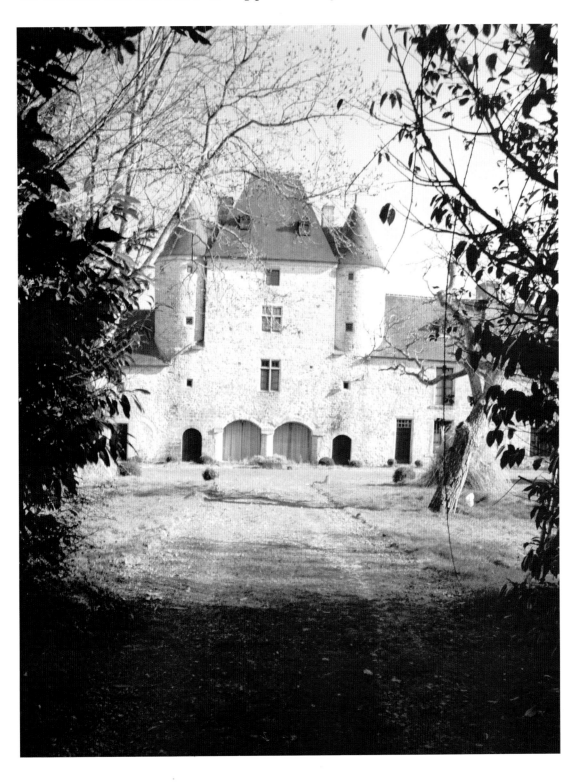

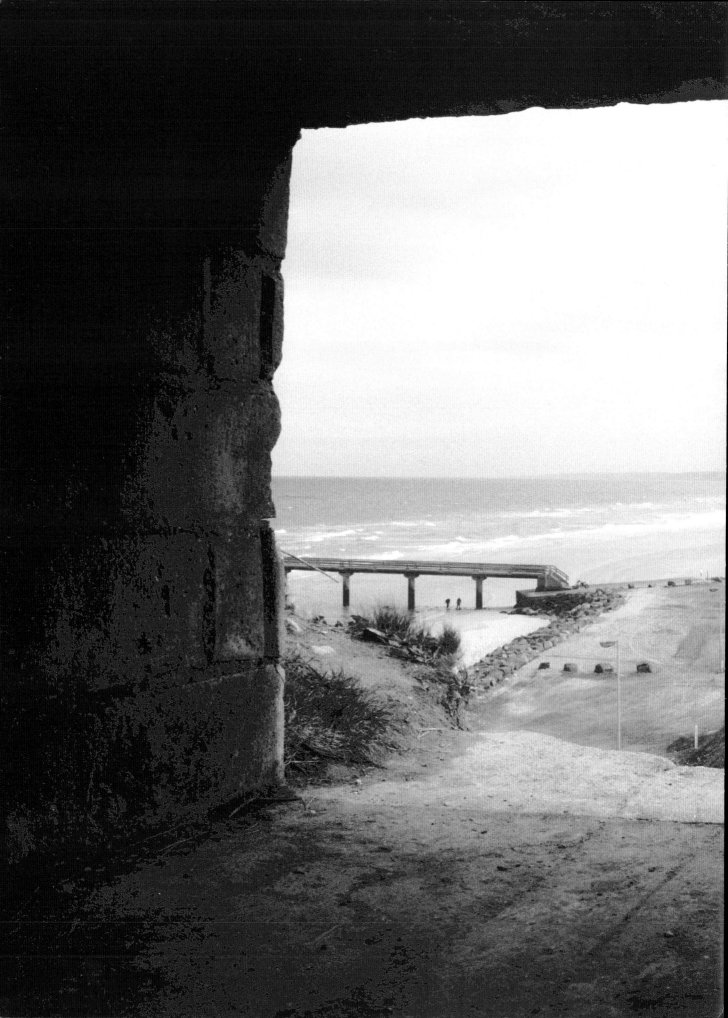

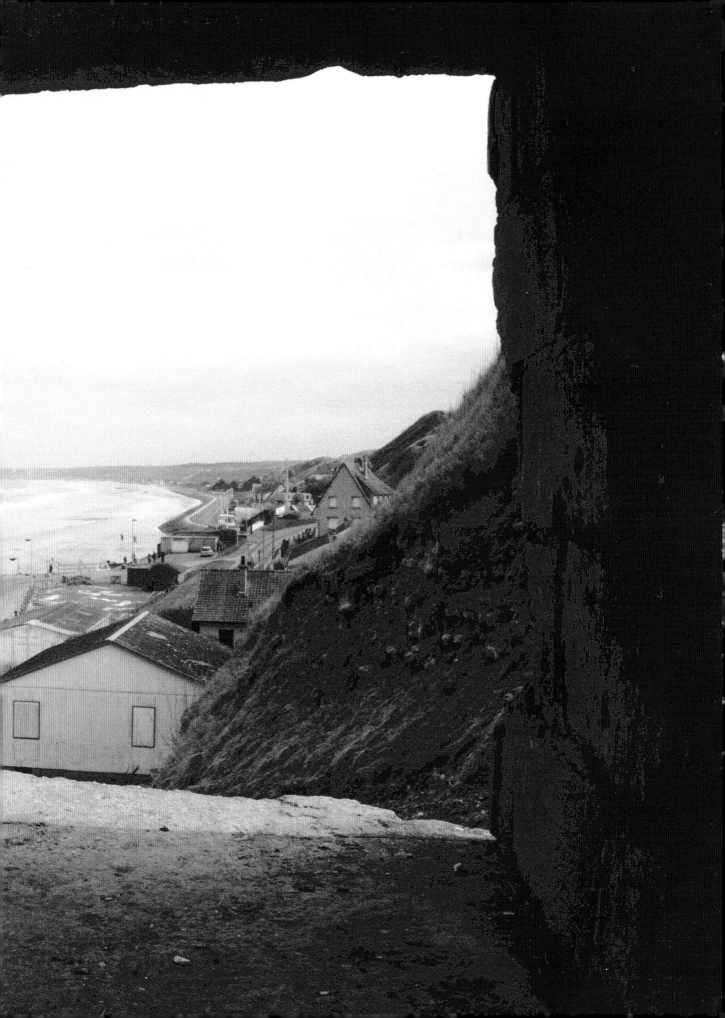

INTRODUCTION

On D-Day – 6th June 1944 – a force of 156,000 American, Canadian and British troops, supported by 8000 sailing craft and 13,000 aircraft, landed on the beaches of Normandy in the largest and most difficult amphibious operation ever mounted in wartime. Their aim was to break through the German defences, advance on Paris and liberate France from German occupation. Despite massive loss of life on both sides, the success of this operation is generally regarded as the turning point of the war.

I was born in London over 30 years later, in 1976. As a small boy I spent a lot time around my maternal great-grandmother who still lived in Dagenham, in the small terraced house she'd occupied during the Blitz. I was fascinated by the strange bump in the middle of the grassy area which was the old Anderson shelter in which she'd spent many anxious nights with my grandmother and my great-aunt, who were then small children. She would often tell me stories about the war and about my great-grandfather's exploits – he had been a soldier and had done guard duty at the Nuremberg trials. One of the little girls eventually became a young woman and married my grandfather. During his national service, he served in Palestine and in later years he developed an interest in things military and in World War II in particular. Between the ages of seven and ten I discovered his books on the war, especially an encyclopaedia of World War II which I never tired of looking at and re-reading.

When I was about eleven I started going to France with my parents. I felt an instant fascination for the first foreign country I had visited. My parents encouraged me to learn the language. Later, I fell under the influence of my French teacher, whose enthusiasm for his subject inspired me to read French at university. When I was still studying for A-Levels I went to La Rochelle and visited an exhibition about the German occupation of France. It showed me a different facet of the war, the everyday aspects of life. I was struck by a photo of German soldiers sunbathing and dancing in the surf – the ordinariness of such summer rituals contrasting with the larger historical picture. As I grew up, my interest in World War II deepened. I collected books,videos and models. All this combined with a newly acquired interest in photography, inherited from my father, who trusted me with his Leica camera.

Like many people I was deeply moved by the opening scene in *Saving Private Ryan*, which shows soldiers of the US Rangers landing on Dog Green Sector of Omaha Beach. It is shot in such a way as to involve the viewer in the action: I felt myself ducking involuntarily to avoid the German machine-gun fire. I had never seen a film which had such an impact and created such stomach-wrenching fear. It gave a focus to my interest in the war and prompted me to learn more about the D-Day landings.

Coincidentally, in 2002 I found myself camping in what had been the invasion zone in Normandy. I took the opportunity to visit the museum at Utah Beach and the church at Carentan. I was struck by the aura of the place – the tangible feeling that important and tragic events had taken place in this apparently placid landscape. I had time to take only a few pictures, but I knew that I would have to come back. It was as though something, someone was calling out to me. I went home and read everything I could lay my hands on concerning the events on D-Day.

I returned six months later and visited the beaches in the order in which the invasion took place. I was overawed by how much remained, the magnitude of the structures left on otherwise eerily empty beaches and in fields, where they cohabited with livestock and the everyday life of the farms. Even after all these years, it is impossible to avoid the feeling that everywhere one looks was once bitterly fought over and that thousands of young lives ended there.

I have always liked what can be achieved through the medium of black and white photography, although I have also worked in colour. It is possible that my early interest in the war, which I saw through the eyes of the great war photographers, influenced me. But for the project I had in mind, there was no question – the sobriety of monochrome was the only possible choice.

From the outset, I was hoping that my pictures would go into a book. I wanted to share the emotions I experienced while exploring the old battlefields. I hope that if someone who had first-hand experience of the D-Day landings picks up this book, he will feel that his recollections of the events and the memories of dead friends are not trivialised by my efforts. Similarly, I hope that some of my contemporaries will be prompted to find out more about these events that took place long before we were born, but which to a large extent dictated our lives and the freedom we enjoy.

The last word should go to Ernie Pyle, Pulitzer Prize-winning war correspondent, who reported on the Blitz, the Battle of Britain and the Normandy landings, and was killed in the Pacific in 1945, just a few months before the end of the war. In his column on 12th June, 1944, six days after D-Day, he wrote: 'I want to tell you what the opening of the second front entailed, so that you can know and appreciate and for ever be humbly grateful to those both dead and alive who did it for you.'

<div align="right">RICHARD BOUGAARDT, SEPTEMBER 2003</div>

Overleaf: The remains of a German bunker, put out of action by a single bomb dropped immediately before D-Day. The bomb created a huge crater. This whole area looks like a lunar landscape, so badly was it churned up by the Allied bombing.

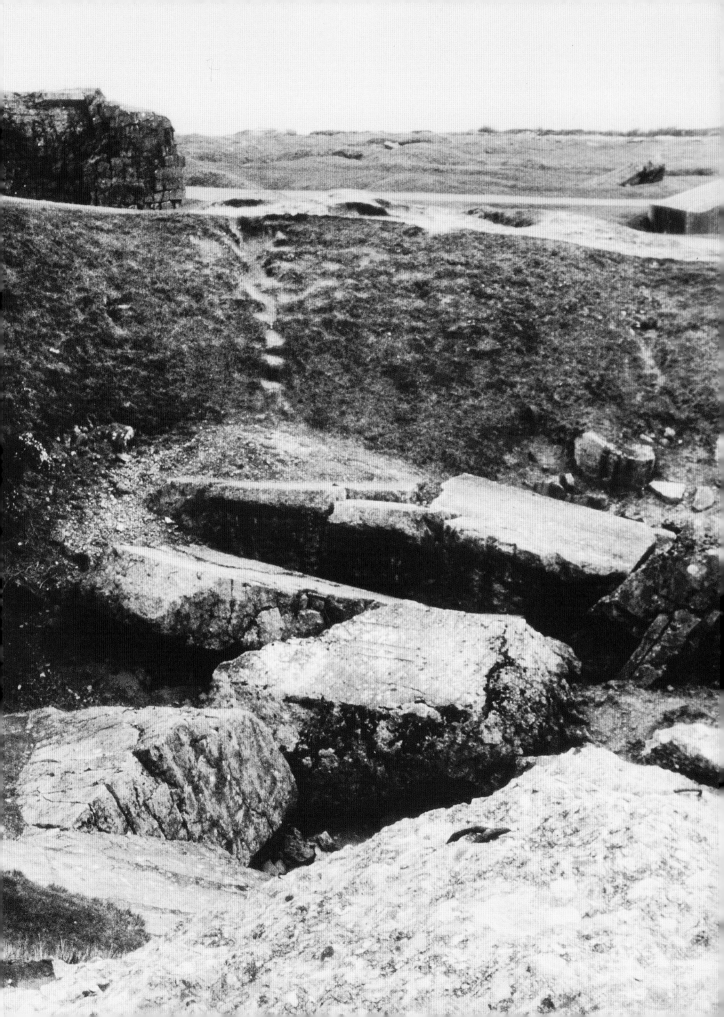

UTAH BEACH

Utah Beach is situated on the east coast of the Cotentin Peninsula and is the furthest west of the five code-named beaches targeted by the Allies for what became known as the D-Day landings. The US VIIth Corps was detailed to land there with the intention of capturing a beachhead that would serve as a reliable landing point for soldiers and equipment. The ultimate objective was to capture the deep-water port at Cherbourg, on the northern coast of the peninsula, which Supreme Headquarters Allied Expeditionary Force considered crucial to the invasion of mainland Europe: not only would it allow heavy equipment to be landed easily; it was also situated on the main inland road towards Paris, the N-13.

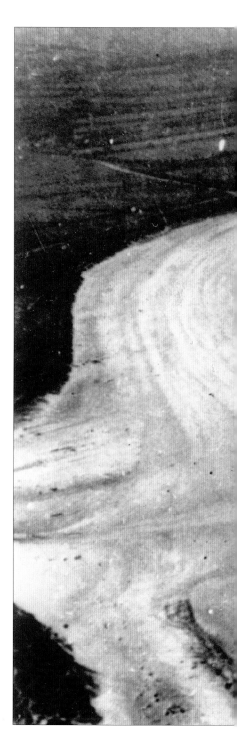

Allied intelligence showed there to be large numbers of German troops of varying degrees of quality in the peninsula. All of them, although lacking motorised transport, were capable of answering the call to defend the Utah Beach area. In order to minimise this threat, General Eisenhower planned to drop paratroopers and glider-borne troops of the 82nd and 101st Airborne Divisions behind enemy lines so that they could capture causeways and bridges and cut communication channels. This would render the reinforcement of the Utah Beach defences much more difficult, if not impossible.

German defences on the planned landing area at Utah were fairly strong. There were various strongpoints and heavy gun batteries along the coast, all of which could rain fire down on the forces landing at Utah. In fact the landing took place 2km (1½ miles) further south, due to the wind and current sweeping the landing forces in that direction. Fortunately for the Americans the area directly opposite this zone was more lightly defended, although it still took several days for the landing forces to overcome the heavy gun batteries.

Thanks mainly to this stroke of luck, but also to the inadequate preparations made by the Germans and the relative success of the airborne troops' operations inland,

the landing at Utah was a successful operation with relatively few casualties.

Below: Aerial reconnaissance photograph of the German beach obstacles, taken near St Vaast la Hougue, north of Utah Beach.

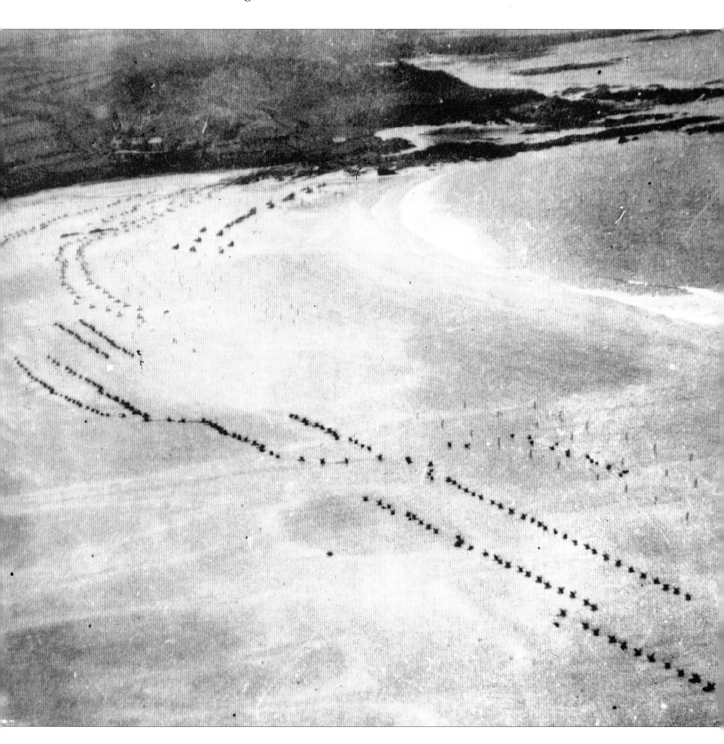

St Come-du-Mont

The going was tough for the US 101st Airborne immediately after their drop into the area behind Utah Beach. They found themselves scattered and unable to form into units of sufficient strength to mount sizable attacks on the German defenders. Their mission was to secure the southern flank of the battlefield (the Cotentin Peninsula), and this meant securing the bridges over the Douve and Merderet rivers.

Officers of the 501st Parachute Infantry Regiment (PIR) thought that St Come-du-Mont had been overrun by US paratroopers in the drop. However, this proved not to be the case and Colonel von der Heydte, Commander of the 6th Airlanding Division, had prepared ambushes around the perimeter of the town. When Captain Sam Gibbons went with a squad to reconnoitre the town, he was fought off by ferocious automatic fire from the superior German force. St Come-du-Mont was a key strategic town for the advance inland as holding it allowed the Germans to maintain control of the railway and road bridges over the Douve river, north of Carentan (see page 40). This would have enabled them to move reinforcements into the area, in order to slow or stop the American advance.

The German Commander, Colonel von der Heydte later stated that the day had not gone as well as he had expected. Many of his men were lost in the floods that had been designed to defend them against the American troops and, although his was the best German unit on the peninsula, he was forced into a defensive position when his unit, above all, should have been launching offensives to push the invaders back into the sea.

Today, St Come-du-Mont is a sleepy little town which straddles a minor country road. It looks down on Carentan, just as the Germans did when they repulsed the approaching Americans.

Opposite: The church at St Come-du-Mont, bathed in brilliant sunshine.

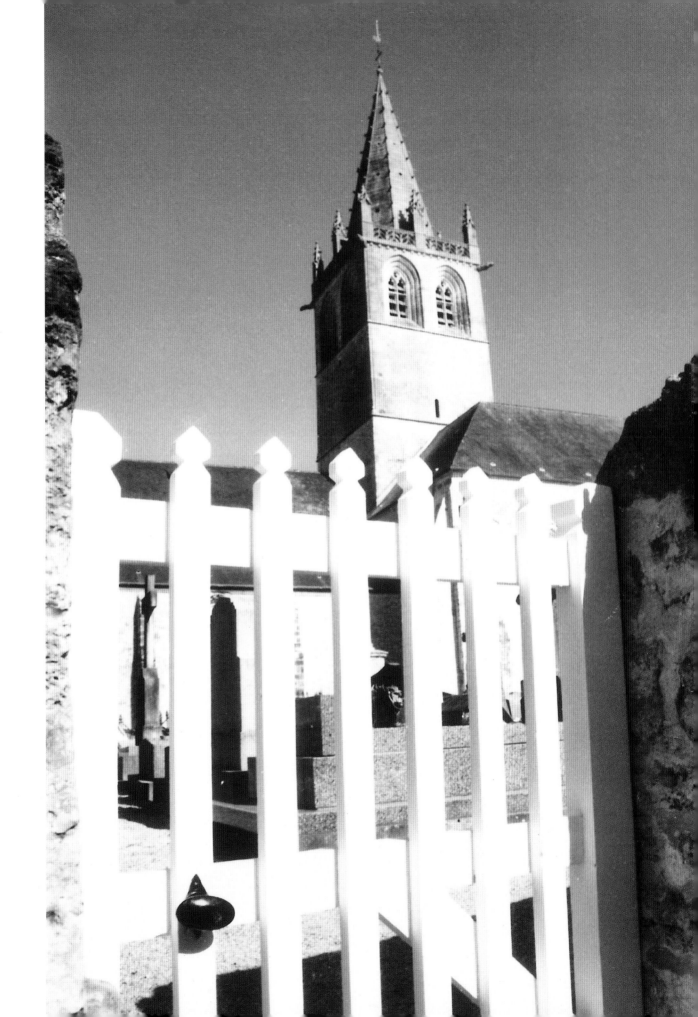

Ste Mère-Eglise

The mission of the US Airborne was to liberate and control Ste Mère-Eglise. On the night of the invasion it was held by a garrison of German soldiers who put up a staunch defence of the town.

In the melée caused by the fighting, one paratrooper, Private John Steele, landed on the roof of the church in the town square, his parachute caught in the balustrade. He acted dead throughout the battle, being rescued later by Germans who were using the church to spot the dropping invaders. His only injury was a gunshot wound to his heel. Many others were not so lucky – the Americans sustained heavy casualties.

The French citizens went into hiding, seeking shelter from the gunfire. This is how one of them, André Mace, recalled the events.

'Alerte! A great number of low-flying planes fly over the town – shaving the roof-tops, it is like a thunderous noise, suddenly, the alarm is given, there is a fire in town. In the meantime the Germans fire all they can at the planes. We go into hiding, what is going on? Thousands of paratroopers are landing everywhere amid gunfire.... We are all huddled in M. Besselièvre's garage with our friends. Our liberators are here!... It is real hell all over with the firing of guns, machine guns and artillery. Around 3 a.m. we risk a peek to see what is going on. The Americans are the only ones in the streets of the town, there are no more Germans. It is an undescribable joy. I was never so happy in all my life.'

Opposite: The church tower at Ste Mère-Eglise with a model of Private John Steele, whose parachute caught on a ledge during the drop. The town makes a lot of its D-Day connections and always seems busy with visitors, many of them veterans. A number of the hotels are named after famous soldiers or the events of 1944.

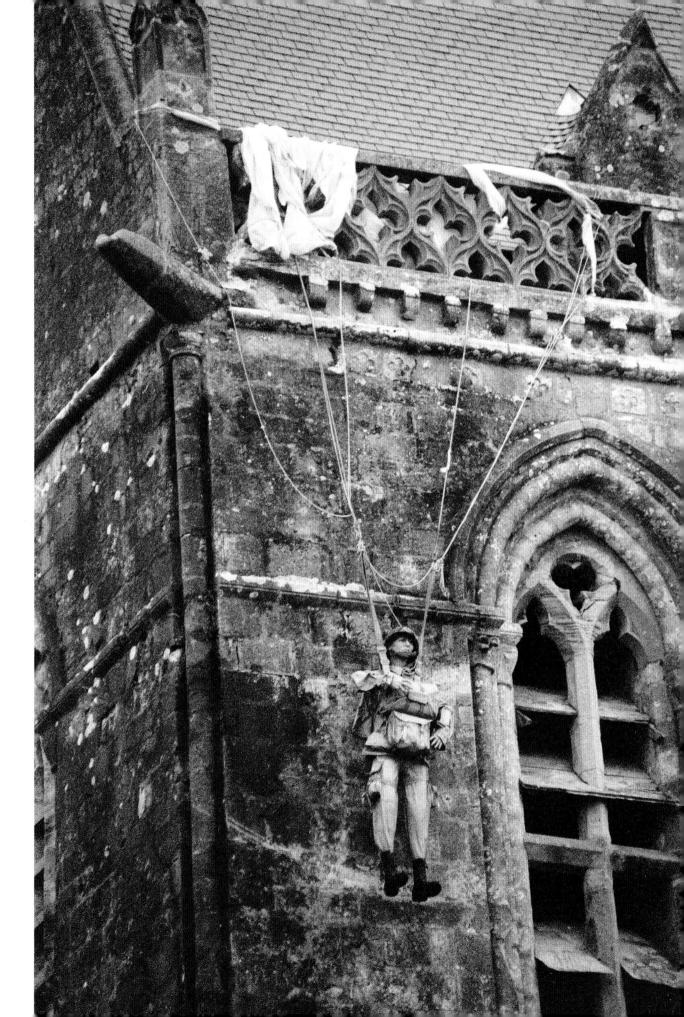

La Fière

Situated about 8km (5 miles) inland from Utah Beach, the bridge at La Fière crosses the Merderet river and the causeway leading to the hamlet of Cauquigny. This causeway stood about 4.5m (15ft) above the surrounding marsh, which the Germans had deliberately flooded, as part of their defence installations. Around 0100 hours on D-Day, it was the task of Able Company, the 505th Parachute Infantry Regiment of the 82nd Airborne Division, to capture this bridge and hold it against all opposition. The purpose of this action was two-fold. Firstly, if this bridge (and others like it in the area) were held by the Allies, the Germans would be unable to reinforce the units defending Utah Beach (see page 45), thus reducing their ability to repel the invasion. Secondly, once the Allies had established a beachhead, they would need to push further inland, towards Cherbourg and the west coast of the Cotentin Peninsula, and it was therefore vital that these bridges stayed intact, in order to facilitate a quicker advance.

Following a ferocious fight against numerically and technically superior force – the German defenders had the use of several tanks – the troops of the 505th captured the bridge and held it for the entire day, before relief arrived.

Marcus Heim was part of A Company, 505th PIR. He jumped out of a C-47 transport plane over Normandy. In his recollections of the day, he describes how his four-man team set up a roadblock next La Fière Bridge, held the position and was responsible for repelling several powerful German counter-attacks. For their bravery, he and his comrades were awarded the Distinguished Service Cross. 'During the battles,' he writes, 'one does not have time to look around to see how others are doing. We were told that when we took up our position by the bridge we would have to hold it at all cost until the men from the beach arrived, for if the Germans broke through they would have a good chance of going all the way to the beach. Our job was to be in the forward position by La Fière Bridge with our bazooka to stop any German tanks from advancing over the bridge and onto Ste Mère-Eglise and the beaches. This we accomplished all the while the Germans were continuously firing everything they had at us. After I went across the road and found more rockets for the bazooka and returned, the third tank was put out of action and the Germans retreated. When the Germans pulled back,

we looked around but did not see anyone. We then moved back to our foxhole. Looking back up the road toward Ste-Mère-Eglise, we saw that the 57-millimetre cannon and the machine gun were destroyed. Looking down the pathway across from the Manor House we could not see any of our men. We were thinking that we were all alone and that maybe we should move from here; then someone came and told us to hold our position and he would find more men to place around us, for the Germans might try again to breach our lines. We found out later that of the few who were holding the bridge at this time, most were either killed or wounded. Why we were not injured or killed only the good Lord knows.'

Below: The church at Cauquigny, which has been extensively rebuilt, having been practically destroyed by Allied bombardment.

Overleaf: The Merderet river seen from the bridge at La Fière during a winter sunset. Knowing the strategic importance the bridge, road and village held during the landing and how bitterly they were fought over, it is quite ironic to see how small and insignificant they appear today.

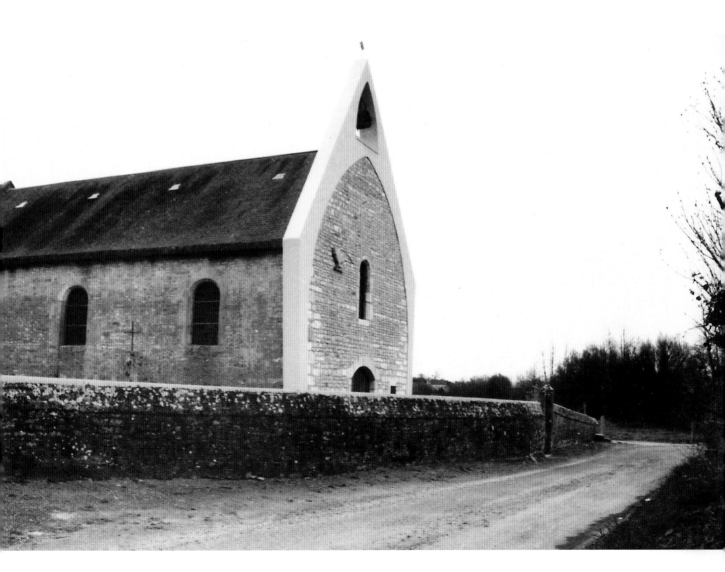

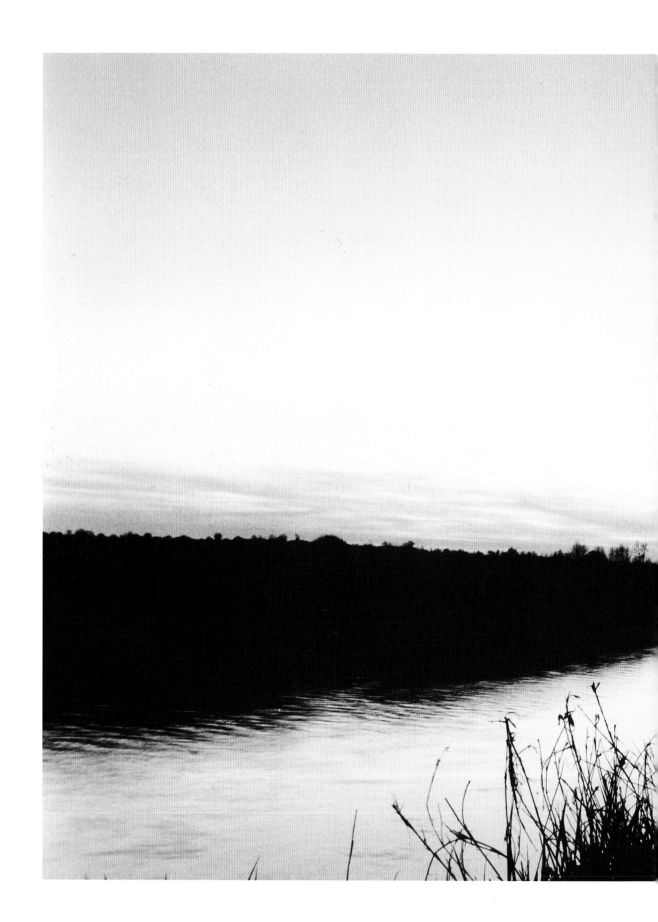

Iron Mike

The statue known as Iron Mike was erected as a memorial to the US 506th Parachute Infantry Regiment and the feats of heroism they performed on the night of 5–6th June 1944, when they held the bridge at La Fière against superior German forces. Iron Mike stands high above the battlefield and the scene he surveys has hardly changed from the one which met the American troops, following the Allied landings.

Next to the statue is a map of the area, cast in bronze. The plaque also describes the events of 5-6th June 1944. Only the presence of modern cars, driving up and down the causeway from La Fière to Cauquigny, reminds the visitor that well over half a century has elapsed since this whole area was covered with tanks and the deadly fire of guns.

Opposite: The statue of Iron Mike at La Fière, for ever maintaining his vigil over the old battlefields of the 1944 landings.

Left: The famous bridge at La Fière. Today it seems no different from thousands of such bridges across the French countryside. Yet in 1944 it was a key position for both the Germans and the Allies. Control of it was vital to the Germans, as it enabled them to send reinforcements and supplies to the front line. It was equally important to the Allies, for precisely the same reason and to enable them to establish a strong bridgehead on Utah Beach. Many lives were lost in the defence of this bridge.

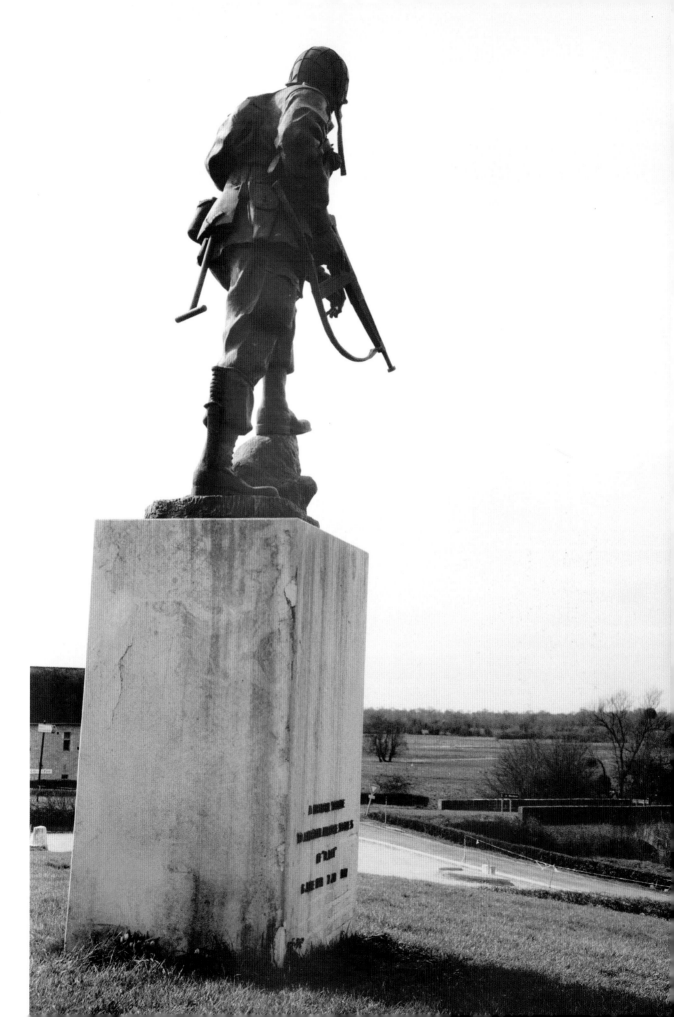

508th Bridge

The 508th Bridge crosses the Douve river, west of Chef du Pont. It was named after the US Parachute Infantry Regiment that captured it from the Germans on the night of 5–6th June 1944.

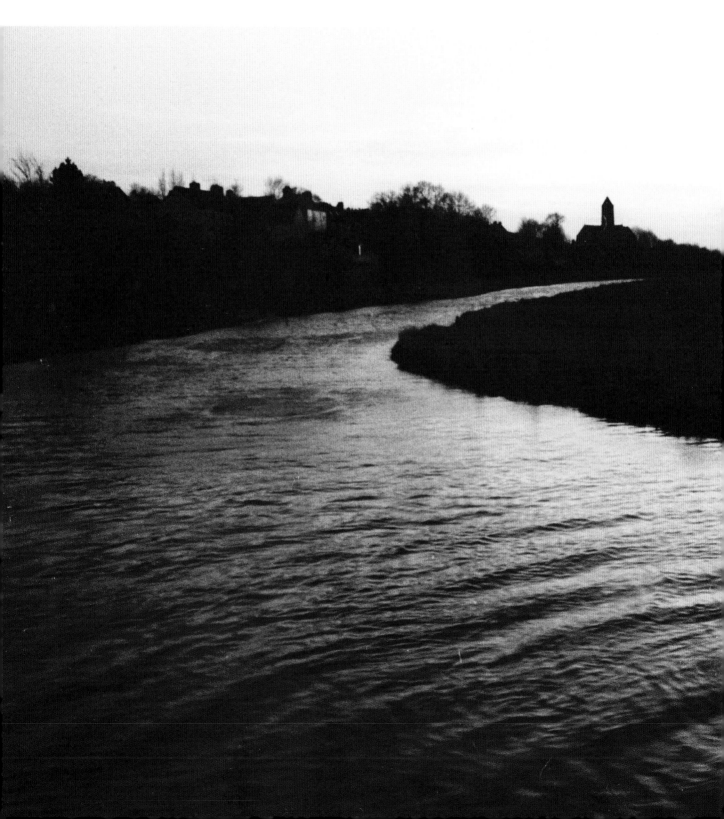

Below: This picture was taken from the 508th Bridge, looking towards Pont-L'Abbé, which can be seen in the background. The road leading to the bridge is one of the routes to Utah Beach which the Germans could have used to reinforce their defences, and it was vital for the US forces to capture the bridge and secure the road.

Amfreville

After leaving a group of 12 paratroopers to defend the hamlet of Cauquigny, Lieutenant Colonel Charles Timmes of the 507th Parachute Infantry Regiment moved out with the rest of his force towards Amfreville, which is where they should have been positioned had they not dropped too far to the east. However, he did not realise how heavily defended the town was. German troops brought the road and surrounding area under deadly accurate sniper, mortar and machine-gun fire and forced the Americans to abandon their assault. The Germans held a line about 1km ($^1/_2$ mile) long on the high ground, looking towards La Fière, until two days after D-Day (8th June). The forces that General Gavin and Lieutenant Colonel Timmes had left behind to defend the bridgehead at La Fière were also forced to withdraw as they were outnumbered and outgunned by German counter-attacks.

At this time, Alex Savidge was a boy living in London. He often used to listen to the planes passing overhead on their way to Germany, but he recalls a particular occasion: 'My ears were very sharp in those days,' he writes, 'and I would hear a faraway drone, like myriad bees flocking, away over to the north-east, but not from any particular point of the sky.

'Then quite suddenly the sky above the horizon was filled with dots, like a huge widespread flock of homeward-bound crows on a summer's evening. It was a while before they came close enough to make out silhouettes – most of us were pretty skilled at aircraft recognition in those days, when life might pivot on the knowing of a Messerschmitt 109 fighter from a Hurricane or a Spitfire....

'Then they were somewhere above central London, with St Paul's Cathedral's dome and towers shining, as if so proud that England was at last striking back at the grey-clad, half-million-strong German VII Army.

'A thrill of excitement ran through me as I stood alone, for a little while, watching approaching aircraft that surely and steadily carried the airborne troops that were to drop behind the Normandy beaches and have such a crucial bearing on the successes of that day: Tuesday 6th June 1944.'

Opposite: The French municipality of Amfreville recently erected this memorial to the American troops who liberated their part of the Calvados coast, so many of them dying in the process. It stands in a beautifully tended garden and shows how much the French still appreciate the determination and courage of their liberators.

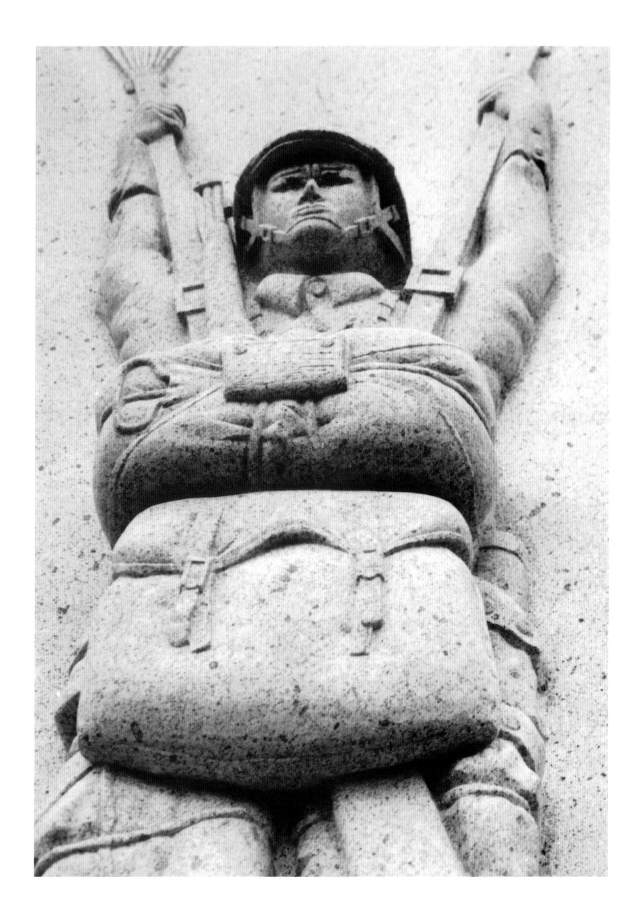

Le Port

Le Port is situated inland, a few kilometres west of Utah Beach, at the point where the Douve and the Merderet rivers diverge. Today it probably looks very much as it did in 1944, the only difference being that the area towards which this photograph looks had been flooded by the German defenders. I took the picture from the viewing platform next to the village church.

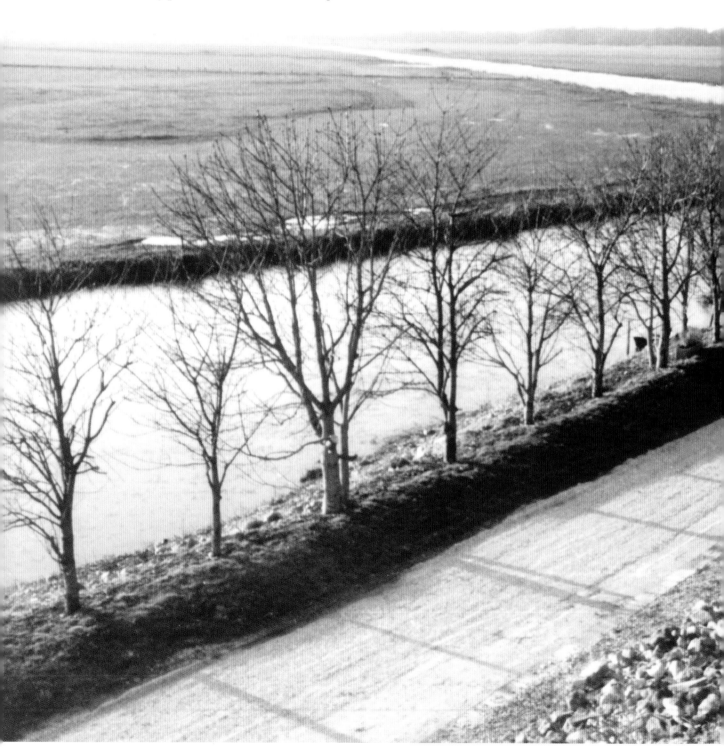

The area was a drop zone for the 101st and 82nd Airborne Divisons. In the small hours of the morning of D-Day, the inhabitants of nearby villages heard the drone of hundreds of planes flying overhead. Air-raids were not infrequent in the area, but once people realised what was happening and saw paratroopers dropping from the planes, they went out to greet them.

Monsieur Michel Lachaud, who was only a boy on the night of the American parachute drops, recalls how when he and his father realised that the long-hoped-for Allied landings were in progress, they went out to meet their liberators. They arrived just in time to become part of a rescue operation. The Germans had flooded the fields and the Allied troops landed, in some cases, into 1.5m (5^{1}/$_{2}$ft) of water. They were weighed down by their own body weight in equipment and many were in danger of drowning. Luckily, the local inhabitants managed to help a good number of them, extricating them from the water.

Opposite: The Douve river, seen from a vantage point as it meanders through peaceful water meadows.

Overleaf: The same river, seen from Le Port. The far shore marks the start of the marshy area which the Germans flooded in their efforts to repulse the invasion.

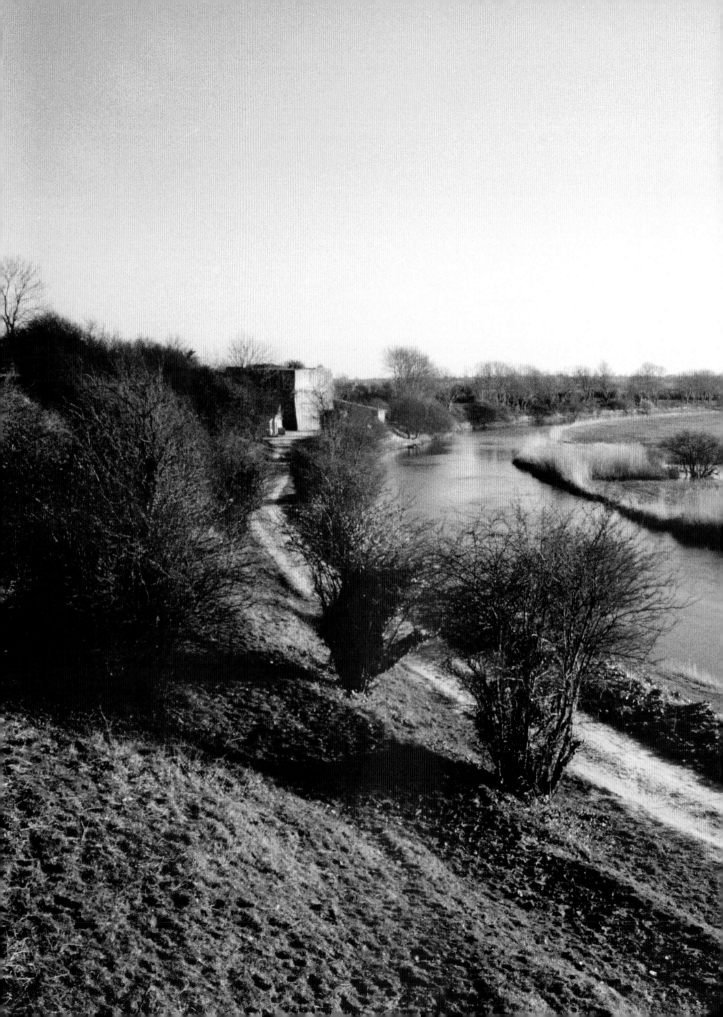

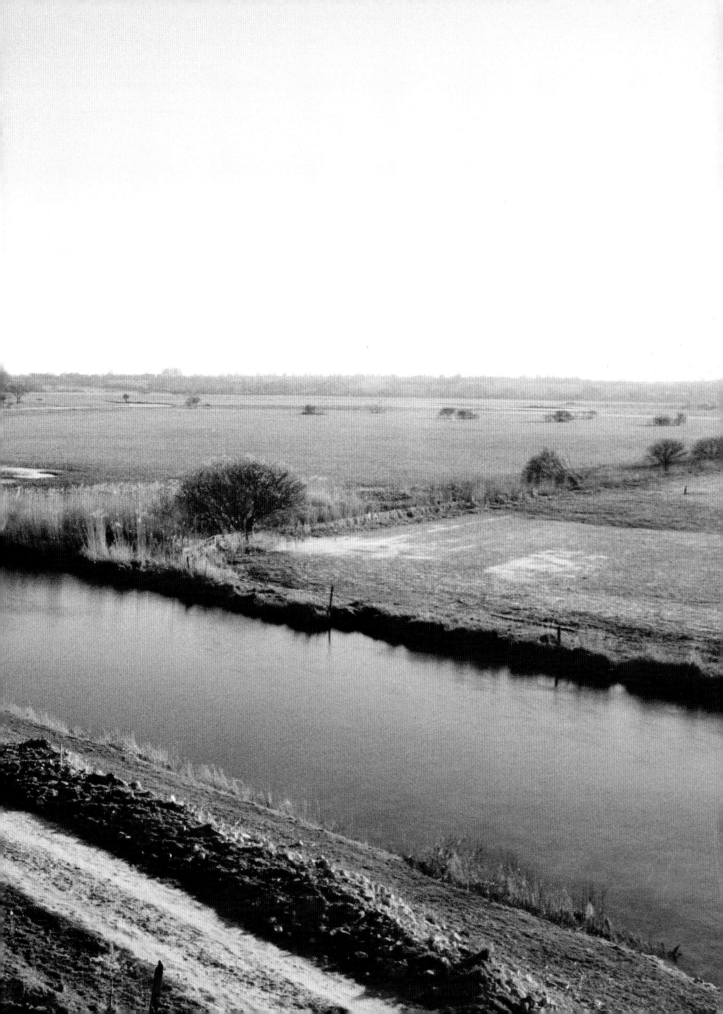

Uncle Red

Uncle Red Sector was the site of the first Allied landings on D-Day. Ten Higgins boats containing troops from the US 8th Infantry Division, 2nd Battalion, were scheduled to land there immediately after the US and Royal Navies bombarded the beaches and their defences by launching a thousand rockets from the rocket-landing craft (LCT(R)s) (ten other 2nd Battalion boats went to Tare Green Sector). The plan involved the Higgins boats following 32 Duplex Drive (DD) Sherman tanks as they powered onto the beaches, providing the soldiers with immediate fire support as they landed.

Things started to go wrong when the swell in the water and north-to-south current

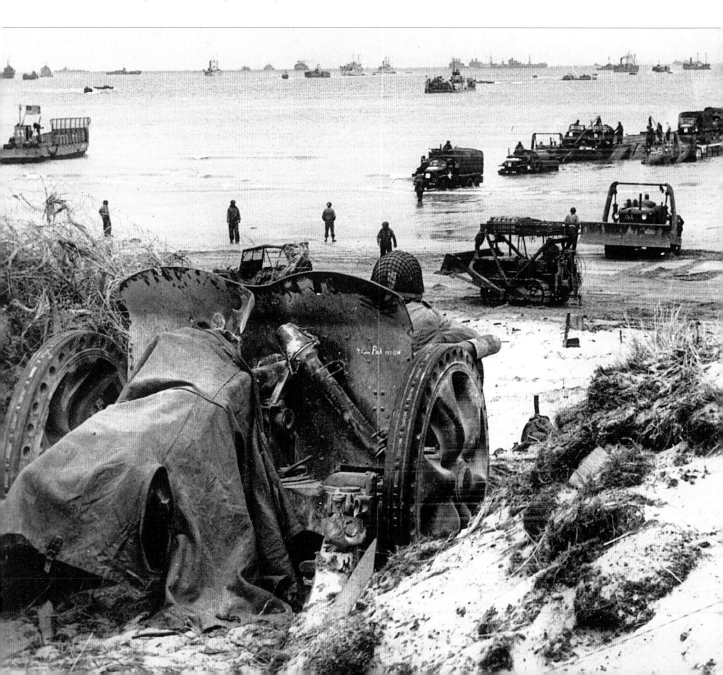

slowed the DD tanks down so much that the lighter, more powerful Higgins boats overtook them on the way in, robbing them of the immediate fire support they had anticipated. Then the landing was thrown into chaos by the sinking of three out of the four Landing Control Craft (LCCs) from which the timing and execution orders for the landing were directed. A third setback occurred when one of the Landing Craft, Tanks (LCTs) hit a mine and exploded, destroying the four tanks on board. On top of this the strong current affected the Higgins boats to the extent that they reached the beach late and up to 1km ($1/2$ mile) south of the intended landing zone.

A number of the Landing Craft, Personnel (LCPs) hit a sandbar 200m (220 yards) from shore – its existence was the reason Supreme Headquarters Allied Expeditionary Force had decided upon the original landing zone – and could not

get nearer to the beach. This presented junior commanders with the dilemma of whether to wait for the LCPs to pull out and attempt to land at another position on the beach, or to disembark well out to sea without fire support or cover, thus presenting an easy target to German machine gunners on the bluff. Some of the boats made another unsuccessful attempt at landing, at which point the company commanders ordered the troops to wade ashore.

Ironically, the high current and waves contributed to the saving of many lives at Utah Beach. The German defences at the original landing site at Les Dunes de Varreville – known as Exit Three off the beach – were much heavier than at the actual landing site at Exit Two, La Madeleine, so landing here may have prevented a bloodbath. Luck or God, or both, were with the Allies at Utah.

Left: US troops landing in Uncle Red Sector, Utah Beach. Note the trucks rolling off the Rhino ferry. In the foreground of the picture stands a captured German PAK-41 anti-tank gun. A German officer's greatcoat is draped over the breech of the gun, possibly placed there by the photographer.

Overleaf: When I was there this stretch of beach was completely deserted, except that, in the distance, I could see racehorses being exercised. It was difficult to imagine the frenzy of military activity portrayed in the archive picture shown here.

Ste Marie-du-Mont

Ste Marie-du-Mont is the first village the Allied troops who landed at Uncle Red Sector would have encountered. During the night of 5th June, the 82nd and 101st Airborne were dropped from their C47 Skytrains with the objective of capturing key points behind Utah Beach, in order to obstruct the inevitable German efforts to reinforce the beach defences when they realised what was happening. The majority of the pilots charged with the drop were young and inexperienced and had never flown through a wall of anti-aircraft barrage such as they faced on that night. Not knowing what to do, they changed course to avoid the fire. Often flying too low and too fast for safe parachuting, the American paratroopers were scattered far and wide by the drop, rarely landing in their correct drop zones; some even landed in the sea, only to drown under the weight of their equipment.

Although confused by what was occurring and thrown into turmoil by the sound of gunfire to their rear, the German defenders maintained as staunch a defence as their situation allowed. Many of them had been on the Eastern Front fighting the Russians and were seasoned veterans, though many others were boys still in their teens. They nevertheless had the presence of mind to act as soldiers, anticipating and working as units, even if they were smaller units than might have been ideal.

One of these units, realising that a parachute drop was taking place, anticipated that one field, with a barn in the corner, might be used as a landing zone and promptly doused the barn in fuel and set it alight. They were proved correct, as a company of pathfinders from the 506th Battalion, who had jumped moments earlier, descended helplessly amidst a hail of machine-gun and heavy-mortar fire, illuminated by the flaming barn. Very few of them escaped with their lives.

Opposite: The church at Ste Marie-du-Mont stands in the town square, some 2–3km (1½–2 miles) inland from Utah Beach. Today the visual reminders of the events of 1944 are few and far between.

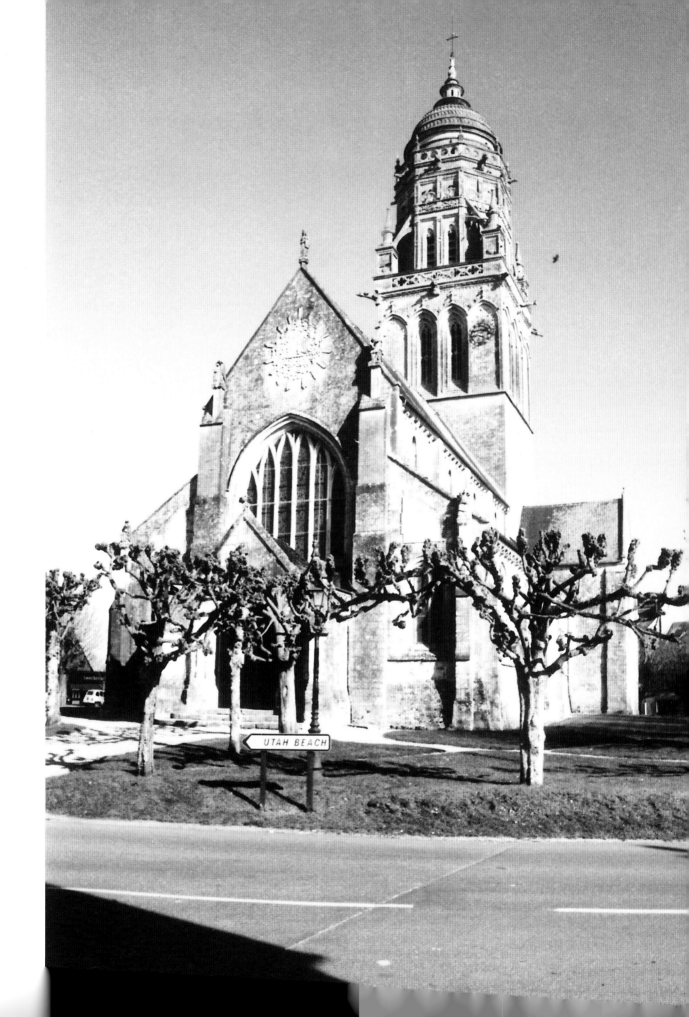

Carentan

Carentan is a town at the eastern base of the Cotentin Peninsula, situated on N13, the road which connects Cherbourg and Paris. This fact made it strategically important to both German defenders and Allied invaders on D-Day. It was, in effect, the only place where troops and armour from Omaha and Utah Beaches could link up and create a continuous and therefore strong beachhead from which the Allies could expand into France.

Troops of the US 101st Airborne Division were assigned to capture Carentan as soon as possible after H-Hour, as the time of the drop was known – for the 101st Airborne this was 0130 hours on the morning on Tuesday 6th June. The Germans had their crack 6th Airlanding Division defending the town under the command of one of their best field commanders, Colonel von der Heydte. The fighting around the town was ferocious and went on for several days, the Americans gaining the upper hand thanks only to better supply lines and numerical superiority. The town fell to them on 13th June 1944, and the two beachheads were united the same day.

As in many of the towns and village in the Calvados region, not much has changed in Carentan since 1944. There is little industry and the population has remained more or less static. From a distance, the town rises over the plain, still dominated by the church in its centre.

In June 1944, Sergeant Alexander Uhlig was serving in the 3rd Battalion, 6th Regiment, of the German Second Fallschirmjäger [Parachute] Division, which was under the command of General Ramke. Sergeant Uhlig was actually on leave in Germany when the Allied landings took place. Speaking in English, he recalls his experiences when he rejoined his unit near Carentan, some two weeks after D-Day: 'During the first days of the D-Day beach invasion, I was at home in Leipzig, on leave for my wedding on 5th June 1944 – one day before the invasion.... I was sent back to Normandy by train about 15 days later, [around] June 20th. I was south of Carentan, between Carentan and Périers. I was around the flooded areas in the bocage, near Méautis and Sainteny and la Roserie. These towns were near the highway [the N171] connecting Carentan and Périers. We were fighting for control of that highway against United States infantry units....

Opposite: A nocturnal view of the large church which dominates the old town of Carentan.

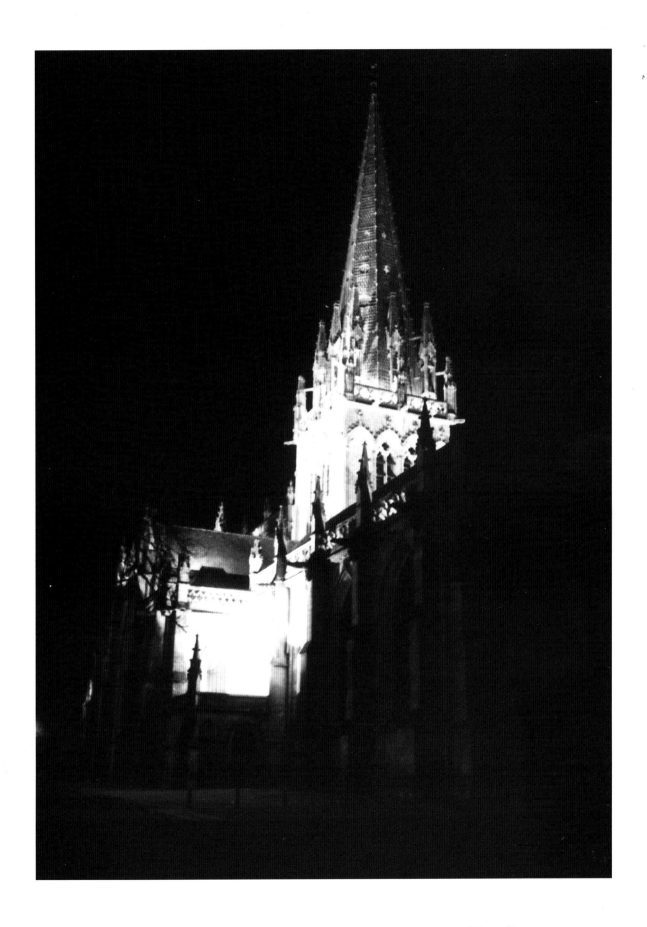

'I had war experience from years before. I fought in Poland, Norway, Crete, Italy, Africa – so I had a lot of experience, but not against Americans. So, Normandy was my first battle experience against Americans. They had a lot of materiel [*sic*], we had less materiel, which made a difference. They were a lot of men, we were less. Our regiment was in action from the first day of the invasion until end of July 1944 and our companies were small; we were 140 to 160 men at the beginning, and at the end of June there were 30 to 40 men. We lost most at Carentan, one battalion, the First Battalion, against American paratroopers.'

Opposite: US troops resting in the streets of Carentan, somewhat ironically in front of a World War I memorial which is swathed in Allied flags. The bank building on the right still stands today and is now a bakery.

The poet Louis Simpson, in this extract from his poem *Carentan O Carentan*, recalls his and his comrades' experience of the D-Day landings in that area of the Normandy coast:

> Trees in the old days used to stand
> And shape a shady lane
> Where lovers wandered hand in hand
> Who came from Carentan
>
> This was the shiny green canal
> Where we came two by two
> Walking at combat-interval.
> Such trees we never knew.
>
> The day was early June, the ground
> Was soft and bright with dew.
> Far away the guns did sound,
> But here the sky was blue.
>
> The sky was blue, but there a smoke
> Hung still above the sea
> Where the ships together spoke
> To towns we could not see.

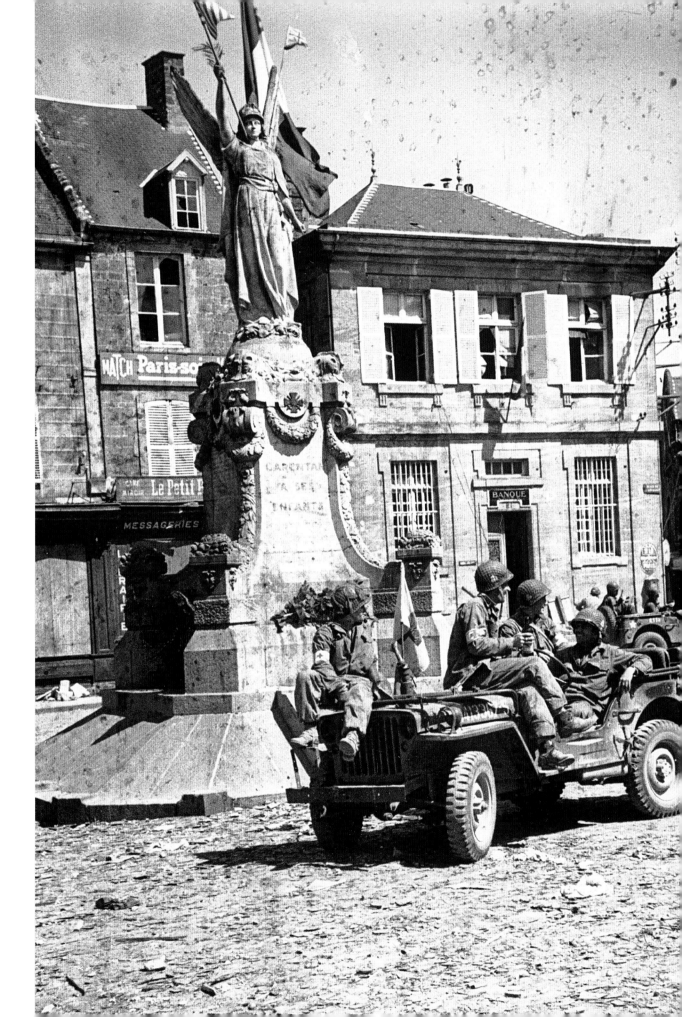

La Madeleine

In December 1941 Adolf Hitler had formulated a plan to prevent the Allies invading Nazi-occupied Europe. He ordered the German High Command to organise the construction of a wall to ensure that the Arctic, North Sea and Atlantic coasts could resist a landing operation of very considerable strength with the employment of the smallest number of static forces. Hitler intended the Atlantic Wall to stretch from Norway to Spain without a break. Massive resources were put into its construction under the aegis of the Organisation Todt, headed by Albert Speer. Initially the workforce came from within the Wehrmacht, but as the armies of the Reich became increasingly stretched, slave labour was brought in from various parts of German-

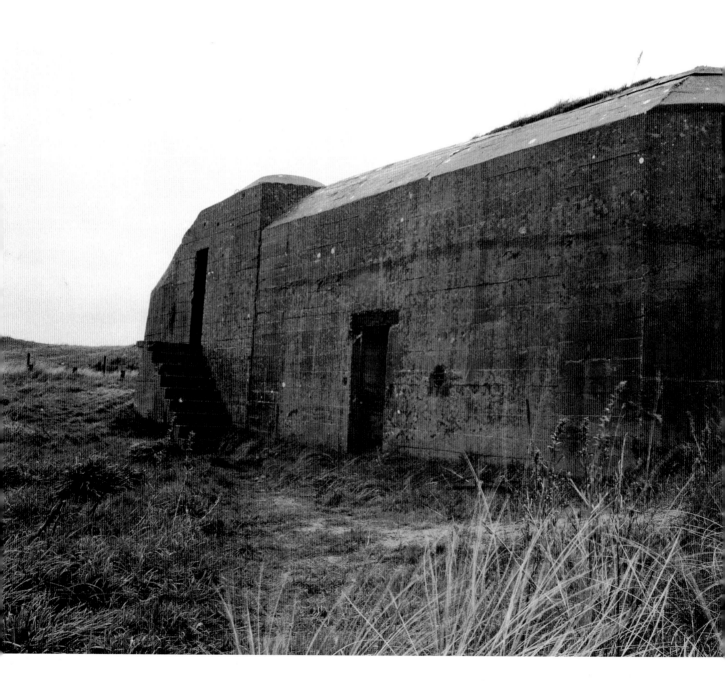

occupied Europe. But this was a project on a scale never seen before and never to be completed. The defences were reinforced at those places the Germans thought most likely to be invaded. As a result, the Pas-de-Calais was extremely well defended, with nearly 50 batteries of heavy artillery, compared to 20 in the Normandy area.

The firepower held within the strongpoint of La Madeleine, however, was impressive. It consisted of a 88mm cannon, two 75mm cannon, two 5mm anti-tank weapons, a 16inch howitzer, three heavy machine guns, five grenade-launching mortars, two flame-throwers and eight explosive-packed, radio-controlled Goliath tanks. The position commander was a 23-year-old lieutenant, Arthur Jahnke, who, in common with many Wehrmacht troops defending Normandy, had been wounded on the Russian Front and re-assigned to the Atlantic Wall. It was he who received Feldmarschall Rommel when he made an inspection of the coastal defences at La Madeleine. Jahnke told Rommel that his men had no lack of drive or devotion to duty, but that there were too few supplies available to the Wehrmacht in this area. Rommel glanced at the bruised and calloused hands of Jahnke and his men and saw the young Lieutenant's point.

Jahnke became confused on the night of 5th June when he heard machine-gun fire to the rear of his position. Only when he sent out a patrol which returned with captured paratroopers who had lost their weapons did he understand what had happened. He was puzzled, however, by his prisoners' anxiety to be moved to and held in a rear position.

Prior to the invasion, the Allies had identified La Madeleine as a threatening defence and as such bombed it – heavily. Unlike at other such blockhouses, the bombings were accurate and successful and most of the massive firepower was either damaged or destroyed. Jahnke, deeply shocked and with some of his troops protesting, organised a makeshift defence, only to be faced soon afterwards with the awesome sight of the invading armada.

Left: An 88mm gun bunker, part of the strongpoint at La Madeleine, named after a nearby hamlet. In 1944 it would probably have been partly concealed by a sand dune, but now stands derelict on the beach front. When I went there a few sheep seemed to be the only visitors.

Les Dunes de Varreville

At H-Hour on Utah Beach landing crafts with soldiers of the US 8th Infantry Division on board were heading towards the two sectors named Uncle Red and Tare Green. When they reached the beach, the disembarking troops were surprised to find that German resistance was lighter than expected. One of the officers landing was Brigadier General Theodore Roosevelt, a cousin of the US President and known for his flamboyance. Roosevelt insisted on landing with his troops and sharing the danger with them. He soon realised that the wave of troops he commanded had in

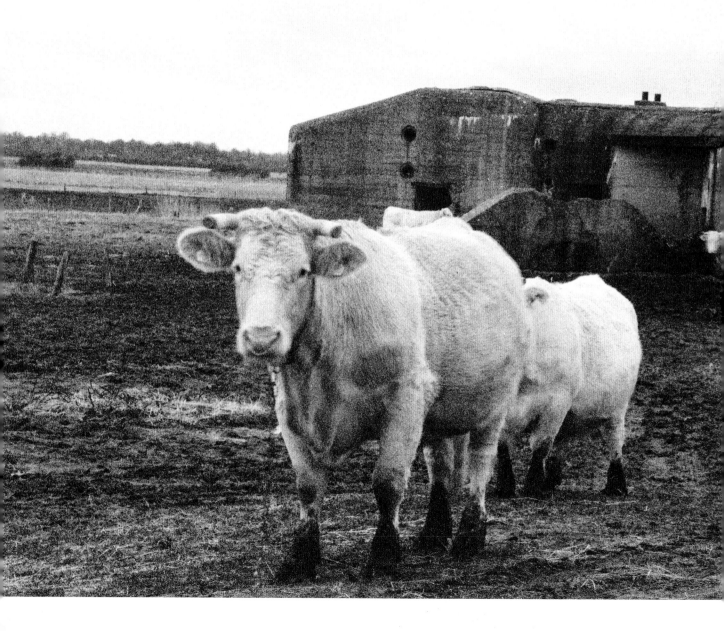

fact been landed further south on the beach than had been planned. Recognising that a choice had to be made – whether to re-deploy at the original landing zone or continue the fight from here, where the defences were clearly weaker – the Brigadier General decided on the latter, stating, 'We'll start the war right here!'

When standing on the sandy beaches of Tare Green and Uncle Red today it is easy to imagine the invasion coming ashore. At this point on the coast the tide recedes over 1.5km (1 mile) out to sea. The wind blows and the sand whips your face, making you want to seek shelter. Looking back towards the beach from the water's edge at Les Dunes du Varreville, you see that the coast is dotted with the remains of the Atlantic Wall. The German defences here were not as dense or well planned as those at Omaha; nevertheless, advancing across the beach under fire must have been a daunting task indeed.

The report of Brigadier Cass, a British commander involved in the planning of the invasion, confirms that the US VII Corps had landed slightly south-east of Utah Beach and encountered stiff opposition on turning towards its objective on its right flank. By nightfall, however, it had penetrated 9km (almost 6 miles) inland and made contact with the US 82nd and 101st Airborne Divisions, both of which had been dropped early on 6th June – although, as in the case of the 6th Airborne, the area covered by the drops was wider than had been planned. The 82nd Airborne captured and held Ste Mère-Eglise and the 101st took St Martin-de-Varreville and Pouppeville.

Left: This bunker was built in a farmer's field, hence the pastoral scene, as he uses it today as a shelter for his cows. Situated away from the beach, it was probably used as a garrison for off-duty gun crews.

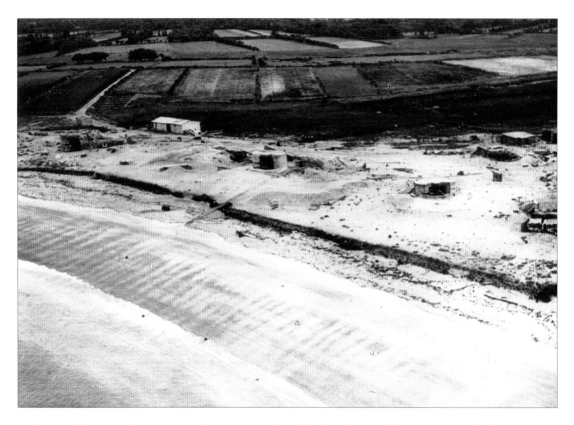

Above: This aerial picture, taken soon after the landings, shows some of the damage done by the Allied forces to the 'impregnable' German defences in and around Cherbourg. It also shows the flat and featureless immensity of these beaches, which offered no shelter whatsoever to the invading troops.

John (Jack) Capell IWM/c. Wireman HQ 8th Infantry Regiment, recalls the briefing he and his comrades received as they prepared for landing on Utah Beach: '...we were briefed by various officers. We were to land on the coast of Normandy in France at 5 a.m. on June 5th. We were to be the first troops to hit the beach. Beyond the head of the beach we were to look for a road and then fight our way inland. The road served as a dike next to low-lying fields that were flooded up to a depth of three feet [1m]. We were shown a detailed map which displayed the type of terrain and the location of some of the German fortifications. Once inland we would link with units of paratroopers and glider troops at some point between the beach and Ste Mère Eglise. An officer stated that some of the German troops would be members of the SS. We were not to take them prisoners but must kill them. They would be identified by their uniforms.... They might be carrying a bomb and surrender in order to get close enough to explode it near an officer or a group of men. Even if they did submit to capture there would be no hope of getting information from them.'

Pouppeville

Pouppeville was the most southerly exit off Utah Beach, situated just inland and next to the Vire river estuary. It was secured by the 101st Airborne, before the start of the US 4th Infantry Division beach landings, and was the scene of the link-up between the 4th and 101st Divisions at 1110 hours on D-Day. Although it had little strategic value, Pouppeville was significant for this meeting, as it provided the Americans with a route and the extra force with which to attack and capture Ste Marie-du Mont later in the day.

The US 4th Infantry Division landed at Utah Beach, opposite Pouppeville, which caused them a problem as their objective was St Martin-de-Varreville, 2km (1¹/₂ miles) to the north. Their commander, Colonel Russell 'Red' Reeder, decided that they should wade through the flooded fields behind the beach towards their objective. Reconnaissance said that the water in the fields was shallow, but the men soon discovered that it was up to their waists, and sometimes over their heads. Any man who fell under the weight of his equipment had to struggle to survive. All the while the causeways and fields were coming under fire from the 155mm gun battery at St Marcouf.

Overleaf: A derelict gun battery on Utah Beach. Some areas beyond the beach are still cordoned off with barbed wire, as there may be unexploded ordnance beneath the shifting sand of the dunes. I visited this section of the beach on a dull grey day and the scene was quite desolate.

Pages 52-3: The estuary of the Vire river, which forms a boundary between the Utah and Omaha Beaches. Even in summer it is extremely muddy and at some point I sank up to my knees, after which I beat a prudent retreat.

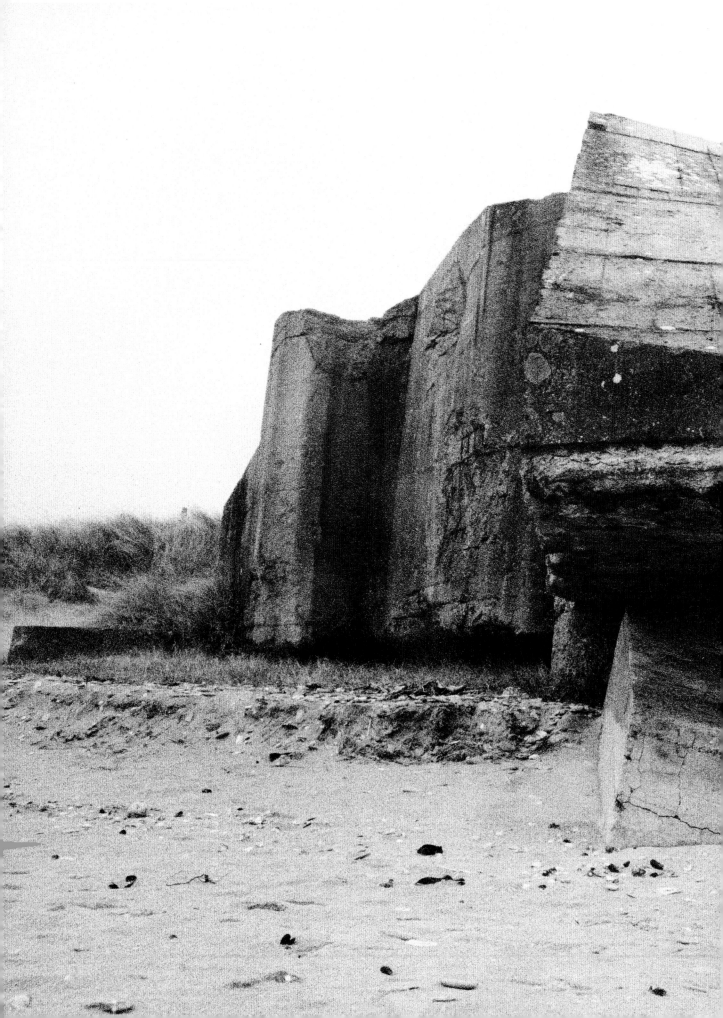

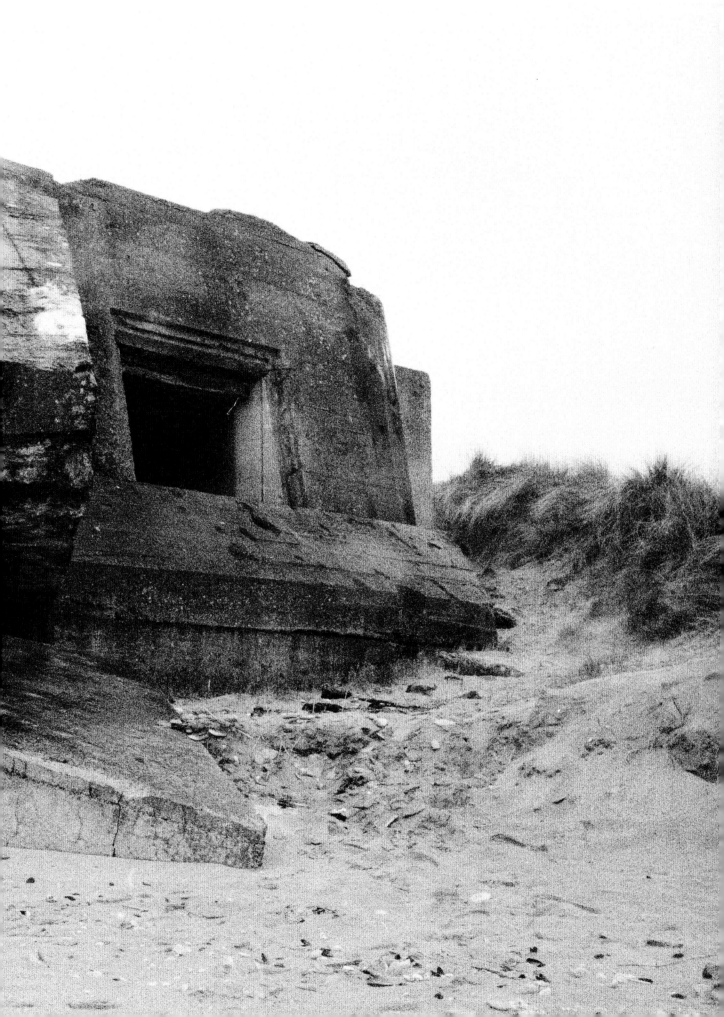

Ravenoville

Ravenoville was one of the places on Utah Beach which the German High Command had seen as a likely site for a potential Allied invasion and it had been heavily defended. In the event, the American troops more or less bypassed Ravenoville, because the strong winds and tide carried them further south than they had planned.

The Atlantic Wall in this area consisted mainly of smaller bunkers and pillboxes, most of which have survived, but they have not been restored and made part of the historic circuit, as has happened in many other places along the coast. For the most part the fortifications have been left to decay and are largely ignored by the locals, to whom they have become part of the scenery. Some, like the one illustrated here, have found a new use as a shelter for the local livestock, making a mockery of Hitler's desire to build a wall which would keep the rest of the world out of Europe.

Below: Looking through an 88mm German gun aperture. The gun crew made sketches on the walls, noting down the gun ranges of various targets, and these survive to this day. Four or five men would have manned this type of gun.

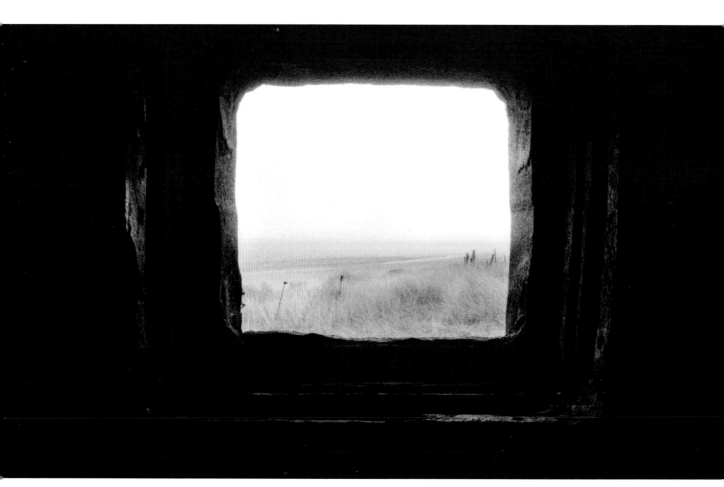

Azeville

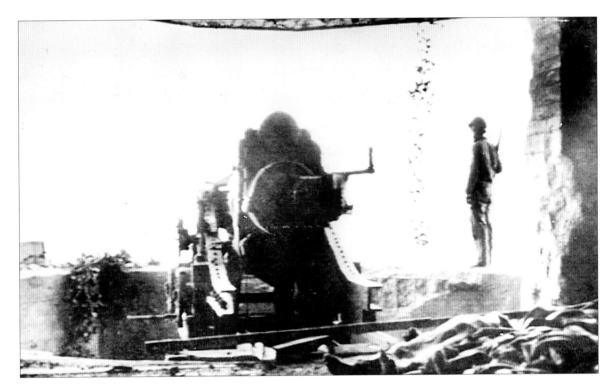

Above: An American GI stands close to the gun aperture of a large German coastal defence gun emplacement. Dead crew members still lie in the foreground.

Azeville was the site of another of the large German gun batteries. As was often the case it had been planned to provide heavy artillery fire onto the beaches in case of an Allied invasion. In such installations the guns provided enough range to engage with enemy shipping out in the Channel. As such Azeville held gunnery duels with the USS *Texas* and other smaller ships. The guns were also able to rain havoc on any troops who reached the beaches.

The site straddles a minor road towards the beach and two of the casemates are in a field now inhabited by sheep which seem quite unabashed by their martial surroundings. They seem happy to use these sinister reminders of the war to sleep, eat and defecate in.

Overleaf: The two gun emplacements shown in the picture are part of a group of four at Azeville. The two which were behind me when I took this picture are used as the backdrop to outdoor concerts.

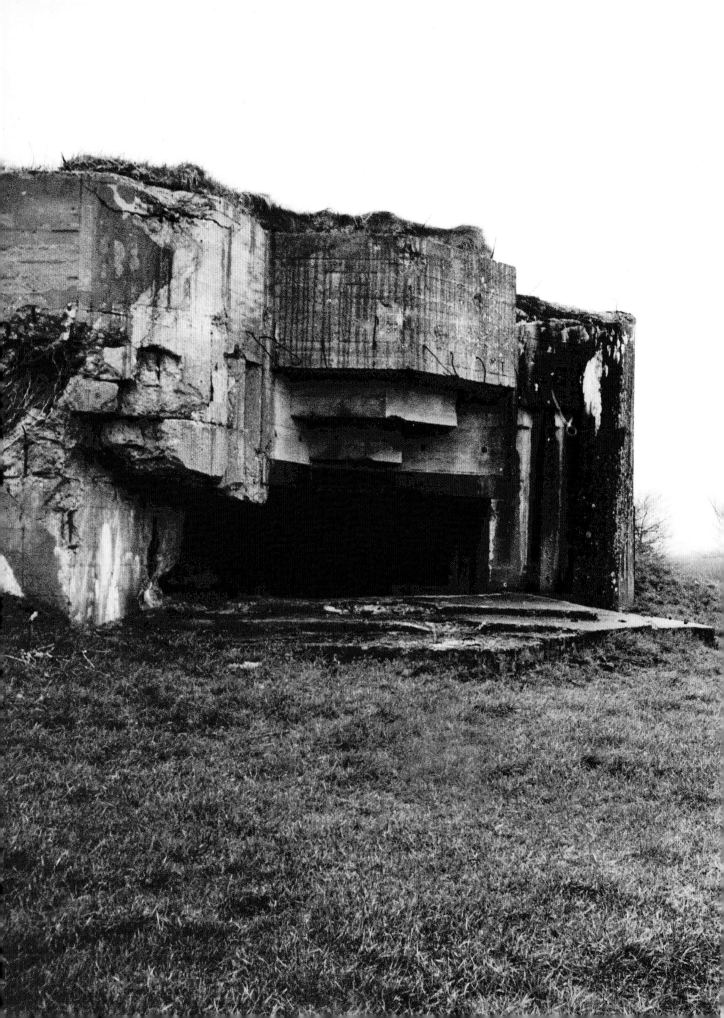

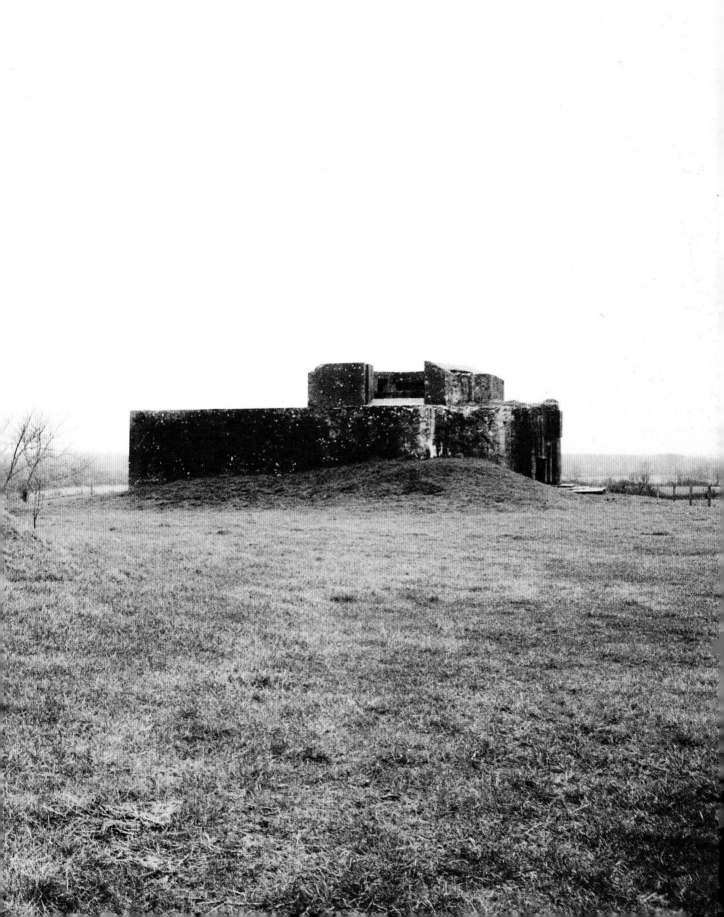

St Marcouf

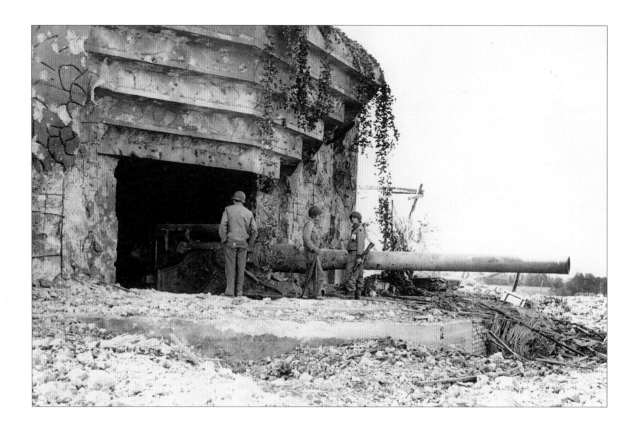

Above: US troops inspecting the huge German gun at St Marcouf, captured after this position held out for two days against the advancing Americans.

The heavy-gun battery at St Marcouf was one of many gun emplacements on the Atlantic Wall. This position, situated part-way between St Marcouf and Crisbecq, became known to the Allies as Crisbecq after its capture.

In the months leading up to the Allied invasion, Rommel himself visited Crisbecq and was impressed by the awesome array of firepower and defences which was concentrated in the area. There were four gun emplacements equipped with 155mm guns of Czech origin, each encased in up to 4m (13ft) of concrete which was able to withstand a direct hit from even the largest of the Allied naval guns. Besides these major defences the site was surrounded by communication trenches, machine-gun emplacements, minefields and barbed wire. The Crisbecq battery continued firing throughout D-Day, D+l and D+2, being captured by the American forces only when it finally ran out of ammunition. Until then it had posed a deadly threat to the success of the landings on both Utah and Omaha Beaches.

The battery was captured intact with its gun, but the US Engineers subsequently attempted to destroy it – without much success, as can be seen below.

The passing years and encroaching vegetation and tarmac have changed this tragic site dramatically. In 1944, the incessant bombardment of the area around the guns and the hand-to-hand combat which followed the landings reduced the landscape to a barren wasteland, pock-marked by bomb craters and littered with the bodies of the dead. Today, nature has softened the landscape, leaving only thousands of tonnes of concrete as a clue to past events.

Below: After its capture by American troops, engineers attempted to destroy the gun battery at Crisbecq/St Marcouf. In the case of this particular emplacement, the explosion only caused the roof to cave in partially. This deterred the Americans from trying to destroy the other three.

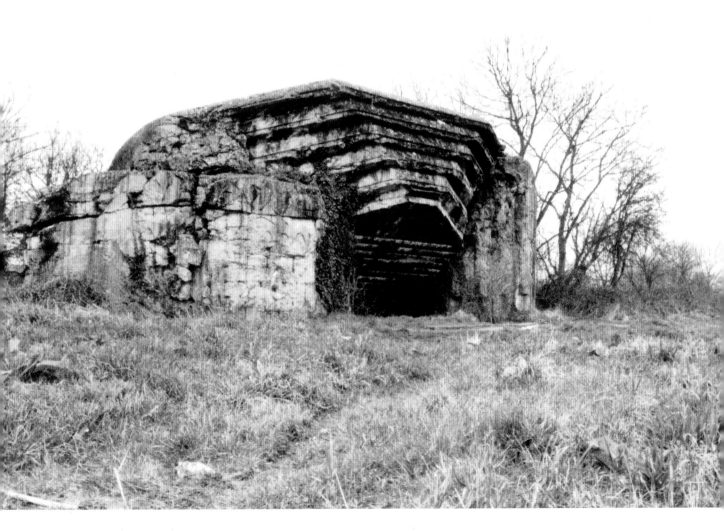

'Tobruk' Defences

Named after the place in the Tunisian desert where Feldmarschall Rommel engaged in a famous siege with the British Army, the Tobruk was a hardened concrete defence sunk into the ground with only a few centimetres of the concrete shell appearing above the ground. Designed to provide protection for one or two men, usually for the manning of a machine gun or light artillery, they proved lethal to

Below: A well-preserved example of the hundreds of Tobruks dotted along the beaches of Normandy. This one commanded a wide-ranging view of the beach and the sea beyond. One or two men would have manned such a position.

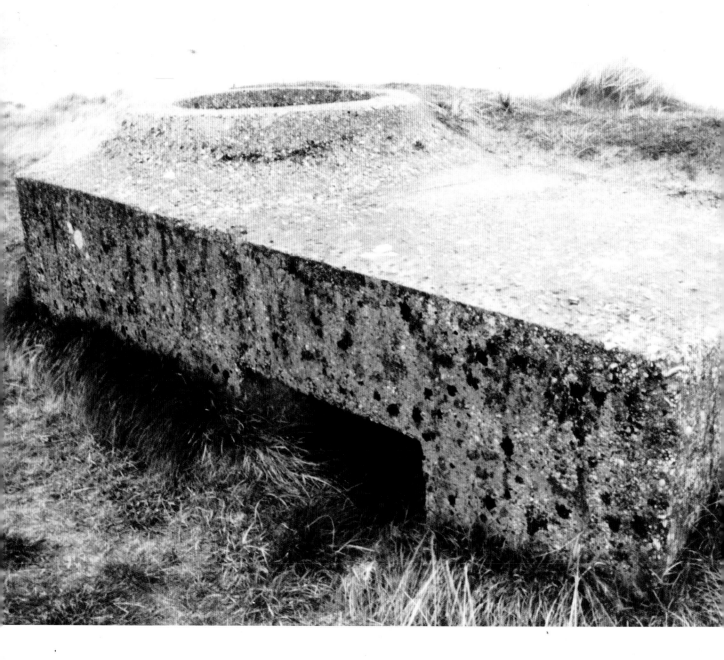

the Allied invaders, particularly on Omaha Beach, where perfect firing positions had been earmarked.

Tobruks gave good levels of protection to an otherwise weakly defended point on the Atlantic Wall, but were also sited to provide good visibility of the beaches and thus an excellent field of fire. When used by seasoned gunners, these positions, armed with MG34 or 42 machine guns, could feasibly engage and defeat squads, platoons or even companies of the enemy, if the latter were unlucky enough to be without

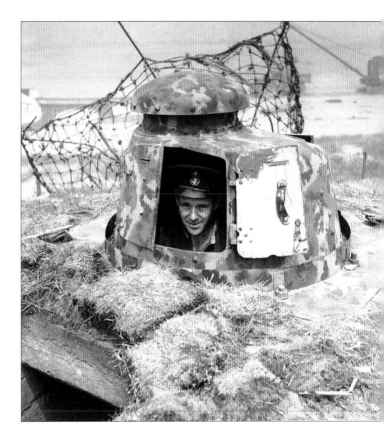

armoured support or accurate artillery (which was often the case on Omaha). The rate of fire and effect of cross-fire from these weapons meant that Allied soldiers could not get close enough on their own to put these positions out of action. In the absence of armoury to attack them, Tobruks were only really vulnerable when they had run out of ammunition.

Above: A captured Tobruk on the beach. This one had a steel turret to protect and conceal the machine-gunner inside. It was entered by an underground passage. A British sailor posed inside for the photographer. One or two men would have manned such a position, accompanied by an MG34 or MG42 machine gun.

57mm Anti-tank Gun

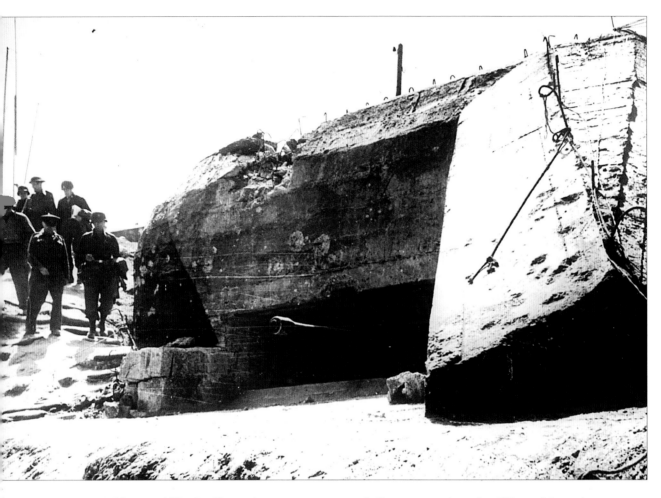

Above: Allied officers inspect a captured German anti-tank pillbox. Note the amazing thickness of the roof and walls.

The Versailles Treaty, which was signed at the end of World War I by all the major powers of the day, was intended to limit the war-making capacity of the nations involved in the hostilities. Agreements limiting air-force numbers were made, as a result of which many planes were scrapped. The sizes of land armies were curtailed (ironically, few of the countries involved had enough men left to sustain an army of note) and the permitted numbers of artillery guns were cut (scrap metal became abundant and the price of steel plummeted). Rules were also laid down restricting the size and power of the world's navies. Before the First World War naval power had been regarded as a deterrent, in much the same way as nuclear weapons are today; the fact that it had now been used (mainly by Britain and Germany) as an offensive weapon – albeit with limited effectiveness – led military

strategists to want to reduce the impact a large navy had on the balance of world power. Mainly, however, Versailles was viewed as a punishment dealt out to Germany for inflicting a devastating war on so much of the rest of the world. Crippling war reparations brought Germany to her knees. In the eyes of many – and not only Germans – the stipulations contained in the Treaty of Versailles's humiliated a once-great nation. Certainly Adolf Hitler viewed it this way, and the desire to restore German prestige was at the core of his rebuilding of his country's industry – in direct contravention of the Treaty of Versailles – and eventually of his persecution of Europe.

Below: A 57mm anti-tank gun in its original position. The Utah Beach Museum is immediately to the left of this gun emplacement.

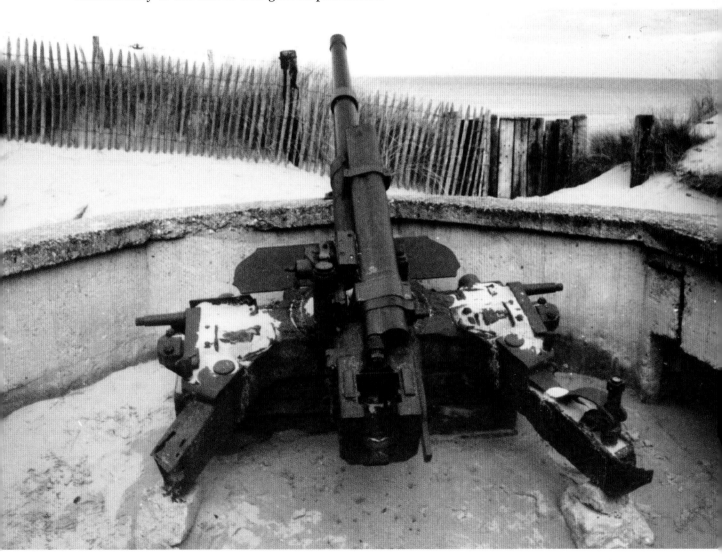

Widerstandsnest 75

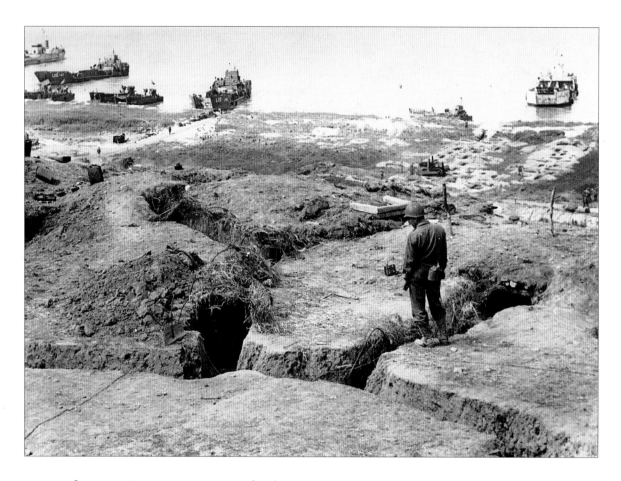

Above: A GI surveys a network of German communication trenches at Utah Beach. Widerstandsnest 75 would have had a similar pattern of trenches.

After his appointment as the inspector of the Atlantic Wall defences, Rommel was vigorous in the application of his new powers. At every opportunity he strove to make his men work harder to complete the building programme. When an officer informed the Desert Fox that he was pushing the men too hard, Rommel retorted, 'Which would your men rather be, tired or dead?' Rommel's defences (see page 178) boasted a formidable array of sinister devices, including sharpened stakes with mines attached to them to blow or rip the bottoms out of landing craft; three steel bars welded together into a tripod shape to form what was called a 'hedgehog,' which also ripped the bottoms out of landing craft, but was additionally used on the beach to protect the wall itself; concrete bunkers; concrete pillboxes to contain vast numbers of artillery and machine guns; flooded fields to impede the invasion force; and over 4 million mines scattered along the invasion beaches.

On the subject of minefields, Rommel wrote in a paper: They 'will contain mines of all kinds and are likely to be highly effective. If the enemy should ever set foot on land, an attack through the minefields against the defence works sited within them will present him with a task of immense difficulty. He will have to fight his way through the zone of death in the defensive fire of the whole of our artillery. And not only on the coast, for numerous and extensive minefields will also exist round our positions in the rear area.'

The Widerstandsnest, or resistance point, was the basic component of the Atlantic Wall. It consisted of a network of bunkers, containing a wide range of armaments, a network of trenches for communication between the bunkers, accommodation for a garrison of troops (usually 150–200 men) and the beach obstacles placed in front of them. The standard weaponry of such resistance points usually included a number of MG42 or MG34 machine guns, a number of light anti-tank guns (usually 57mm) and one or two heavy artillery pieces (usually 88mm or 105 mm).

Widerstandsnest 75 was just one of many such defences. It was repeatedly bombed and bombarded by the Allies, to little avail. Many soldiers died on the beach at Omaha because of the presence of the Widerstandsnests – in fact it could be argued that they could well have formed part of a successful defence had they not been so vulnerable to concentrated *and* accurate fire. It was rare for these two circumstances to coincide on D-Day, but it was such a coincidence that knocked out the 88mm gun at WN75. A well-aimed shot from a Sherman tank (one of the few to land at Omaha) went directly into the opening for the gun and impacted against the wall of the ammunition room. Most of the gun crew were killed instantly.

Since 1944, relative normality has returned to this part of the coast. However, as one passes through this area of one-time devastation and tyranny, only the lack of bustling activity bears witness to the fact that the war is over. Buildings that today have no apparent purpose sit uncomfortably in this otherwise serene landscape.

Overleaf: The entrances to this bunker have been completely blocked by shifting sand and encroaching vegetation.

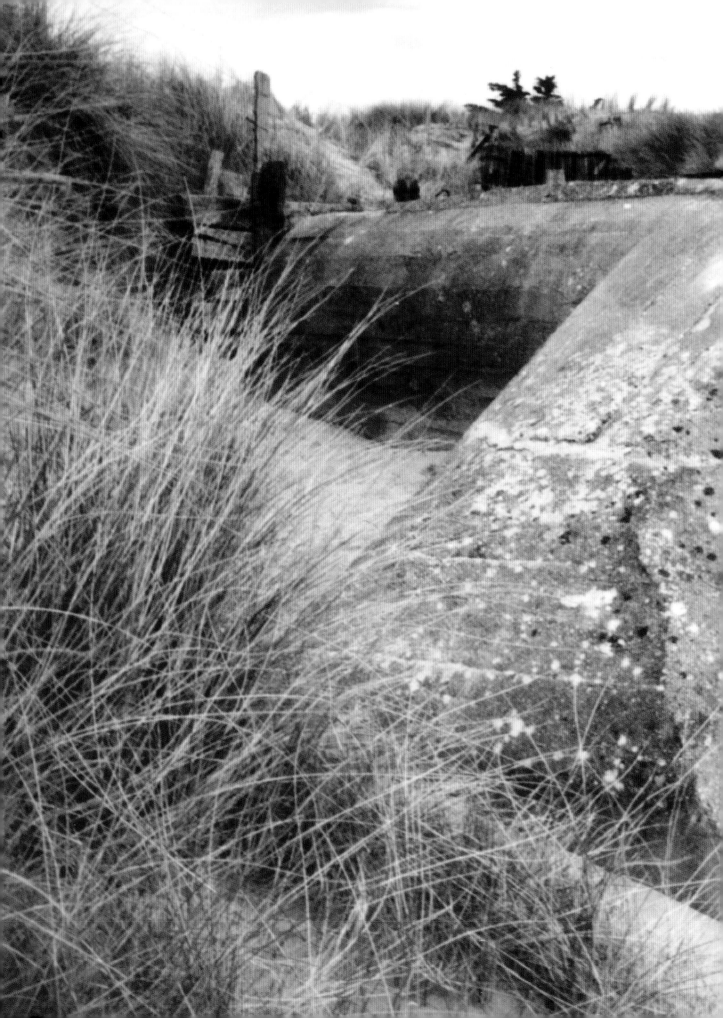

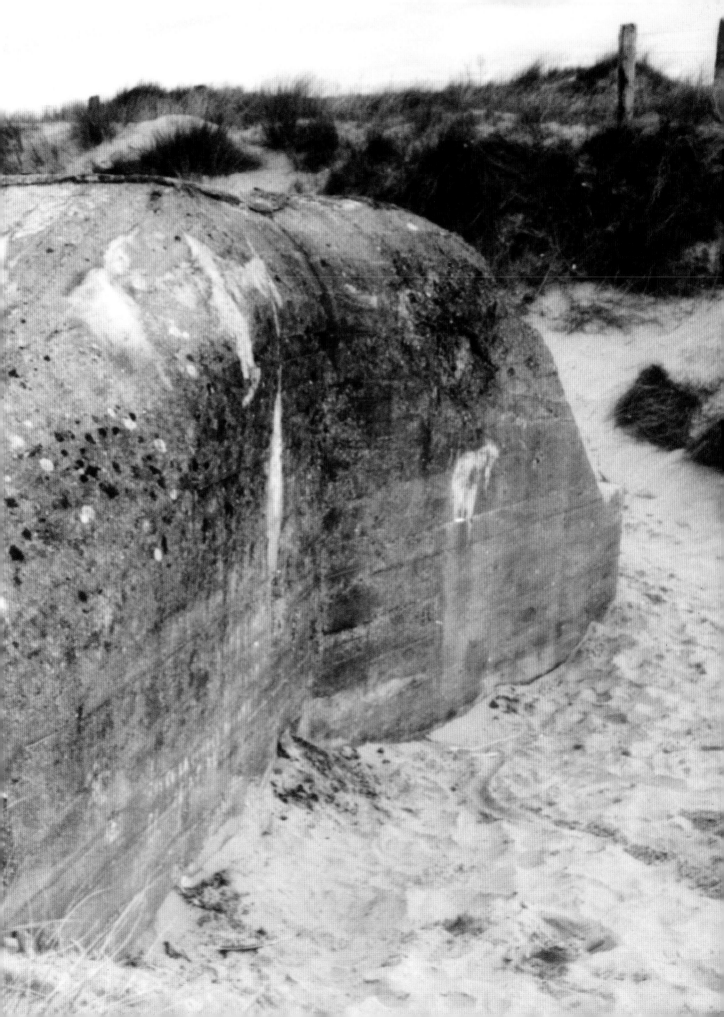

OMAHA BEACH

The beach that the Allies designated by the code name Omaha was the second on which American troops landed on D-Day. It was also the largest and most heavily defended of all the beaches involved in the invasion, stretching from Vierville in the west to Cabourg in the east (Fox Red sector). Every inch of the way was bitterly defended by the Germans and, because of the terrible loss of life sustained by the Allies, the beach came to be known among the combatants as 'Bloody Omaha'.

The first wave of the attack involved the 116th and 16th Regiments and two companies of the 2nd Ranger Battalion, all belonging to the US 1st, 8th and 29th Infantry Divisions. Further regiments from the same divisions followed soon afterwards. Rifleman Ernie Tayler of the US D Company summed up the misery endured by the troops before and during the landings: 'We were so sea-sick that we had preferred to be shot on the beaches rather than go back on those Landing Craft.'

Omaha was of enormous strategic importance for the Allies on the one hand and for the Germans on the other. Its size made it the most suitable beach on the Calvados coast on which to land large numbers of men and equipment; it would also provide the Allies with a vital link between Utah and the British beaches. As early as mid-1943, Rommel had realised that an Allied invasion was inevitable and that Omaha was a good candidate for a landing. When Hitler gave him the task of organising the defence against invasion in France, Rommel became aware that the existing defences were far from impregnable. It is fascinating to see that, around this time, in a conversation with General Fritz Bayerlein, he expressed the fear that 'with the coastline held as thinly as it is at present, the enemy will probably succeed in creating bridgeheads at several points and in achieving a major penetration of our coastal defences. Once this has happened it will only be by the rapid intervention of our operational reserves that he will be thrown back into the sea.'

In a letter to to his son, dated 31st January 1944, Rommel wrote: 'There's still an endless amount of work here before I'll be able to say that we're properly prepared for battle. People get lazy and self-satisfied when things are quiet. But the contrast between quiet times and battle will be tough and I feel it essential to prepare for hard times here.'

To this end, Rommel personally supervised the construction of new defences and the improvement of the old ones. He saw to it that every inch of Omaha Beach was covered by machine-gun fire and pre-sighted

artillery, including 75mm, 88mm and 105mm guns and 60 and 81mm mortars. In addition to the obstacles described on page 64, which were installed both in the shallow water and on the beach itself, hundreds of thousands of mines of various types were laid on the sand – Rommel had learnt the importance of minefields from the British in the desert. His instinct that this was where an invasion was likely to take place was correct, but even this formidable array of defensive weaponry was too little too late.

Nevertheless the Germans did almost succeed in hurling the Allies back into the sea. Many Allied veterans of Omaha maintain that the only thing that saved the landing – and thus, it could be argued, the rest of the invasion – was the fire support the infantry received late in the day from a number of Allied destroyers. Sailing unbelievably close to the shore, these destroyers bombarded the German strongpoints, using infantry to spot targets and relay information to the ships by means of Aldis lamps. As well as this, Sherman tanks in fixed positions fired from

Below: US troops wading ashore at Omaha. Note the tightly packed German beach obstacles. The white marks on the left of the picture and behind the landing craft were made by the censor, obliterating a sensitive item of visual information.

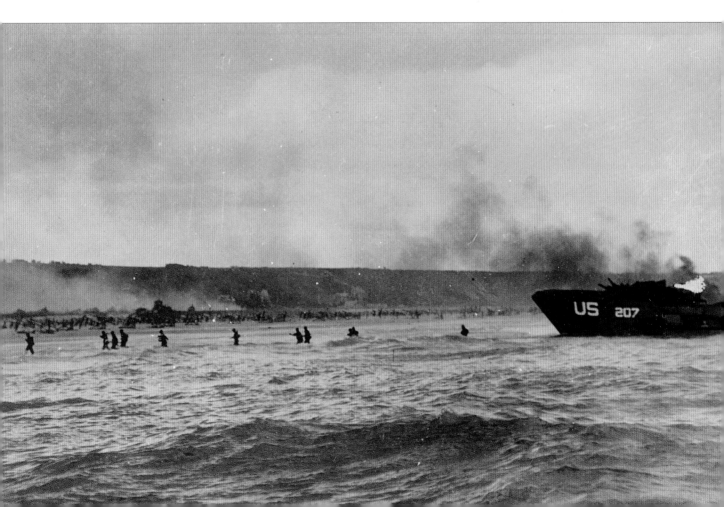

guns, allowing them to target the defences more accurately and save on their heavier and more expensive ammunition.

It was a close-run thing and the events on Omaha show that. had Rommel been allowed to follow his instinct and to implement his ideas fully, the outcome of the D-Day landings might have been very different.

Many Allied soldiers were decorated for their heroism and dedication to duty on D-Day. General Omar Bradley, like many others in the Allied High Command, realised not long after the beginning of the landings that if they were to succeed in their objectives, the soldiers on the beaches would have to excel themselves, both individually and in their units, from squads to corps. One man who did just that was Captain Edward F. Wozenski, 16th Infantry, United States Army, who received the Distinguished Service Cross for his conduct on that day.

His citation reads: 'On D-Day, Captain Wozenski's company suffered numerous casualties in reaching the fire-swept invasion beach. Boldly, he moved along the beach, at the risk of his life, to reorganize his battered troops. The reorganization completed, he courageously led his men through heavy machine-gun and small-arms fire across the beach and toward an enemy-dominated ridge. Demoralizing fire from a powerful installation on the ridge threatened to stop the attack. Ordering his men to deploy to the flanks of the enemy position, Captain Wozenski, with great valour, advanced alone to within 100 yards of the emplacement. With cool and calm efficiency, he engaged the fortification single-handedly with rifle fire to divert attention of the enemy from the flanking movement. Upon observing this valiant soldier, the enemy directed the fire of its machine guns on him, but Captain Wozenski, with complete disregard for his own safety, continued the harassing fire until his men reached their positions safely. His inspired troops charged the strongpoint vigorously and completely destroyed it, inflicting numerous casualties upon the enemy. By his superb leadership and fearless

courage, Captain Wozenski exemplified the highest traditions of the Armed Forces.'
(Courtney H. Hodges, Lieutenant General, US Army, Commanding)

Below: View from the beach at Colleville, directly in front of Widerstandsnest 62
(see page 108). The US military cemetery is just to the right of the area shown
on the photograph.

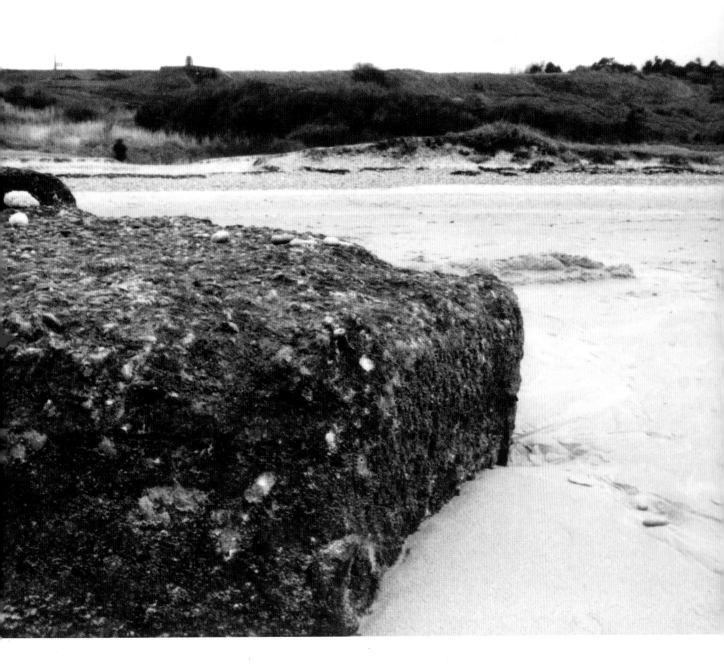

Pointe du Hoc

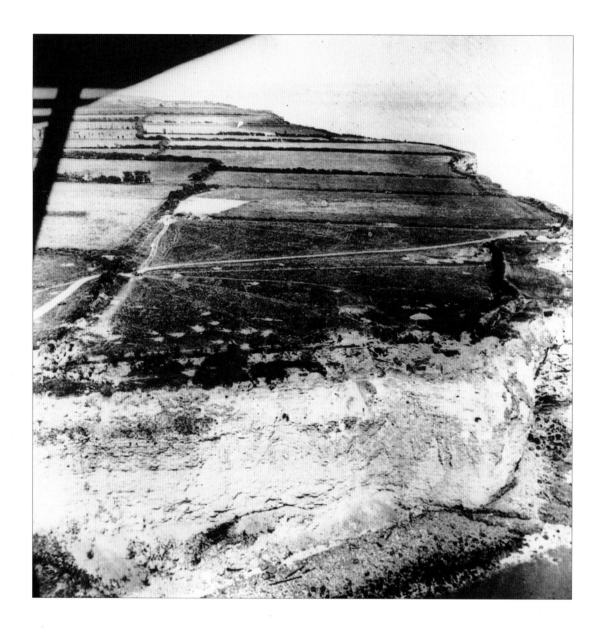

Pages 72-73: The distinctive shape of Pointe du Hoc was used by the invasion planners as a major landmark along the coast, yet on D-Day many of the landing craft missed it altogether in the bad weather and rough seas and went off to Pointe de la Percée, further along the coast. I took this picture from the top of the cliff, where some of the old barbed wire still survives.

Above: Aerial view of Pointe du Hoc, taken in 1944. The tall cliffs, which Colonel James Rudder's US 2nd Rangers had to climb to reach the mainland, show up very clearly in the foreground.

Prior to the D-Day invasion, Pointe du Hoc was identified by the Allies as a major threat to the success of the landings, due to the presence of six German large-calibre artillery guns. The Allies expended enormous amounts of ordnance in an attempt to destroy these, before the actual troop landings. It is estimated that more TNT tonnage descended on the Pointe du Hoc area in the days up to D-Day than was dropped on Hiroshima by the atom bomb.

The terrain along this stretch of coast formed a wonderful natural defence, as far as the Germans were concerned. The aerial photograph on the left-hand page shows the high cliffs which the assailants had to negotiate in order to reach the mainland. It is easy to imagine the carnage the German defences were able to inflict on them.

Below: It is an eerie feeling to be standing inside one of the gun emplacements on Pointe du Hoc. From here the German crew would have caught the first glimpse of the invasion fleet.

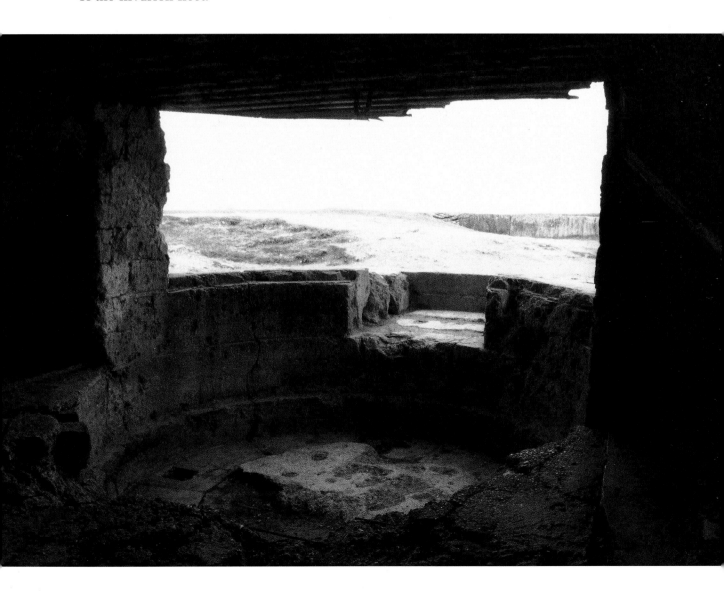

Pointe de la Percée

When Colonel Rudder and his men of the 2nd Rangers set off on the near-suicidal mission to capture the gun batteries mounted on top of Pointe du Hoc, they were not aware how close they would come to total failure. A navigational error meant that for a long time their landing crafts were heading towards Pointe de la Percée, a number of kilometres to the east of their objective. When the mistake was realised and the necessary changes to the course made, the landing crafts were heading against the strong tidal current which delayed them further, so that by the time they eventually reached Pointe du Hoc, it was too late to make the pre-arranged call to request reinforcements in the shape of the 5th Rangers. The 2nd Rangers still managed to capture the batteries, but paid a very high price and suffered heavy casualties from German machine guns and hand-to-hand fighting.

There is an ironical twist to this story. When the battery was eventually taken, Rudder and his men discovered that the Germans had moved the guns inland before the assault. The terrain, and the fact that the Germans had the advantage of being on top of the cliff, made Rudder's task difficult enough. Had he failed in his objective, it could have resulted in many more Allied deaths on that day on Omaha Beach.

Opposite: Pointe de la Percée can be seen in the background of this picture. The US 2nd Rangers mistook this coastal feature for Pointe du Hoc and wasted valuable time making up for their navigational error.

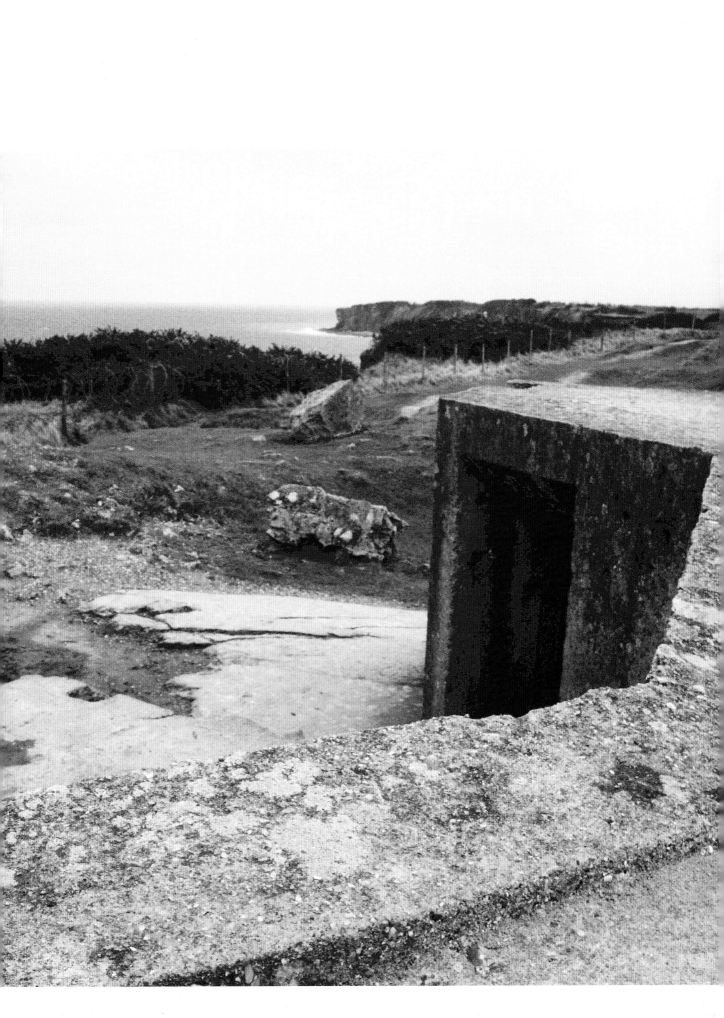

Dog White Sector

Dog White was one of the sectors assigned to the 29th Infantry Division for the assault. The plan was for 16 Landing Craft, Tanks (LCTs) to take four Sherman Duplex Drive (DD) tanks each to within 3km (2 miles) of the beach and launch them into the sea. They were scheduled to arrive on the beach at H-5 minutes – five minutes before the rest of the operation – to engage the beach defences and provide covering fire for the assault troops. This plan rapidly turned against the Allies as the first tanks sank in the rough water. When he realised what was happening, Lieutenant Rockwell, a junior officer on one of the LCTs, broke radio silence to inform the rest of his flotilla that the DD tanks had to be taken in to shore to avoid further losses. As a result of his initiative, the flotilla was put back on course and came to rest directly opposite its objectives on Dog White and Dog Green, at the very moment that the Allied naval barrage was lifted. Lieutenant Rockwell's ship, LCT535, was the first to unload its heavy cargo of tanks on Omaha. This equipment provided much needed support to the assault troops.

One survivor of a Landing Craft, Infantry (LCI), jumped overboard when it was hit in the stern by an 88mm shell. He was carrying so much equipment that even with two life jackets – Mae Wests, as they were known, because when inflated they allegedly resembled that voluptuous actress – he could not remain afloat in 2.5m (8ft) of water. Mercifully, he was very close to the shore. Crawling onto the beach exhausted, he was met by the full force of the German firepower. It brings to mind the lines from Tennyson's *Charge of the Light Brigade*:

Cannon to the right of them,
Cannon to the left of them,
Cannon in front of them
Volley'd and thunder'd.

The soldier somehow survived to tell the tale.

Private First Class Bob Sales was 18 years old and an infantry radio operator with the US 29th Division. His recollections of D-Day and the terrible scenes he witnessed are clear and matter-of-fact. It is difficult to imagine the effect such experiences would have had on an 18-year-old:

'I was 10 minutes behind the first wave. My officer, Captain Zapacosta, told me to stick my head up over the side of our landing craft. All I could see was bodies, smoke and fire. All the men of the first wave were either dead or wounded.

'The beach was supposed to have been bombed out, giving us craters to hide in, but there wasn't a hole there. We would be sitting ducks for the German heavy machine guns.

'The ramp went down and we ran out. I tripped and fell sideways off the ramp and went under the water. I was carrying our radio and I struggled to get it off before it dragged me down.

'When I surfaced, Zapacosta was shouting that he was shot. He sank down in water that was just full of blood. There was nothing I could do for him. People were dropping in the water like you wouldn't believe. I was the only man not hit.

'My sergeant was wounded. He raised himself up to talk to me and he was immediately hit full in the head by German machine-gun fire. I began to make my way from body to body up the beach. The Germans stopped shooting at me – I guess an incoming landing craft must have been a better target.

'There were bodies, body parts, men blown apart and still alive, hollering. I was amazed how bad a man can be hit and not die straight away. I was scared all the time, but I kept going. I had no rifle and even my shirt had been ripped off.

'I reached the shelter of the sea wall and from there I'd run back out on to the beach to get bodies. Some of them were still alive when I dragged them back and a medic would try to help them.'

Overleaf: Though there was relatively little fighting on Dog White Sector, it retains an importance as the place where the Omaha Beach Mulberry harbour was sited. Unlike the one at Gold Beach, for instance (see page 112), this Mulberry harbour did not survive. This is surprising in view of the sheer size of these structures, but the ferocity of the storms in July 1944 may account for it. I could not identify the rusting hull embedded on the fine sandy beach, but it may have been one of the harbour's components.

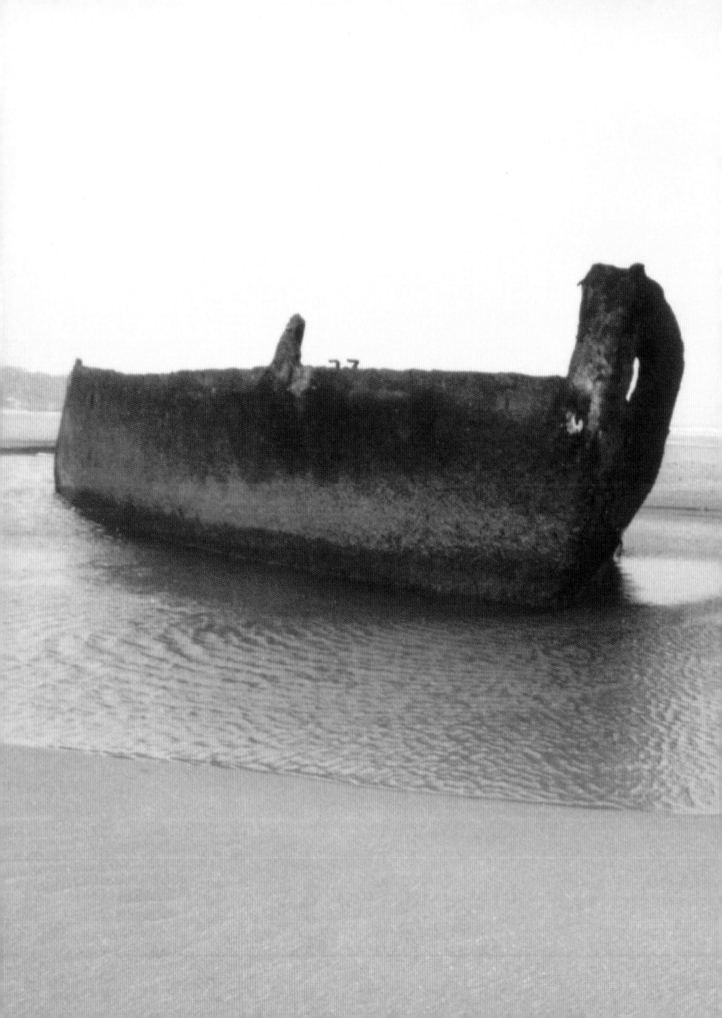

Dog Green Sector

Dog Green Sector of Omaha Beach was the scene of the most fearsome fighting of the invasion. As one of the most likely sites for a landing (in Rommel's estimation) it was afforded the staunchest level of defence on the Calvados coast. The troops that landed in the first wave on Dog Green Sector were from Company A, 116th Regiment. As the ramps on their Higgins boats dropped, a barrage of machine-gun fire tore at the young soldiers – in many cases before they had a chance to take a step. In at least one instance the entire assault team of 30 men was killed without leaving the boat. At the same time, another large-calibre barrage was going on. Howitzer fire was landing all around those who made it off their landing craft, severing limbs and causing horrific shrapnel wounds, as well as scarring the men mentally.

It had been the Allies' plan to bomb the beaches heavily prior to the invasion; in doing this they would have destroyed some of the landmines and provided foxhole cover for the troops as they worked their way up the beach. These vital advantages were lost, however, when the low cloud cover and naval bombardment of the cliff-top defences obscured the view of the bombers. Most bombs were dropped well inland by pilots, trying to make sure that they didn't bomb their own troops.

The horrific casualties on Dog Green and the stiff defence of the exit from the beach almost caused the Allies to abandon the invasion at this point on the coast. Thinking that no progress was being made off the beaches, General Omar Bradley, who was watching the carnage through binoculars from aboard the USS *Augusta*, contemplated pulling the survivors out from Omaha and redeploying them to Utah or the British beaches. The necessity of implementing this drastic decision was avoided when signals were received late in the day from small groups of troops who had made it to the top of the bluff. The fact that this could be achieved against seemingly impenetrable firepower averted the possible failure of the entire invasion.

If the Allies had not been able to establish a near-continuous front, the Germans would have been presented with an enticing weakness to attack with the full force of their Panzer Divisions. In all probability, the Allies could not have resisted such concerted attack.

Below: The area photographed here is the exact spot where the opening sequences of the film *Saving Private Ryan* are set. While I was in the area, there were also many veterans, mostly British and American, revisiting the scene of their war experiences.

Charlie Sector

Charlie Sector, which was adjacent to Dog Green Sector on Omaha Beach, was the site of the landing of the 5th Rangers (plus two companies of 2nd Rangers). They were originally assigned the role of back-up to Colonel James Rudder's 2nd Rangers force which assaulted Pointe du Hoc. Whilst Colonel Rudder and his men attacked the Pointe, the 5th Rangers circled in their Higgins boats (the coxswains of such boats were instructed to circle until ordered to launch attacks), awaiting the signal to follow and reinforce the assault force. The signal (a flare from a Very pistol and 'Praise the Lord' in Morse code from an Aldis lamp) was not sent. Tidal resistance and navigational errors meant that the assault force was late in attacking the Pointe and the pre-arranged time for the 5th Rangers to join in was missed. Plan B meant that the 5th Rangers would attack Charlie Sector on Omaha Beach in support of the 116th Infantry Regiment, then push inland before making a right turn to assault Pointe du Hoc from the landward side.

The Rangers were a group of crack troops, based on the concept of the British Commandos and trained especially for this moment on D-Day. Professional soldiers who had volunteered for the roles they found themselves playing, as opposed to the 'citizen soldiers' of the 116th Regiment whom they were now to be assisting in the assault on Omaha, they had begun their training under the eye of senior Commandos in Scotland. That training was tailored to the problems presented by heavily defended areas such as the Calvados coast.

Resistance on Charlie Sector was heavy, as it was placed directly beneath the Widerstandnest 72 and 73 resistance points. According to official reports after the battle, the Vth US Corps had landed on time and on the right of the XXX British Corps, on Omaha Beach. Owing to heavy seas, beach obstacles, wire and minefields, the landing was costly and for some time leading troops were unable to move off the beach. It is noteworthy that no special armoured equipment was used in this landing, except Duplex Drive tanks, and a very large proportion of these foundered in the rough seas when making their approach. Consequently, the infantry landed without tank support. It also met with greater opposition than it had expected, as the Germans had conducted an anti-invasion exercise in the area. By midnight, however, a strip approximately 9km (5½ miles) long and with a maximum depth of 3km (1¾ miles) was in Allied hands.

Private First Class Bill Merkert, aged 24, served in the US 741st Tank Battalion. This is his account of approaching the beach aboard an amphibious tank: 'I was assistant driver on a swimming tank. Armour usually followed the infantry in an

invasion, but we were going to sail in to the beach before our soldiers and take out the German machine-gun nests. In the water, our tanks just looked like small assault boats. We would be a big surprise for the Germans when we came out of the surf.

'In sight of the beach, my tank was the first to launch from the LCT. The other three tanks never made it into the sea. The canvas screens which kept the waves out and kept the swimming tanks afloat had been ripped on each one, so they stayed on board.

'The sea was pretty heavy, we'd never practised in that kind of weather and I'm not sure why they let us go. The swell was really big. One moment you'd ride a crest and get a view of the beach, the next you'd be at the bottom of a trough and just see water all around you.

'The motor driving our twin propellers was working quite well, but the struts holding up the canvas screen started to buckle. I was bracing the strut on our right side, but I was in no doubt we were in serious trouble.

'We were the first tank to sink. It went straight down with a big gulp, dragging a couple of guys down with it. They floated back up, but one of our life rafts didn't work at all and the other only half-inflated.

'The water was really cold and we just had to wait for the LCT we'd left only minutes before to pick us up again. Of the 32 tanks to launch out to sea, 27 sank.

'That lost firepower could have made a big difference to the soldiers fighting on Omaha. The LCT sailed right up to the beach to drop the other three tanks, then we were taken back out to sea.'

Overleaf: Charlie Sector, shown in this picture, was where the US 5th Rangers came ashore in support of the 116th Regiment. Their task was then to attack the nearby Pointe du Hoc from the landward side.

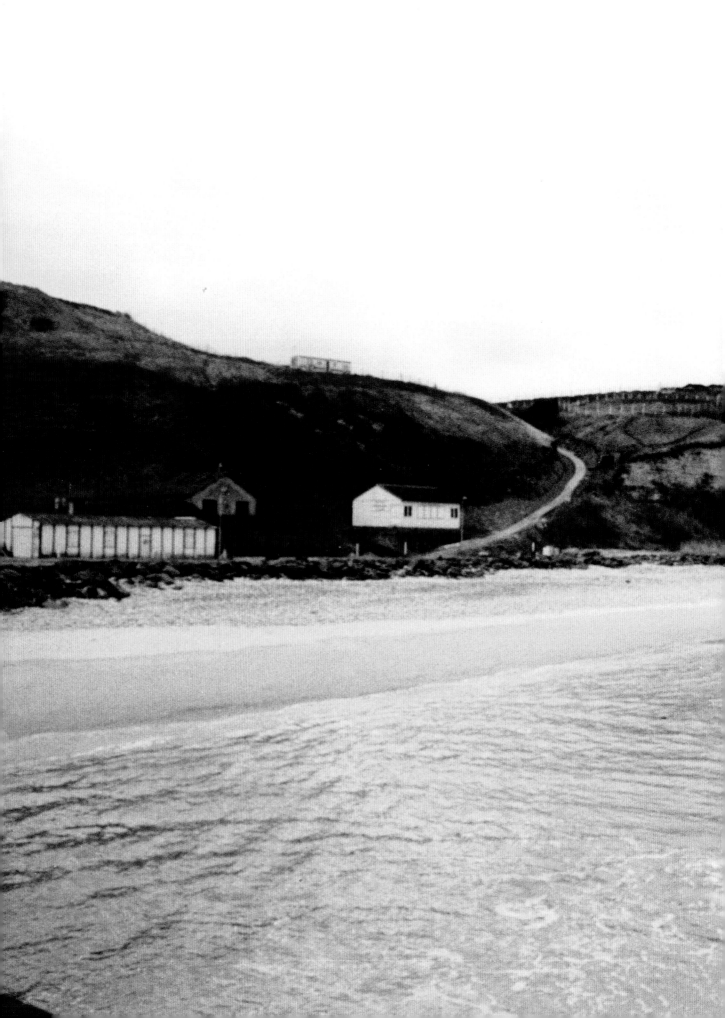

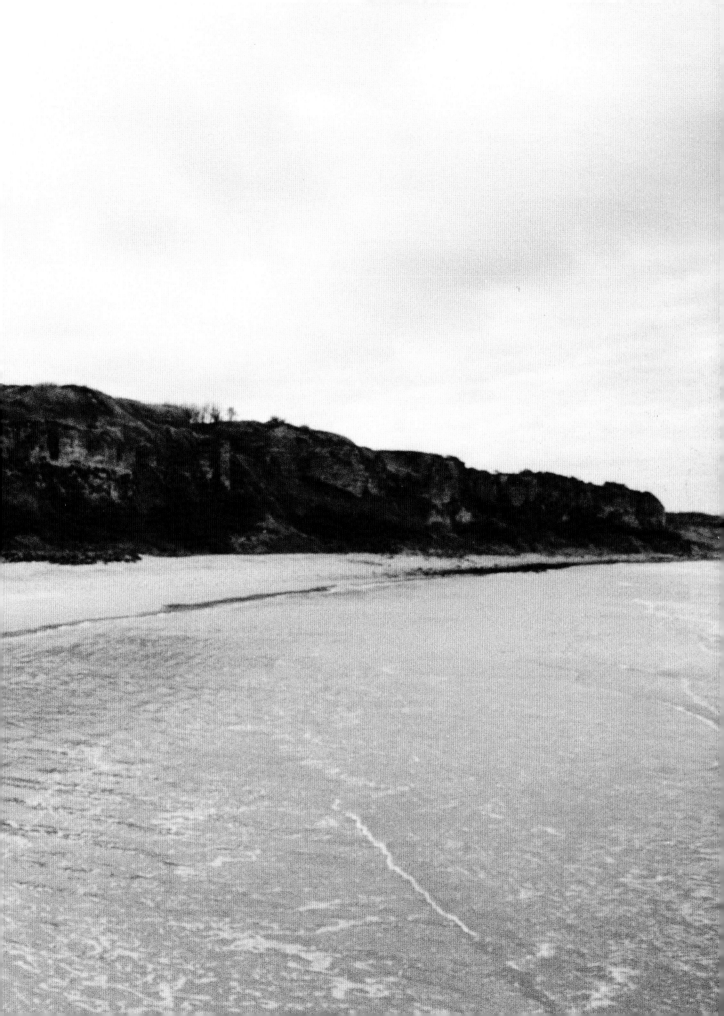

Colleville Church

As Allied landing craft descended on Omaha, the Allied navies bombarded the beach with their large-calibre guns. The smoke and debris rising in the air largely obscured the view of the beach from the sea, making it difficult for the coxswains on board the landing craft to navigate in to the beach. They had, after all, been trained to memorise the beach according to its landmarks – the shape and size of fields, houses, trees, etc. Colleville Church made an excellent landmark, big enough not to be obscured and easily recognisable. It served as a guide to a number of landing craft on Fox Sector.

However, the position of the church was also helpful to the Germans. They used it as a vantage vantage point from which to observe the invasion and order artillery strikes from their lethal 88mm and 105mm gun batteries, causing massive damage to the invasion forces. Eventually the US troops realised the purpose for which the Germans were using the church. They called in artillery strikes of their own from the Western Naval Task Force and reduced the spire to rubble. It has since been rebuilt to its original specification. Like most of the scenery in the area around the landing zone, its current serenity belies the destruction and horror of D-Day.

Opposite: The restored tower of Colleville church. Like most church towers in villages and towns along the coast, it was used as a vantage point by German snipers and artillery observers to try to slow down the Allied landings.
Once the Allies realised this, they promptly trained their naval guns on the spires, practically destroying many churches in the process.

St Laurent

The church at St Laurent has, in common with many of the churches in the area, a spire from which the view on a clear day is unrestricted for miles. This church, along with every other building on the Calvados coast from Ouistreham to Crisbecq, was documented, photographed and mapped out in fine detail. Once the go-ahead for the invasion was given, Allied Command put out a request to the British public for holiday snaps taken by anyone who had visited the area before the war. It was seen as vital that the invasion went ahead with full knowledge of the terrain and the difficulties that lay ahead. The public replied by sending over 5 million of their photos to the invasion planners. By adding these to the reconnaissance photos taken by low-flying P51-Mustangs or Spitfires and information fed from the occupied territory by the French Resistance, the planners were able to build a meticulous and highly detailed picture of what was awaiting the Allied forces.

Like other churches that were readily visible from the sea, St Laurent was often used as a landmark by the coxswains of landing craft to help them to navigate on to the beach. However, also like other churches, St Laurent was an ideal observation post for German artillery spotters. They were able to relay accurate information to their gunners, who then rained down 88mm, 105mm and 155mm fire onto the invading troops. Late in the day, when it was realised how the artillery managed to be so accurate, the navy bombarded St Laurent. In fact, many veterans have said that there were no church spires left standing in Normandy after the battle, for precisely this reason.

Corporal Maxwell Moffatt was 24years old, serving with the US 29th Division, 115th Regiment. He had first-hand experience of how dangerous a church steeple could be for the invading soldiers: 'I was a medic in the second wave. Being a medic was dangerous work. Of the 96 men in the medical corps of my regiment, half of them died on D-Day.

'When our large landing craft beached, the Germans had zeroed their guns on the ramp. I was the last man and thought about staying aboard and letting it take me back to England, but I felt I couldn't do that to the boys. I wasn't going to go down the ramp where men were getting shot, so I dived over the side since I could swim pretty well. God must have been looking out for me. The landing craft backed on to a mine and exploded. If I'd been on it I'd have been dead.

'On the beach, the first wave had really taken a beating. It was pitiful. But I was

told to get off the beach and let the navy medics care for the wounded. l didn't want to leave my friends who had been hit, but I ran like a rabbit.

'We didn't get far inland, about 1,000 yards [900m]. The Germans were putting up heavy resistance. We lost lots of men to snipers – including another medic who I had to fix up. The Germans climbed trees to shoot at us. We weren't used to that, but you learn pretty quick when you're under fire.

'I had to be on my knees to fix people – you couldn't do it lying down. To make myself less of a target, l'd drag the wounded behind a hedge.

'We came to a little church and there were snipers firing from the steeple. We called in artillery from the ships and three shells screamed overhead like freight trains. The church came down.

'A lot of the people who got hit you couldn't do anything for, lots of them got hit in the head. l did fix up about ten of our guys on D-Day. One had been hit by a mortar and his foot was hanging off – the heat sears the wound so they don't bleed too much. He lives near me and I still see him sometimes and he thanks me.'

Overleaf: The St Laurent church. As at Colleville, the spire was used by German snipers and it suffered the same fate. It has long since been rebuilt and its square Romanesque bulk dominates the countryside once again. I lay in the grass in the corner of the cemetery to catch this dramatic late-afternoon view.

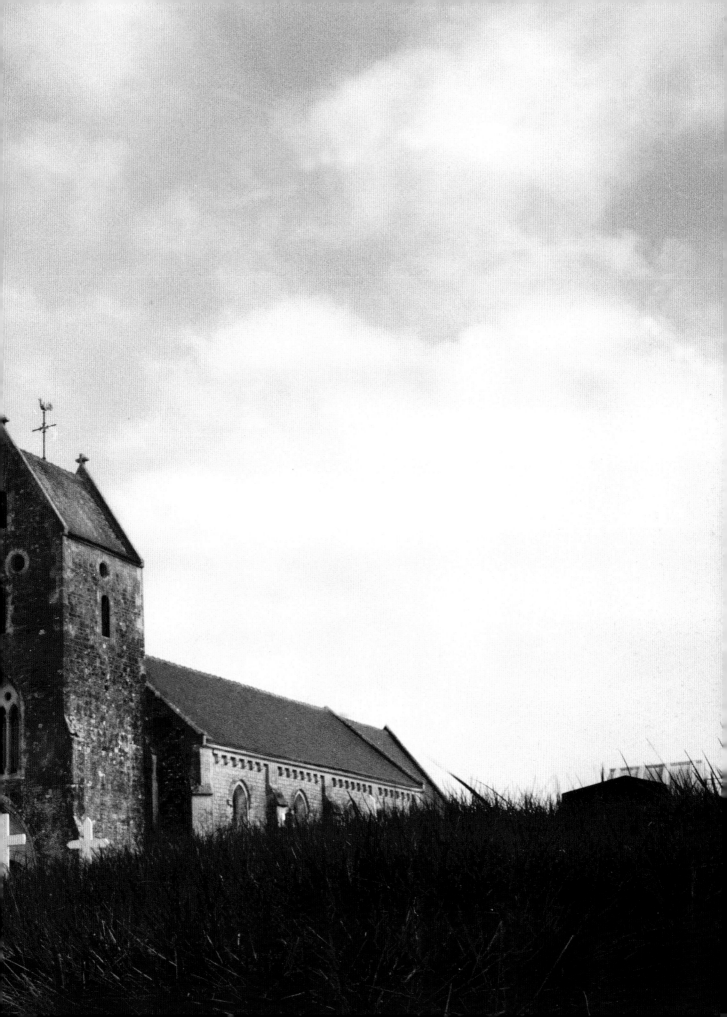

Lookout Tower

Below: The remains of a medieval lookout tower, close to the edge of a cliff. It bears witness to the centuries-old fear of enemy invasion. But in 1944 the invaders were also the liberators.

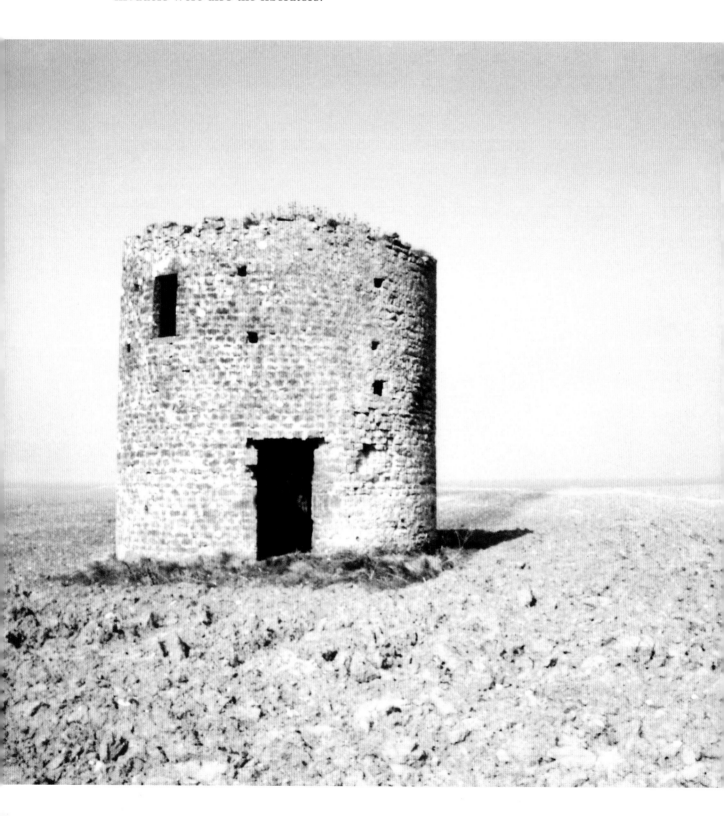

All along the road that runs behind the invasion beaches are physical reminders of the Battle of Normandy. Some of the beach defences once placed by the Germans to repel the Allied invasion now mark crossroads or sea fronts. Restored examples of heavy weaponry such as tanks or artillery often stand guard at the entrance to museums or provide points of interest in the small villages that were

fought over after D-Day. But perhaps most interestingly and poignantly the number of buildings that have survived is quite astonishing. The Atlantic Wall consisted of millions of tonnes of concrete and steel. Many examples of it stand today as a memorial to the men who fought and died over them. Seemingly frozen in time, these escarpments lack only the soldiers manning them in order to transport you back to 1944.

However, in some places, as on the English coast, there were defences built long before the Nazis invaded Europe. Like the British during the reign of Elizabeth I, the French built fortresses and observation towers (known in Britain as martello towers) on the sea front to act as early warning in the event of an attack by Sir Francis Drake's Royal Navy. That invasion never came to pass, but the buildings designed to detect it, like the one pictured here, were put to use hundreds of years later by a regime altogether more fearsome than that of Henri IV.

Fox Green Sector

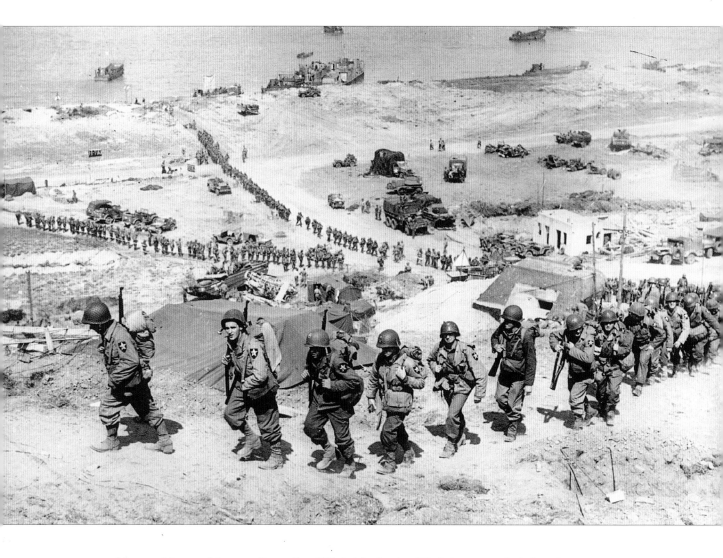

Above: Lines of troops from the US 1st Infantry Division march inland, past the communication bunker at Fox Green Sector, soon after D-Day.

Opposite: The same bunker photographed in March 2003.

Fox Green Sector on Omaha Beach was the scene of some of the heaviest fighting of D-Day. Though casualties were not as heavy as at Dog Green, the potential for a disaster on a similar scale was there. The landings ran into every possible difficulty: navigational errors, delays and serious enemy opposition. The German machine guns had been sited very effectively. As the Allied landing craft made their final approach they were sprayed with automatic fire and there were many

casualties before the men even made it on to the beach. Once the ramp at the front of the landing craft was dropped, the massacre was even worse. On some craft, the entire complement of men was cut down inside the boat. Others were killed in the water or while going back, trying to help wounded friends. Most of these men belonged to the 16th Regimental Combat Team. Of the eight companies involved, only Company L, reduced to 125 men, was able to perform as a combat unit, after crossing the beach and reaching the bluff.

In the days which followed the landings, Fox Green Sector became a major marshalling area and communication point for the Allied forces. Captured German positions, such as the anti-tank bunker shown below, were used as communication centres to facilitate the smooth flow of men and equipment into France.

Fox Green Sector, like many other battlefields in Normandy which have been turned into memorials to the drama of war, has an eerily quiet air about it.
A few holiday homes have appeared among the dunes, but by and large the area seems hardly touched by the passing years.

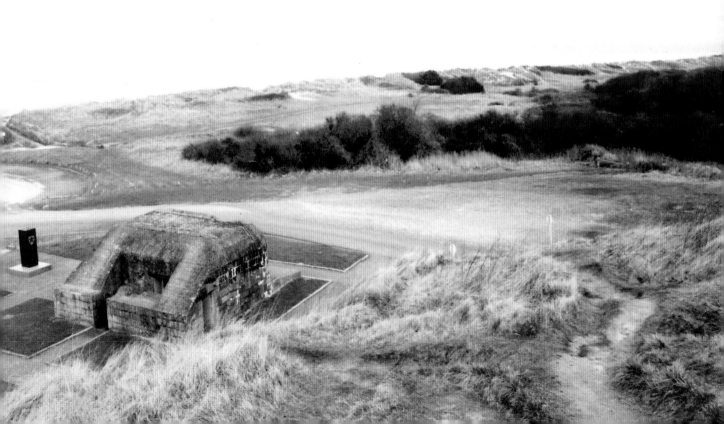

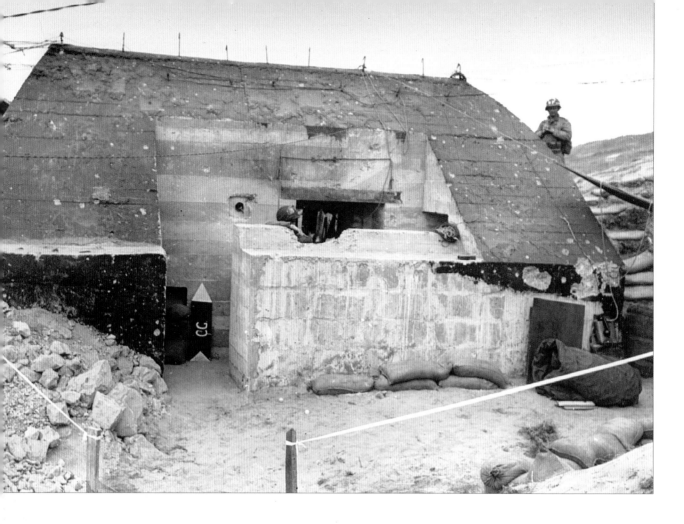

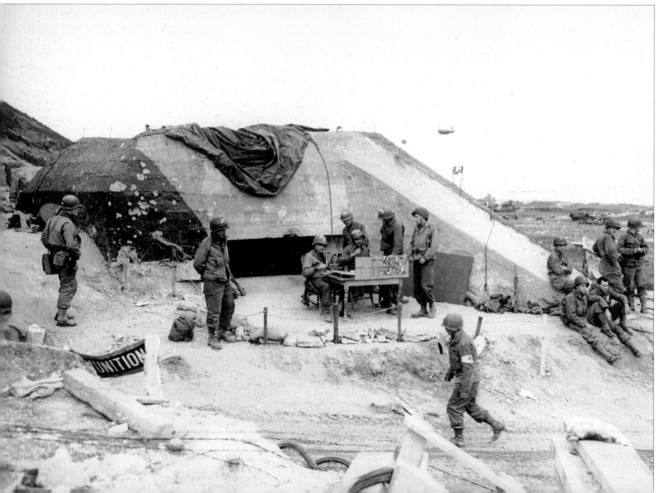

Opposite: A German anti-tank bunker at Fox Green Sector (top picture), photographed soon after its capture by the Americans, who converted it for use as a communication post (bottom picture). Note the dainty table occupied by the radio operator and probably 'liberated' from some local farm.

Below: The same carefully restored bunker today. The French authorities have even replaced the original gun.

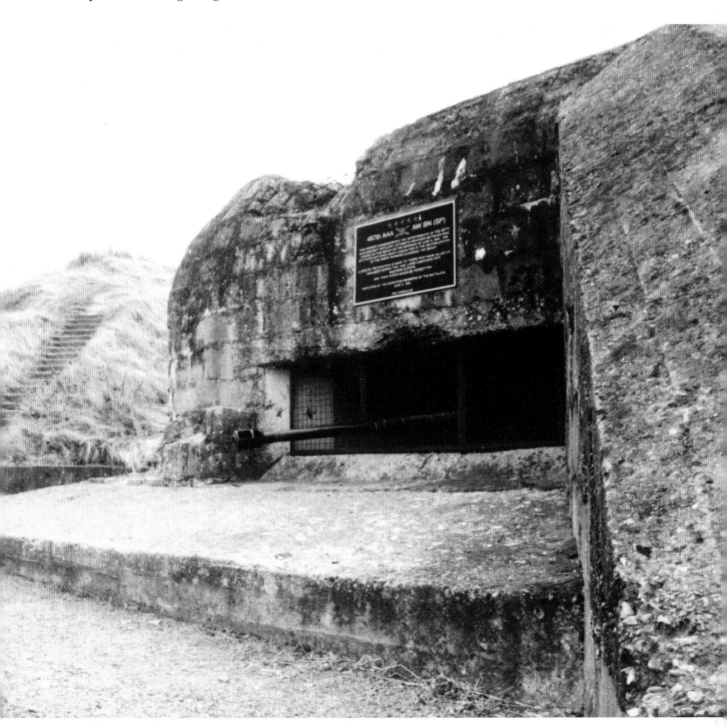

Les Moulins

Les Moulins is a hamlet on the Normandy coast. On D-Day, it was an exit off Omaha Beach inland between Dog Red and Easy Green sectors. Along this stretch of the Atlantic Wall were placed some of the most formidable defences on the Normandy coast (which were nevertheless rather less heavily defended than the coast at the Pas-de-Calais). They comprised 155mm, 88mm and 75mm howitzers, 50mm and 57mm anti-tank guns, many, many MG34s, 38s and 42s, and of course the infantry's own sub-machine guns. In spite of repeated and heavy bombardment of these defences right up until the moment the troops landed on the beach, the Allies expected heavy casualties. The first wave of troops to land on Omaha came mainly from the 1st and 2nd Battalions of the 116th Infantry Division and the 2nd and 3rd Battalions of the 16th Infantry.

The Commander of the 116th Infantry was Brigadier General Norman 'Dutch' Cota and at H-hour he, perhaps unusually for a brigadier-general, found himself at the heart of the action. Pinned down by heavy automatic fire and artillery bombardment and waving his pistol in the air, he assumed command of the 116th's left flank while Colonel Charles Canham took command of the right. 'They're murdering us here,' Canham screamed above the firing. 'Let's get inland and get murdered!' Advancing under such ferocious fire ran contrary the nature of most soldiers on Omaha Beach. Certain death seemed to await anyone who even stood up, let alone advanced towards it. But it was moments of courage in the face of total adversity that made the landing on Omaha a strategic success.

Further to the east, the commander of the 16th Infantry Division, Colonel George Taylor, shared Canham's courageous view: 'There are two kinds of people on this beach – the dead and those who are about to die. Now let's get the hell out of here!' One by one, troops pinned down by searing fire from the German defenders and artillery followed the example set by their leaders. They fought their way off the beach and reached the bluff of Les Moulins around 0830 hours, followed and supported by those elements of 5th and 2nd Ranger Battalions not directly involved in the fight to capture Pointe du Hoc.

On Omaha Beach the US Vth Corps suffered 3000 dead, wounded and missing. This represented a casualty rate of 7.2 per cent, which on any other day would have been considered appalling. On this occasion, however, it was 5 per cent less than projected.

Sub-Lieutenant Jimmy Green of the Royal Navy, who was 22 years old at the time,

gives this account of his experience aboard a landing craft which took American troops in to Omaha: 'We were called the suicide wave, the first ones to go in. Our landing craft were lowered from a larger troop ship and into the sea about 15 miles [25km] from Omaha Beach. It was pitch black and blowing a gale. I suppose I was scared, but I was more concerned with getting all my boats in on time for H-hour. Aged 22, I didn't think anything would happen to me. All the British crew were quite relaxed – we chatted among ourselves. The American soldiers we were taking in were apprehensive. They'd never faced enemy fire before. Nor were they used to the rough conditions and some were being sea-sick. We really bashed into the waves as we tried to keep up our speed. We were taking a lot of sea spray.

'About one kilometre [1/2 mile] out, one of my landing craft took on water and sank. All the men went into the sea, one went straight down under the weight of his kit. I shouted that I'd be back, but I just had to carry on. Anyway, there was no room for them in my boat.

'I had a job to make out anything on the beach, visibility was so poor. I could pick out some nasty gun emplacements. I thought that if they were manned we'd be in trouble, but the only things they fired at us were mortars and anti-tank rounds. One of the latter penetrated the armour of one landing craft. It went through one side, through a soldier called Frank Draper, then through the other side. He was bleeding to death and nothing could be done for him.

'We went full speed ahead towards the beach and when we hit bottom I released the ramp. There was an eerie silence, just the wind and waves. The Germans must just have been watching us. I think we were the very first to land in Occupied France.

'The Americans were very grim faced, but filed out with no hesitation into the water – which in some places was up to their knees, and up to their shoulders in others. My job was finished, I'd taken them to the beach. Their job had only just begun.'

Overleaf: One of the many memorials marking the points of entry to the European Continent by Allied forces on D-Day. This one commemorates the US 116th Infantry Regiment at Les Moulins.

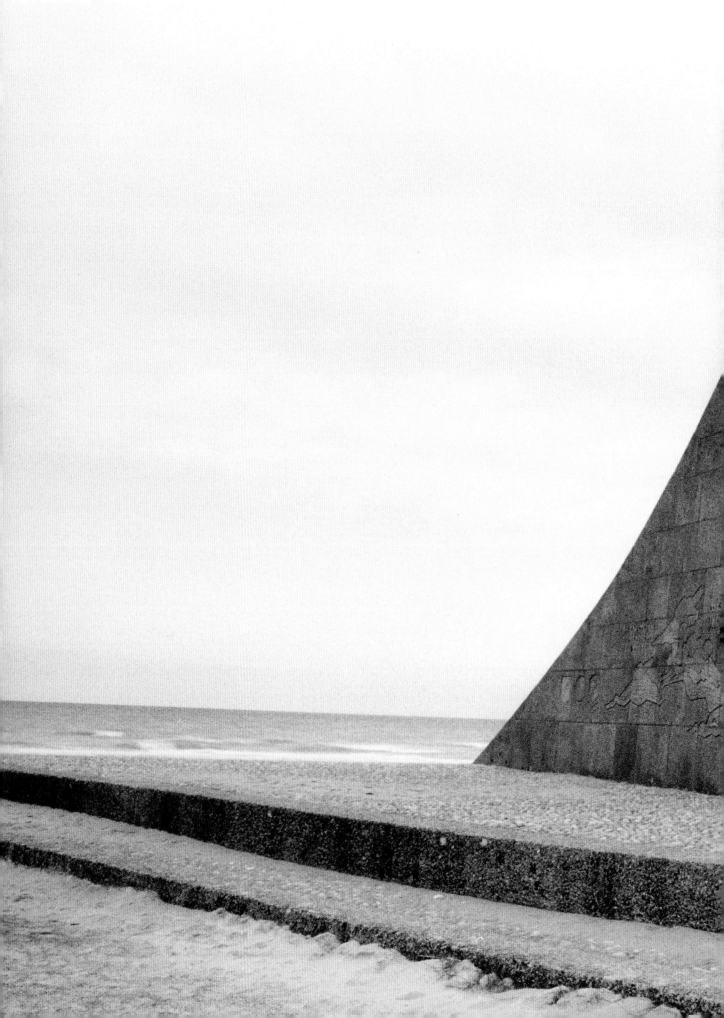

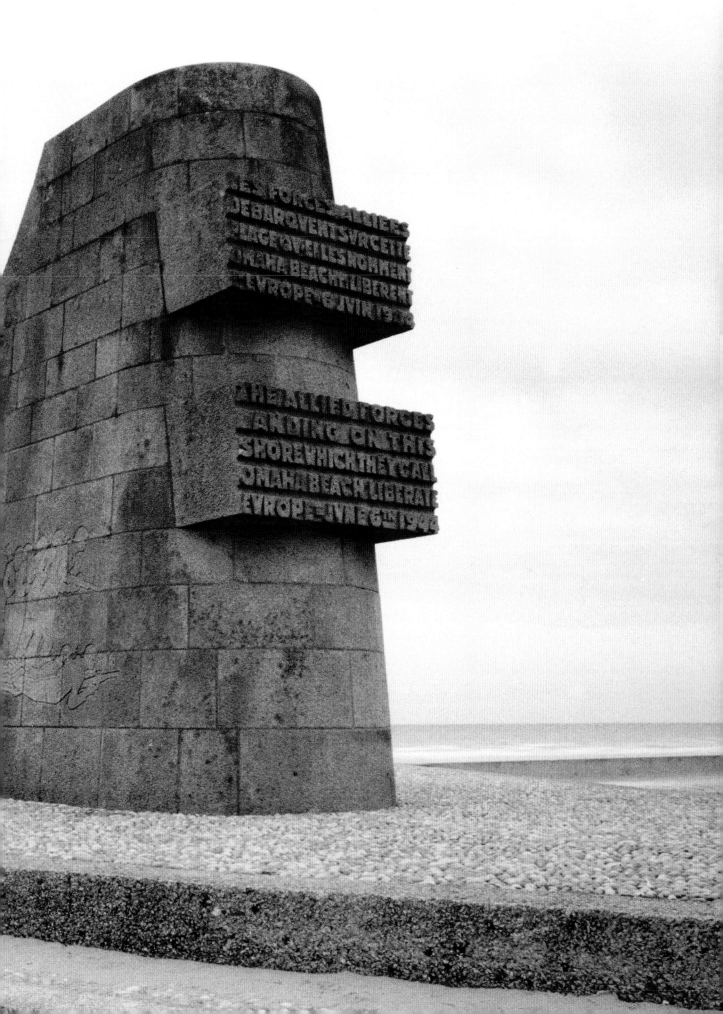

Isigny

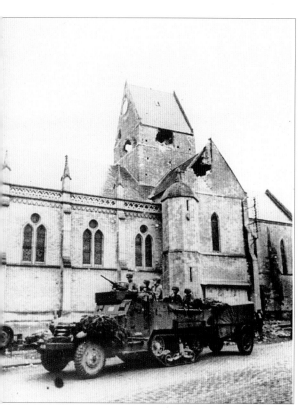

Left: An American half-track passing the badly damaged church in Isigny, soon after the libération of the town.

Below: This church is also situated in the centre of Isigny, close to the so-called Voie de la Libération, which marks the route taken by Allied forces as they spread into France and the rest of Europe. The Voie de la Libération begins at Utah Beach and ends at Bastogne in Belgium. The US 101st Airborne Division followed that path exactly.

This short quotation from one of Friedrich von Schiller's plays (1759-1805), spells out the misery war brings to civilians:
'The town is burnt and empty
And in the gaping windows
Horror dwells.'

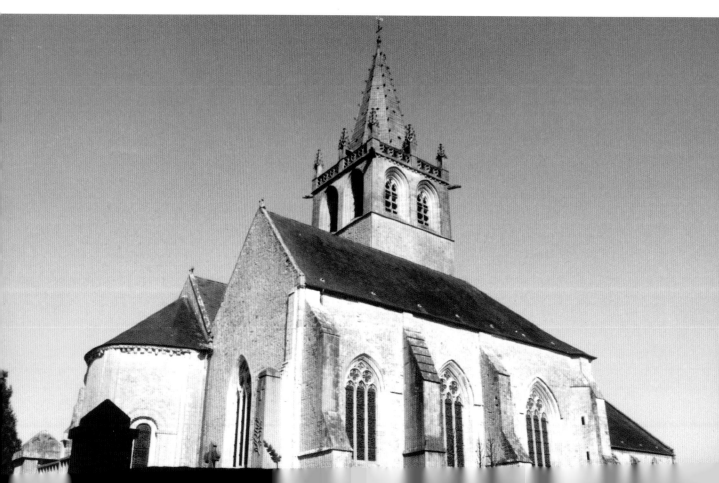

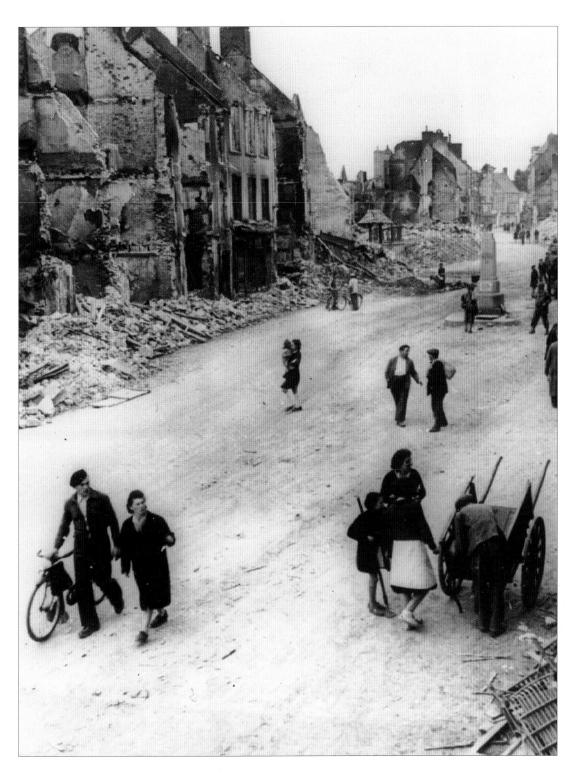

Above: Local inhabitants examining the damage to the high street of Isigny, following the heavy bombardment by the RAF and the US Air Force which preceded the landing. The only thing that appears intact is the World War I memorial standing in the middle of the street.

The Atlantic Wall

Below: One of the massive 6inch guns sited on the cliff at Longues-sur-Mer. It was restored after being attacked by Allied naval guns. The entire site now looks as it would have done to its German garrison, prior to the invasion.

During 1942 the Allies had launched two operations which partly provided the basis on which the Atlantic Wall was designed. The first, a costly but ultimately

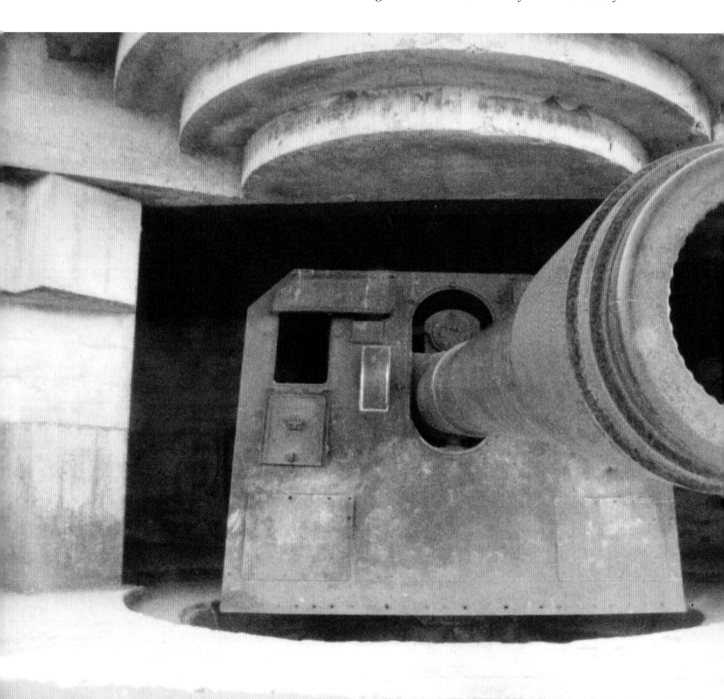

successful Commando raid on the dry dock at St Nazaire, showed the Germans the need to defend important static points heavily. The second was Operation Jubilee, also known as the Dieppe Raid and in a sense the forerunner of D-Day. It was a full-frontal amphibious landing on a partly fortified harbour, and it ended in disaster for the Allied troops, many of whom were Canadians (see page 136).

Ironically, from this Allied disaster the Germans learned a lesson that would prove most costly to them. As a result of their success at Dieppe, German military philosophy placed heavier emphasis on static fortifications. Hitler had clearly not paid attention to another German leader, Frederick the Great, who said that he who defends everything defends nothing. As if to prove the truth of this statement, by summer 1944 the Atlantic Wall consisted of a loosely connected chain of semi-complete concrete fortifications linked by weak and scattered armed observation posts. In reality the only places likely to hold up a landing significantly were the Pas-de-Calais and Dog Green Sector on Omaha Beach.

In terms of military, civilian and slave manpower, the Germans could ill afford the resources used to produce the wall, which they diverted from the Russian Front. In addition, the inefficiency and inflexibility of the command structure instituted by Hitler meant that the tactics employed to defend the wall were incompetent. Relying on static troops largely unsupported by mobile armour would prove costly in the face of sustained overwhelming force from the sea. All these factors contributed to the Atlantic Wall being summed up of as one of the greatest military follies in history.

Widerstandsnest 62

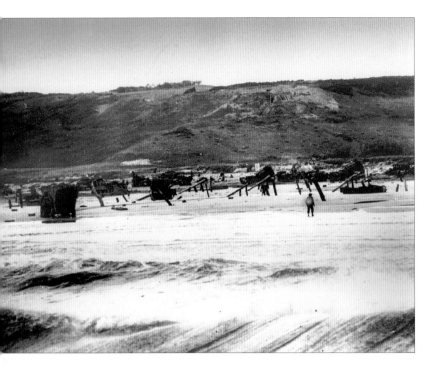

Left: German beach obstacles in front of the Colleville bluff, soon after D-Day. The path in the centre/right of the picture leads up to Widerstandsnest 62 – a German resistance point on Omaha Beach. The US military cemetery is now situated on top of the bluff, to the right of the picture.

Private Franz Gockel was 18 years old and serving with the 352nd Division, 726th Infantry Regiment, on D-Day. These are his recollections of the momentous day: 'The alert came at 1 a.m. We were told to man our positions and that the Allies were coming. There had been many false alarms before.

'Then at 5 a.m, with the dawn, I spotted the approaching Allied fleet. The horizon was black with ships. It was unbelievable. Some people still thought the real landing would come at the Pas-de-Calais, but I knew that this number of ships could only have been amassed for the genuine invasion.

'I was shocked that the attack was at last coming, but I was also angry with the Allies, angry that they were sending such a huge force against us. Soon the Allied bombardment began. It was incredible – the Earth shook. It caused us, as we say in Germany, to lose all sight and hearing. We could not talk and no orders could be given. So I did what my mother had told me to do in one of her letters, I prayed a lot and very loudly.

'My platoon was stationed at Widerstandsnest 62. Half of us were under 18, the others were older troops injured on the Eastern Front and not yet fully fit. We had two concrete gun emplacements linked by trenches. I was alone in an earth and wood machine-gun nest, waiting to fire.

'When the landing craft arrived, the tide was out and the Americans had a lot of beach to cross. As they swarmed towards me I opened fire. The Americans fell

and many never stood up again. I don't know how many I killed. I just wanted to defend myself, to survive.

'At noon, some Americans broke into our area. They caught me by surprise, running along our trench system, and shot me in the hand. My American friends tell me this is what is called "a million-dollar wound". It wasn't a bad wound, but it was a good excuse for me to be evacuated back to Germany.'

Below: A typical 88mm gun emplacement which formed part of Widerstandsnest 62. This example was knocked out by a lucky shot from a Sherman tank which came through the gun aperture and hit the magazine, destroying the gun and killing everyone inside.

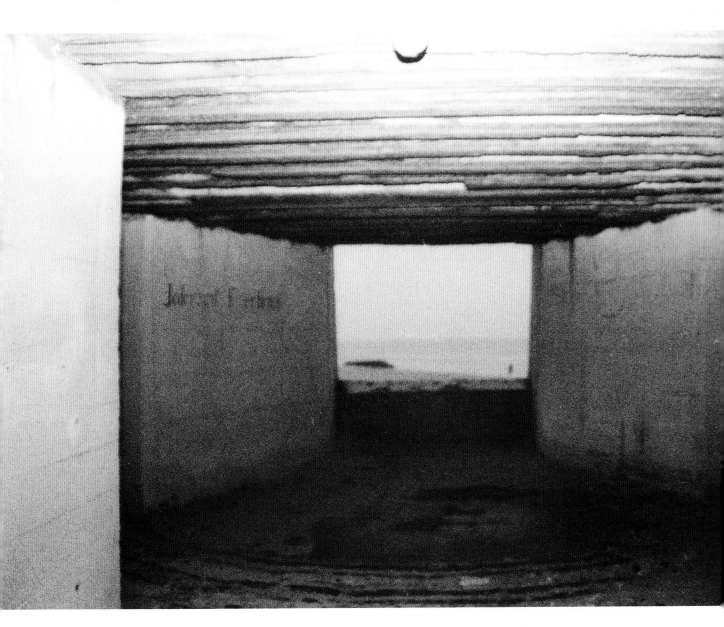

La Cambe

Perhaps the most famous personality buried at La Cambe cemetery is the German tank ace, Michael Wittmann. Wittmann had earned a considerable reputation as a tank commander on the Eastern Front and had been highly decorated. At Villers-Bocage in June 1944, he destroyed much of the lead elements of the 7th Armoured Division (the Desert Rats) when he caught them off guard in his Tiger I. Eventually he was forced to abandon his tank, but only after causing massive damage to the British force. He finally met his end just south of Caen in August 1944, when his Tiger was knocked out and everyone on board killed. Wittmann's remains, however, were not recovered until the 1980s.

The German war dead from the Normandy campaign were scattered over a wide area. In the post-war years, the German War Graves Commission created six main cemeteries in the battlefield area. The one at La Cambe was started in 1954 and completed in 1961. In the course of those seven years, the remains of more than 12,000 German soldiers were brought in from many locations in the area of Calvados and the Orne. Since then over 700 more have been buried here. In total there are 21,222 German soldiers in La Cambe cemetery, 207 of whom are unknown; 89 of the unidentified are buried in a mass grave below the central mound of the cemetery.

Like many of the German cemeteries in Normandy, La Cambe was originally an American cemetery. The following reminiscence from a soldier of the US 7th Corps gives a brief outline of the immediacy with which the dead were regarded:

'I was present when this cemetery was inaugurated. Three people were picked from each company of the 175th Regimental Combat Team. We were trucked down to La Cambe and dedicated this cemetery, which was for the dead of 29th Division. I happened to be one of the people chosen. It was a very touching ceremony with the dead not yet buried piled up on either side of the honour guard. We were dressed in the cleanest battle uniforms we could find with three people from each regiment carrying guidons.'

Opposite: This mound at the centre of La Cambe cemetery contains the remains of unidentified German solders who died during the Battle of Normandy.

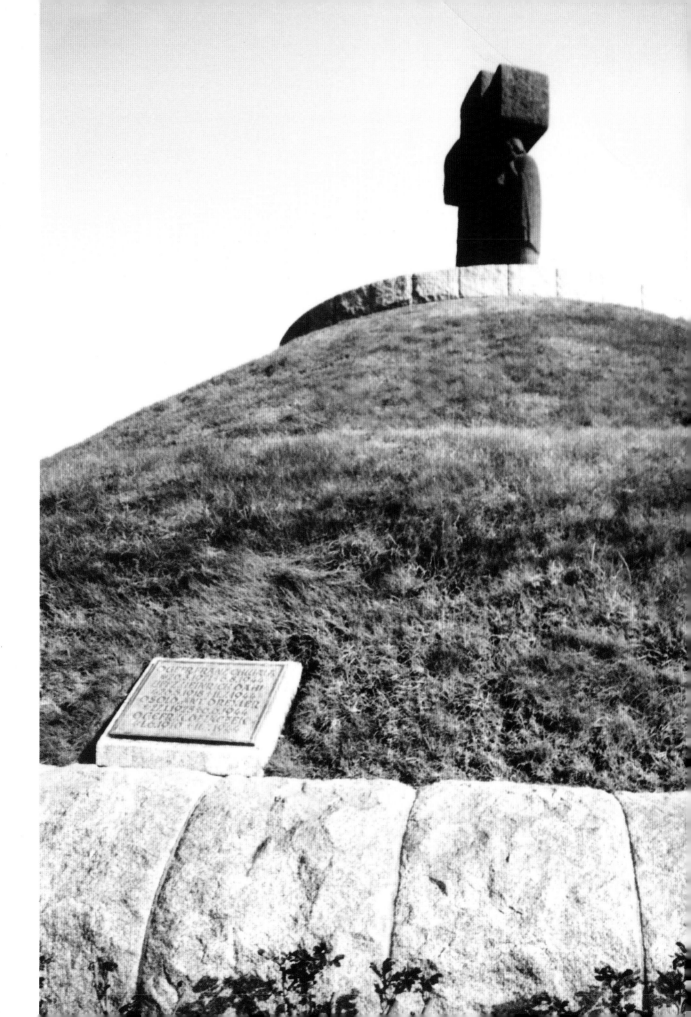

GOLD BEACH

Gold Beach is an 8km (5-mile) stretch from La Rivière to Le Hamel. To the west the small port of Arromanches-sur-Mer would later be used as the site of an artificial harbour. Defending the beaches at this point were portions of the 716th Infantry Division and the much higher quality 352nd Infantry. Many German troops fortified holiday homes on the beach front, siting numerous MG34 and MG42 machine guns inside them. Just behind these defences the Germans planned to take advantage of the mobility and firepower of Kampfgruppe Meyer, a unit attached to the 352nd Infantry, which was equipped with mechanised armour. The ability to use armour in a counter-attack was seen as crucial, because the Germans knew how vulnerable their coastal positions were to Allied naval and aerial firepower. With this in mind, Kampfgruppe Meyer had frequently practised repelling an attack on the beaches.

Like Sword and Juno Beaches further to the east, Gold was assigned to the British 2nd Army for the assault. The units tasked with assaulting the beach included the British 50th Division (which included the Devonshire, Hampshire, Dorsetshire and East Yorkshire regiments) and the 47th Royal Marine Commando, which was attached to the 50th. Their objectives were to join up with the Americans on Omaha Beach and with the Canadians at Juno; to cut the Caen–Bayeux highway in order to prevent the Germans from reinforcing to the east; and for the 47th Commando to capture the cliff-top gun battery at Longues-sur-Mer (see page 122), which consisted of an observation post used to direct fire and four heavily protected 155mm guns set back from the cliffs. These guns represented a serious threat to the invasion. They were engaged during the day by the cruiser HMS *Ajax* – famous for its role in the Battle of the River Plate and the destruction of the *Graf Spee* during the battle for the Atlantic in 1939 – and eventually neutralised.

Jump-off for the British part of the invasion was 0725 hours, an hour later than on the American beaches because of the direction and flow of the Channel tides, which come from west to east and were exacerbated on the day by the wind blowing in from the north-west. This meant that the beach defences which the Germans had laid were already submerged before the Allied engineers had the opportunity to deal with them, and resulted in around 20 armour-carrying landing craft being damaged or destroyed. However, two positive features of the landing in this area were the success of getting armour onto the beach in order to support and protect the infantry, and the lack of German armour to confront them.

The British in this sector made optimum use of the designs offered to them by the range of specialised armour developed by Major Percy Hobart, which included AVRE (Armoured Vehicle Royal Engineers). Duplex Drive (DD) tanks, flail tanks (Crabs)

and bridging tanks – popularly known as Hobart's 'Funnies'. DD tanks made it ashore and laid down suppressing fire, while Crab tanks cleared paths in the minefields. In fact many argue that the effective use of these machines made for a relatively light loss of life. In possible comparison, the Americans refused to use Hobart's 'Funnies' (apart from DD tanks, which they used ineffectively by launching them too far out to sea) and suffered much higher losses.

The British were also aided by the accuracy of the fire coming from the naval guns, which quickly neutralised many of the German strongpoints. These factors enabled the British to attain most of their objectives by midday on D-Day. They failed to cut the Caen–Bayeux road, or to link up with the Americans at Omaha. But they did land 25,000 men and moved about 11km (7 miles) inland whilst suffering only 400 casualties. This represented a reasonable start in this area for the liberation of France.

Below: This battered contemporary photograph shows British troops landing on Gold Beach. The German beach defences, which appear just over water level, can be seen in the background.

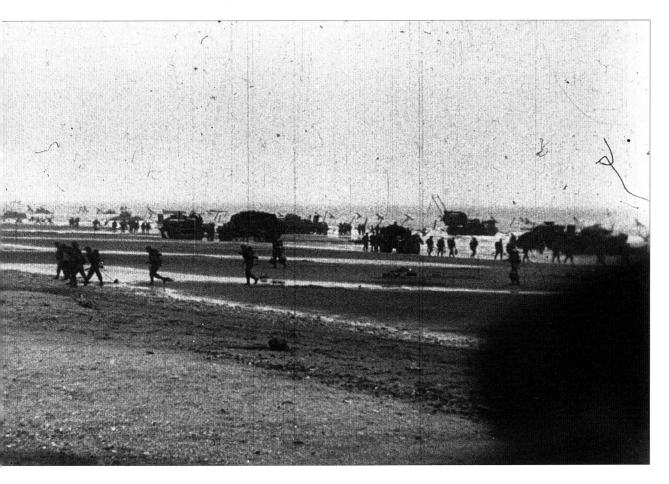

Arromanches-sur-Mer

Parts of the vast Mulberry harbour at Arromanches still survive. The picture overleaf shows the beach and part of a roadway and floating pier that transported millions of tonnes of supplies to the European mainland. The invention of these harbours and their successful construction were elemental in the final victory in the European theatre of operations. Today they form an important tourist attraction in the area and the D-Day Museum at Arromanches is one of the best on the Normandy coast.

On 30th May 1942 Winston Churchill wrote the following memorandum to the Chief of Combined Operations in which he expressed the requirements for piers to be used on beaches, as he saw them: 'They must float up and down with the tide. The anchor problem must be mastered. Let me have the best solution worked out. Don't argue the matter. The difficulties will argue for themselves.'

The military engineers knew better than to argue and the Mulberry harbour was born.

An officer who found himself selected for the special outfits designed to build these floating harbours recollects his thoughts at the time: 'We were told that we should be proud to have been selected from the corps of Royal Engineers to take part in this operation; that we (the 969th and 970th Port Floating Equipment Companies) would be responsible for the construction of the piers and pierheads in the field. [They said] the success of the invasion of Europe depended on us. In fact, they told us that this project was so vital that it might be described as the crux of the whole operation

'I was not at all thrilled by this information; quite apart from a natural reluctance to get involved in anything that looked so dangerous, I was appalled to think that the British Army was so desperate, so near the bottom of the barrel, that they had to choose me. And, if it were really true that the success of the assault on Europe depended in any way on me, then I could not see much hope for the Allied Armies.

'Something of these unhappy thoughts must have shown in our faces (my forebodings were shared by the others); we were assured that orders had already been passed to every RE Unit in the United Kingdom to send, immediately, their finest, bravest and most highly skilled soldiers to join this crack invasion force, because Mulberry Must Not Fail.

'Alas, what really happened was that every unit in the U.K. seized this golden opportunity to unload on to us their most formidable and desperate criminals.'

Below: Aerial photo of the Mulberry harbour at Arromanches. It gives a clear picture of the length of the pontoon bridges. Each section of these had to be floated from various locations in Britain, as far afield as Scotland, and assembled once a beachhead had been secured.

Overleaf: Remains of the concrete and steel floating roadway which linked the Mulberry harbour to the shore. The association with D-Day has turned Arromanches into a thriving visitor attraction.

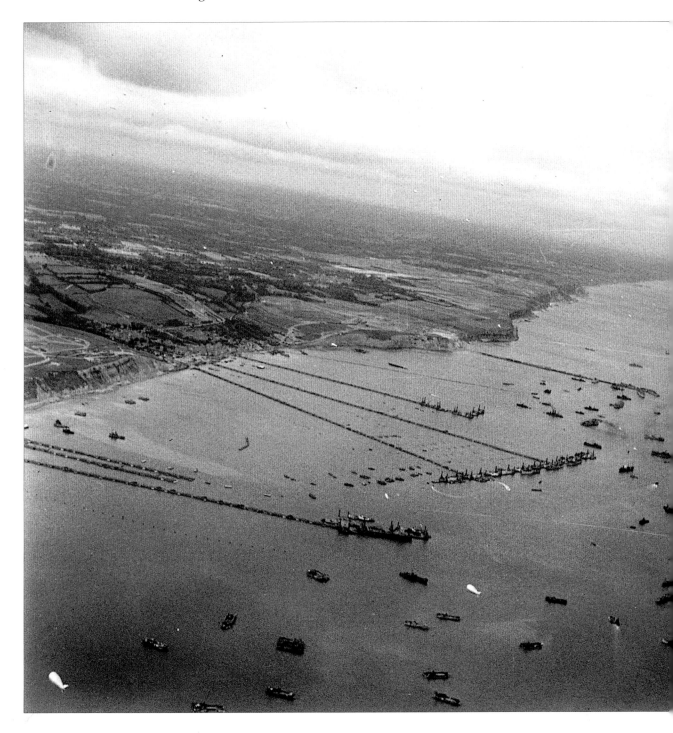

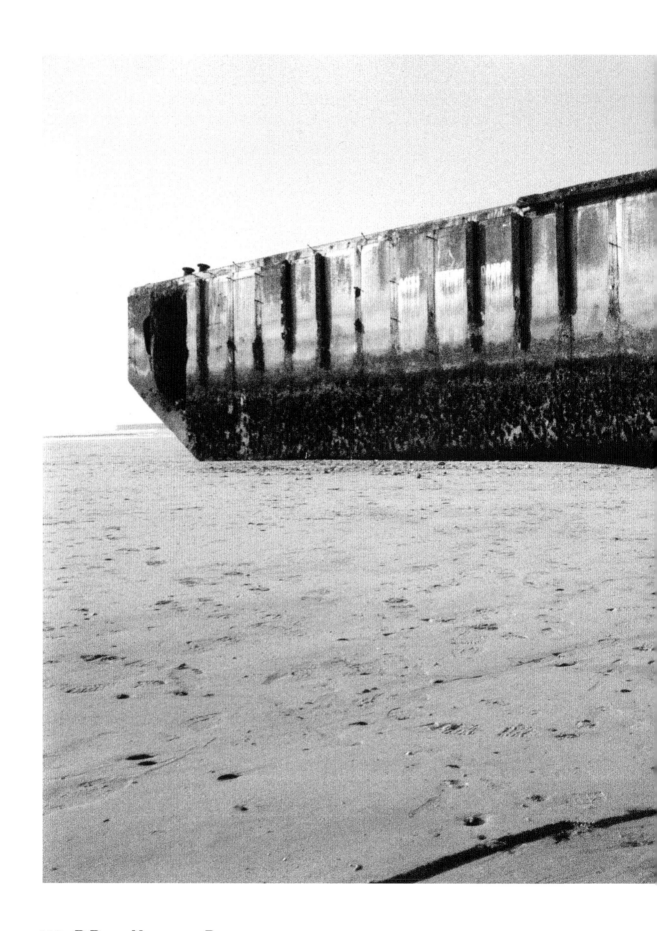

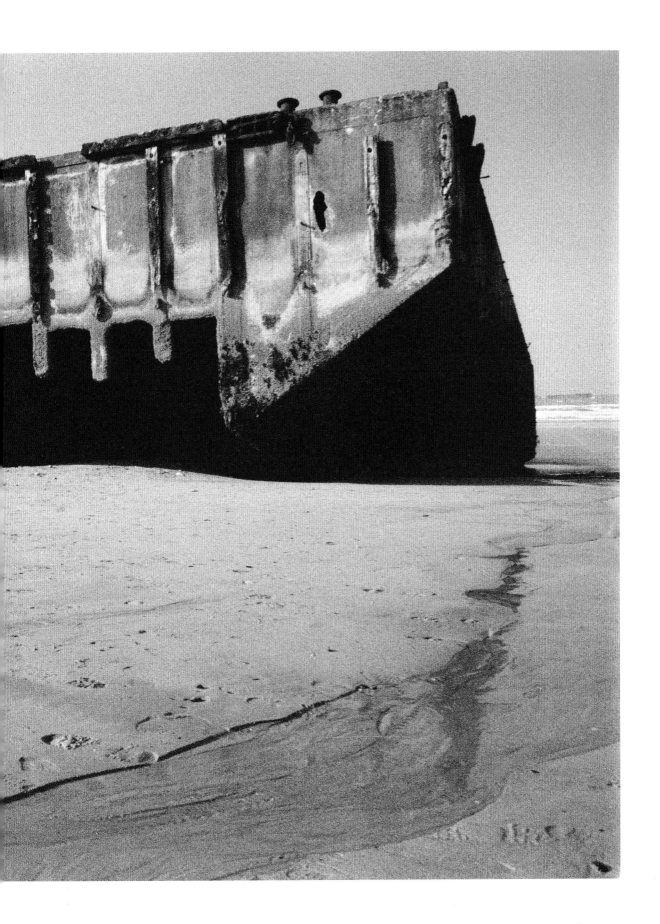

Below: The village of Arromanches and the landing point for all equipment unloaded from the Mulberry harbour.

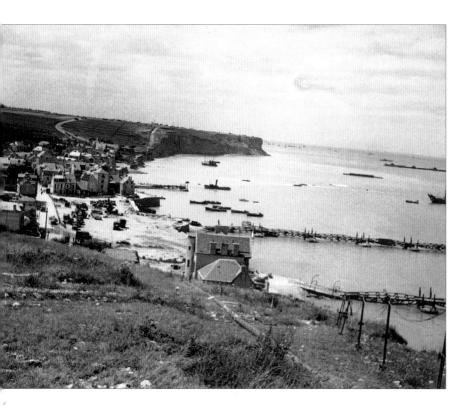

Below: Equipment being unloaded at the Mulberry harbour, Arromanches. The line of sunken block ships in the background acts as a breakwater for the temporary harbour.

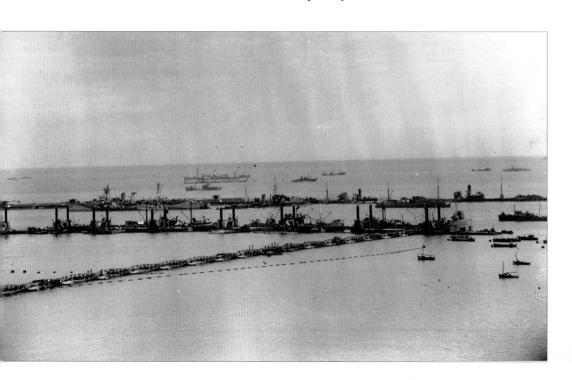

Below: The remains of the Mulberry harbour at Arromanches are still clearly visible on the beach and out to sea.

Overleaf: I took this picture from inside another section of the Mulberry harbour from which part of the floating roadway shown above can be seen. The breakwaters out to sea are also relics of the invasion.

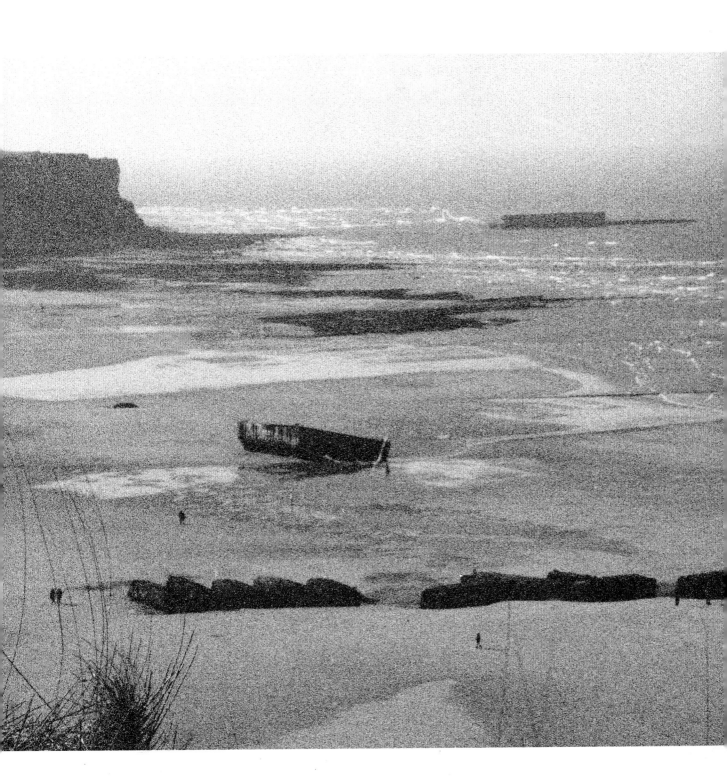

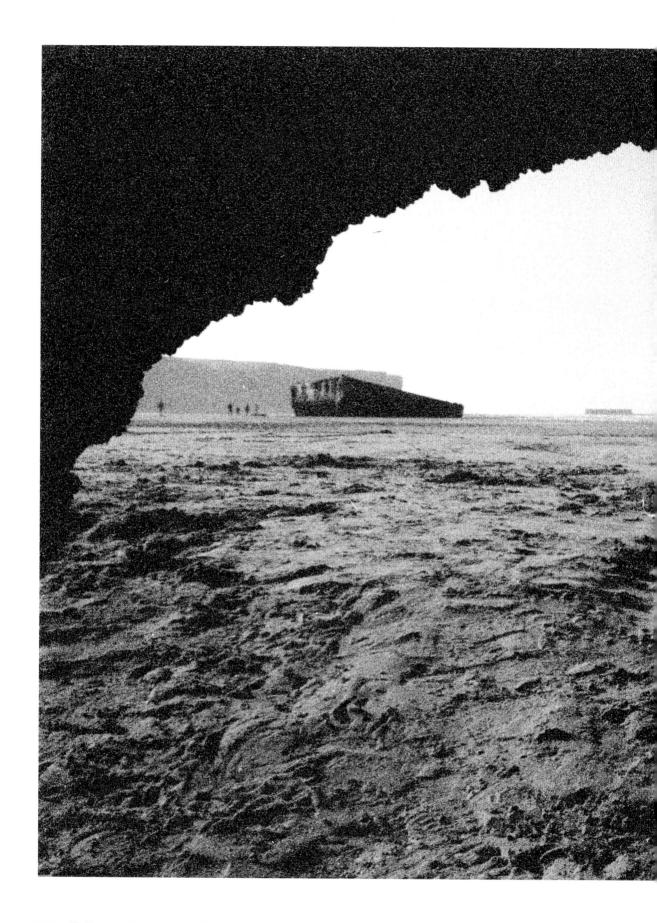

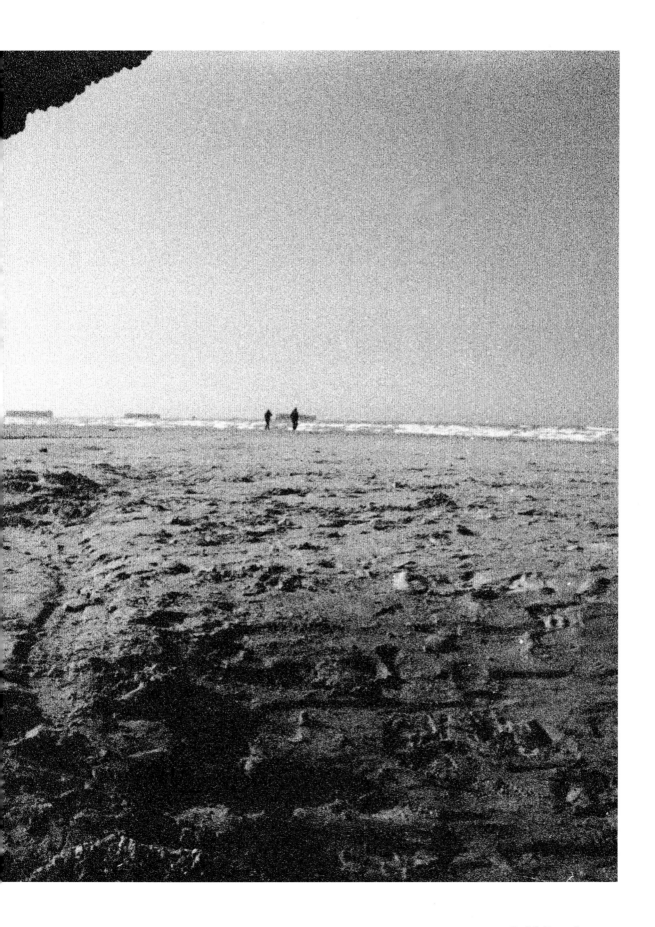

Longues-sur-Mer

The Germans' 6inch gun emplacements which still top the cliff at Longues-sur-Mer became known to the locals as 'Le Chaos', due to the ferocious sound they made whenever they were tested. There are four casemates like the one shown on page 125, arranged in a convex semi-circle to maximise their firing arc. As a result of this placement, the battery was able to threaten the landings on both Omaha and Gold Beaches, as well as Allied shipping up to 21km (13 miles) out to sea.

On D-Day the battery was repeatedly bombed by Allied air forces. But, although this cut the communication wires between the observation post (on the edge of the cliff) and the guns, the battery remained in action. After gunnery duels with several ships of the Eastern Naval Task Force, direct hits eventually silenced 'Le Chaos' and the 184 German troops manning the emplacements surrendered to British troops.

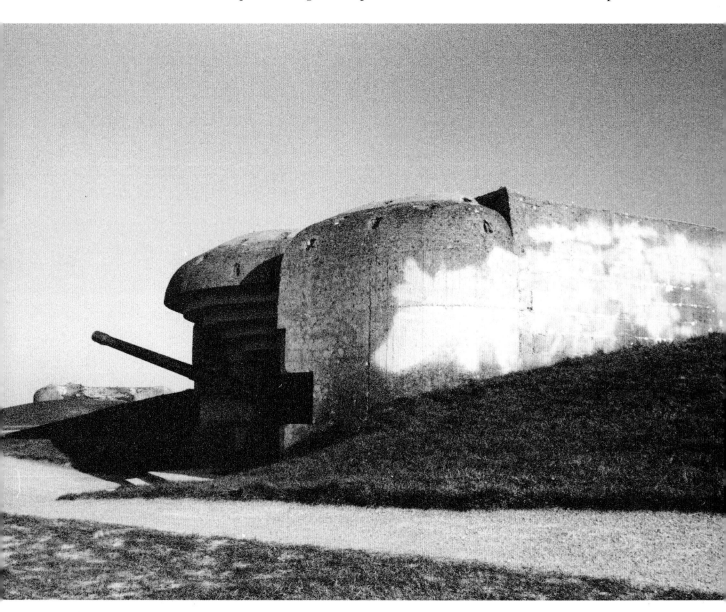

George Tuffin, a British soldier who landed on Gold Beach, recalls how his experience of the war, and of the Normandy landings in particular, influenced his thinking: 'I was on an American landing ship tank and the skipper took us so far up Gold Beach that sometimes I wonder how he ever got off. But the Germans were shelling the beach and it was early morning, just barely light, and the first thing we saw was several rows of dead bodies wrapped in blankets being prepared for burial and then we moved out from the beach area to an assembly area. I was 20 years old. It was rather strange, really. I don't suppose my experiences are really different from others, but did find that for a couple of years after coming home I lived a very solitary life. I didn't really want to get involved with people. I just stayed at home with my family. I didn't want to make friends. And I hadn't realized that my behaviour was a result of my experiences. I had already lost so many friends that I didn't want to lose any more.

'Some people say you should forget, but you should not because the war was such a big part of our lives. There were the people you knew, and friends you lost. I belong to the Normandy Veterans' Association and everyone says the same thing – hardly a day goes by when you don't remember something regarding the war. Something will trigger off a memory and you go back to all those years for a short period. Not all of them are bad things, some of them are actually quite humorous....'

As the troops fought, the French civilians caught in the battle watched the proceedings with a mixture of hope and fear. Madame Dubois, a resident of Monceaux-en-Bessin, near Bayeux, recorded her memories of D-Day, as it affected her village: 'All the Germans left around 4 in the morning...there were 50 of them. They were quite a few in the village. The first English motorbikes passed by the village at about 7 a.m. and half an hour later we found ourselves surrounded by English soldiers. At the bridge they had to fight with a few German soldiers scattered in the countryside, but since some Frenchmen were in the middle, the English soldiers did not dare open fire; the Germans did. Near the church as well, they were at grips with a handful of Germans, but it did not last for long.'

Opposite: One of the concrete gun emplacements that made up the battery known as 'Le Chaos'. The noise produced by such massive guns must have made the lives of the local inhabitants hell whenever they were fired on exercise.

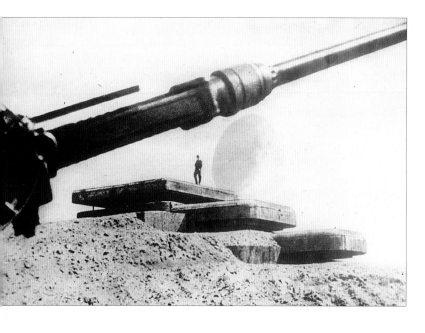

Left: German observation post on the cliff top at Longues-sur-Mer. It was used to direct the battery's gunfire against enemy target and can still be seen today.

Opposite, top picture: One of the restored gun posts. It may be the damaged one shown below it.

Opposite, bottom picture: This picture illustrates the result of a near hit outside the gun aperture of one of 'Le Chaos' gun emplacements. The impact severed the gun from its turret, putting it out of action. The GI in the foreground holds a large brass shell casing.

Below: This German coastal gun battery was one of many that failed to be completed before the Allied invasion. It lacked the concrete housing that would have protected the crew from enemy shelling.

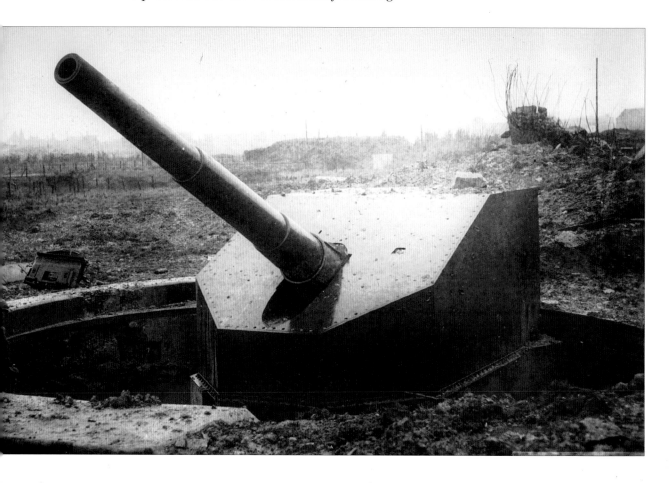

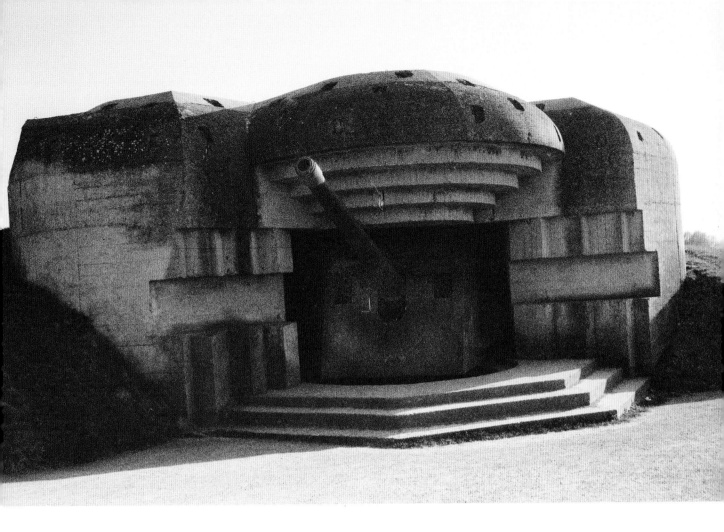

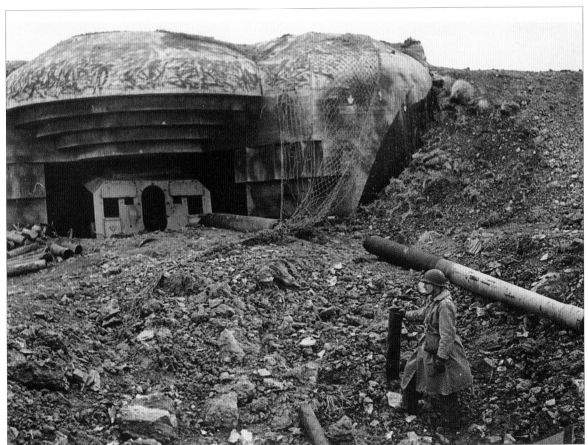

Bayeux

Left. Bayeux Cathedral sustained severe damage from RAF bombing attacks. It has now been fully restored.

Bayeux is noted for its beautiful Romano-Gothic cathedral. A town of obvious historical importance to both the British and the French, given its links to William the Conqueror, it is situated in what had been designated the centre of the D-Day invasion zone. Historians later concluded that this was an over-ambitious objective for the British invaders to have set, Bayeux being far too far inland to be a realistic target for the first day of the invasion, especially as the German troops defending the city – the 352nd Infantry Division – were of higher calibre than those on parts of the coast.

The German garrison of the town was engaged by the British 50th Northumberland Division, though little progress was made on D-Day itself. Although the unique Bayeux tapestry had been moved earlier in the war and hidden at Sourches, near Le Mans, the British still tried to avoid damaging the historical fabric of the city. Eventually, they managed to fight their way into the outskirts of Bayeux, but were unable to capture it until some days later, after much bloodshed.

These are Major F. D. Goode's memories of the day: 'My objective was the west side of the town, covering the road to Port-en-Bessin to the north-west and to Vire and St Lô on the south-west. The countryside seemed calm, we passed the occasional rough cross with a tin hat and a name where one of 7th Armoured Division had been buried the day before. We were soon mixed up with tanks belonging to the rear units of 7th Armoured Division who had gone on to the village bocage but were even then being

forced out by the Panzer Lehr Division and 21st Panzer Division. There were also a number of war correspondents in jeeps....

'We came to the outskirts of Bayeux. Here the whole populace were lining the road with flowers and beer and wine and cheers; they had even managed a few Union flags along with the tricolour. We soon arrived at my objective, the Place St Patrice, on the north-west of the town. I sent the leading platoon off to the bridge, left one in position on the Port-en-Bessin road and kept one in reserve in the houses around the place. I chose as my HQ a substantial house on the corner of the Port-en-Bessin road. It belonged to a schoolmaster.... I told him that his family could have half the cellar and we would use the other as an aid post. There was some firing from the south-west and sniping from the cathedral tower. I took a party and searched the gardens at the backs of the houses and made my way up to the forward platoon. I noticed a large tub of tripe in the yard of the café.... There were no Germans about and I arrived at the bridge to find that the firing had ceased and the enemy withdrawn.'

Below: The Aure river runs through the heart of Bayeux. The bridges across it became very important to both sides during the Battle of Normandy.

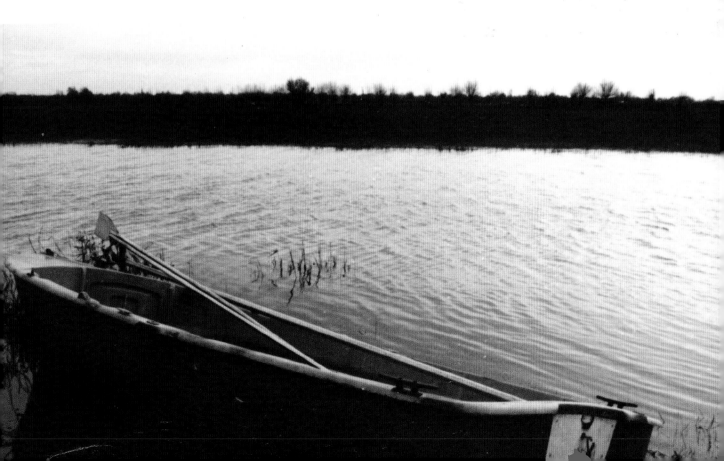

Creully and Le Hamel

Like many other seemingly insignificant bridges, the one at Creully was strategically important. The river Seulles, which it crossed, ran west to east across the Normandy countryside, making it a potential obstacle in the troop deployment planned by the Allies once the bridgeheads were secured. German snipers and small groups of soldiers were the sole resistance during the Allied advance on the village. D Company of the Royal Winnipeg Rifles, with a section of riflemen, silenced an enemy machine-gun nest along the bridge at Creully. The Canadian Headquarters signal section was under constant mortar fire. With evening fast approaching, the battalion set about digging in just south of the village. Five officers and 78 troopers arrived from the reinforcement unit that evening.

On the beach, lifeless bodies wearing the white and black shoulder flashes of the Royal Winnipeg Rifles lay in the dunes and in amongst the pillboxes. Many more wore the dreaded swastikas. The regimental war diary's final entry on that day emphasizes: 'Not one man flinched from his task, no matter how tough it was, not one officer failed to display courage and energy and a degree of gallantry.' It is thought that, with this day's work, the 'Little Black Devils', as the Royal Winnipeg Rifles were nicknamed, more than maintained the tradition of their regiment. Casualties for the day exceeded 130.

Le Hamel is a hamlet near Creully, on the far west side of Gold Beach. The Germans turned the area into a strongpoint, guarded by artillery and machine guns. On D-Day the first wave of Allied troops landing there was the 1st Battalion the Hampshire Regiment of the British army. They faced a stiff fight to take the heavily defended village, but eventually overwhelmed it in the late afternoon after eight hours of fighting. Heavy casualties marred this success, which included the loss of their CO, their second-in-command and over 200 troops.

The Hampshire Regiment was followed in the second wave by the Commandos of the 4th Special Service Brigade, whose task was to push further inland and wipe out any remaining resistance.

Opposite: Today the beach at Hable de Heurtot is given over to the gentler rivalries of the local children and their sandcastles.

Hable de Heurtot

There were many, many feats of tremendous heroism on D-Day. One such was carried out by Sergeant Major Stanley Hollis of the 6th Green Howards, who was single-handedly responsible for the capture of 25 prisoners – the garrison of a German pillbox at Hable de Heurtot. Within five minutes of landing on Gold Beach, he stormed the pillbox under searing machine-gun fire, putting the German guns out of action and preventing many British deaths. For this action he was awarded the Victoria Cross for Gallantry in Action, the only man to receive this honour as a result of his efforts on D-Day.

After that, strong opposition meant that it took several hours for the British troops to make further headway inland. Eventually, the deadlock was broken and good progress was made. By the end the day the British had landed over 24,000 men on Gold Beach with a thousand killed and wounded.

Overleaf: The incoming tide seen from inside one of the German gun emplacements at Ver-sur-Mer, on Gold Beach.

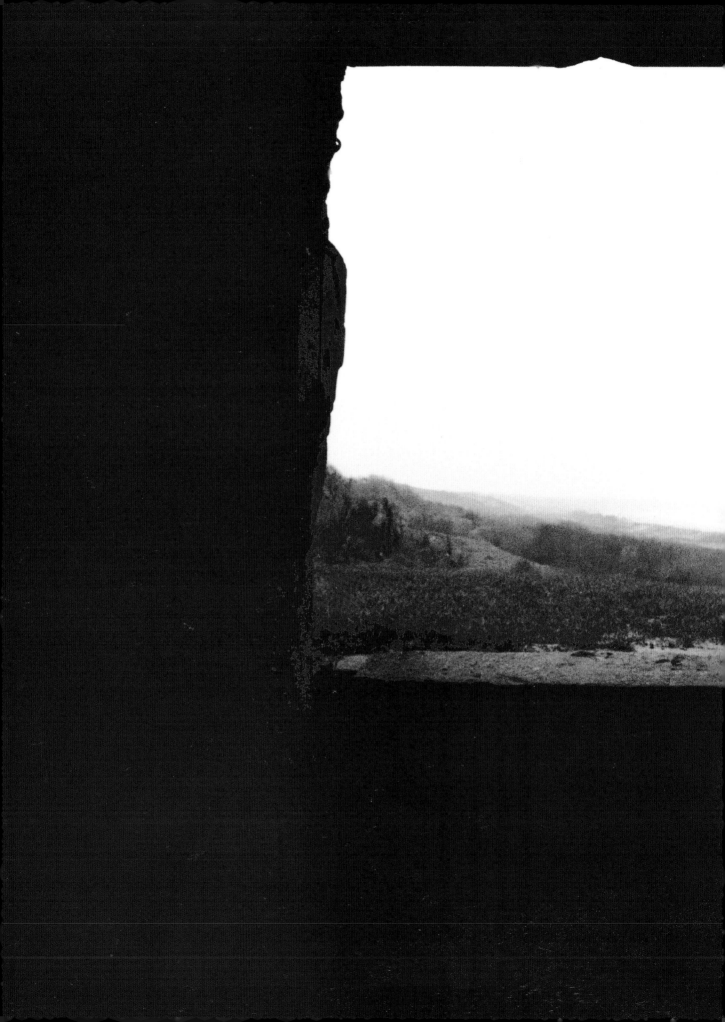

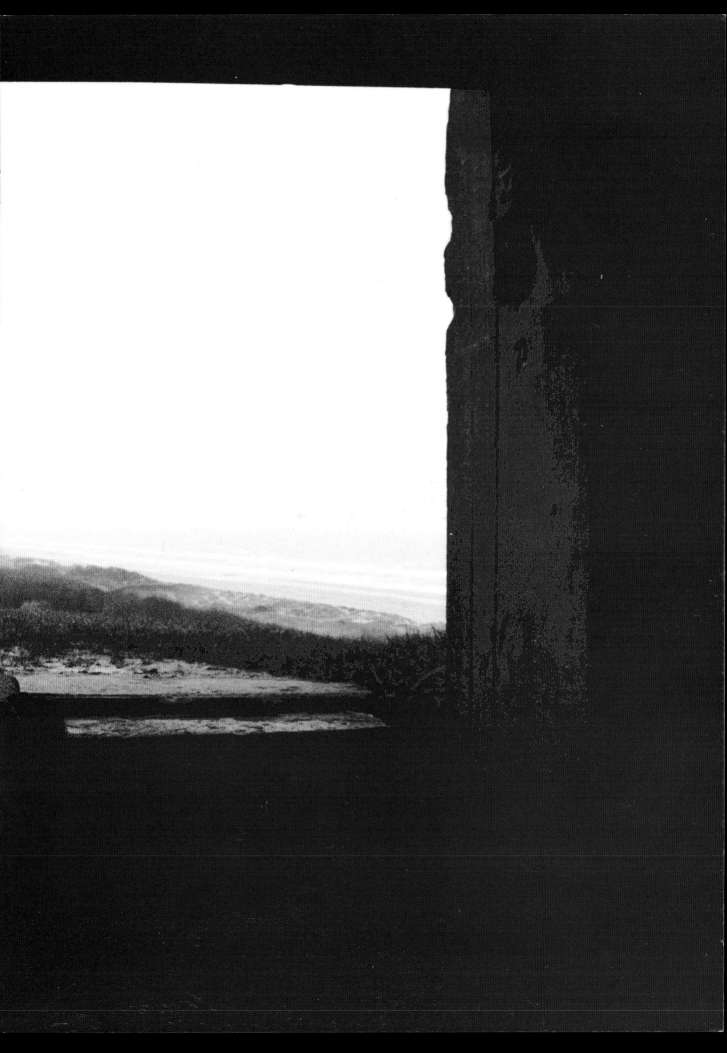

Ver-sur-Mer and Crepon

Ver-sur-Mer was another strongpoint along the Atlantic Wall. The 50th Infantry Division, commanded by General Graham, landed on Gold Beach, its D-Day objective Bayeux. The 2nd Devonshire Regiment cleared the beach at Le Hamel, the 47th Commando attacked Port-en-Bessin, the 69th Brigade landed at La Rivière supported by tanks and naval artillery, the 5th Yorkshire Regiment took the German positions around the lighthouse of Ver-sur-Mer. After landing at 0820 hours, the 7th Green Howards entered Ver-sur-Mer without meeting any resistance, and they neutralised the battery of La Mare-Fontaine, taking over 40 German prisoners. The Allies now had the upper hand.

There is a newly erected war memorial at Crepon dedicated to the Green Howards, the unit in which Sergeant Major Stanley Hollis (see page 129) served. Sculpted by James Butler, the statue depicts a British soldier at the end of D-Day reflecting on his exploits.

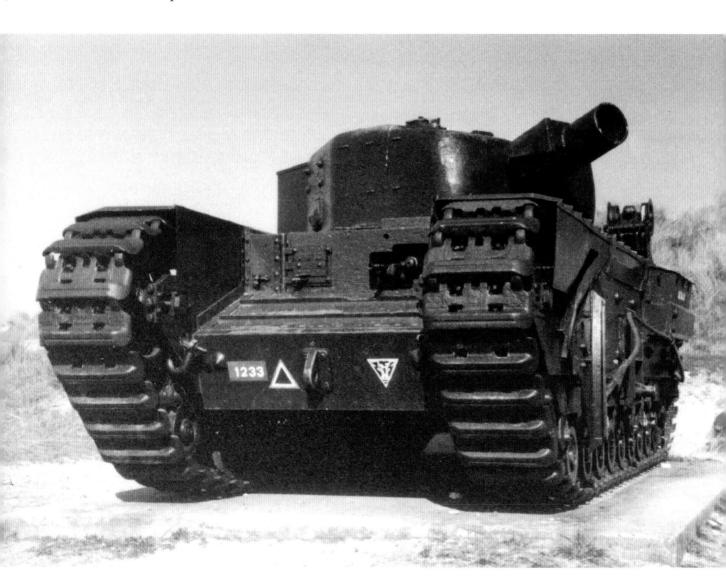

A local man, Mr Guillotin, remembers how he discovered that liberation was near for his village and for France: 'It was nearly six in the morning, time for milking the cows, and I had to fetch the milk from the farm where I worked... I had gone about a hundred metres when I saw a bare-headed man crossing Mr Emile Poret's meadow. I continued on my way while watching this person. It was definitely a German soldier. He had lost his helmet and his rifle, and one of his puttees trailed along the ground (not all Germans were equipped with jack-boots). After cautiously approaching the road, he crossed it a few steps behind me and went through the hedge to disappear in Mr André Lefèvre's pasture. It was just at this moment that a flash of light rose up behind the houses and a cloud of smoke went skywards. For a moment I was shell-shocked and paralysed.... The large explosion which caused this was that of a half-track of the Somua type which was full of ammunition for the German 88mm battery. One could still hear some small secondary explosions.'

In a letter to his wife, a British captain, Frank Holden, of the King's Own Scottish Borderers, describes his first impressions of 'the locals'. 'It was quite an experience landing yesterday morning, and suddenly finding oneself in a foreign country with two sets of foreigners – one not quite sure whether to smile at us and the other set knowing definitely what to do about us! Anyway, we are showing them they aren't so good as they thought, and are getting on very nicely. It was bad luck in the first hour of landing yesterday to get the Brigadier and two or three others of our HC hit, including KH, but only one fatally....

'The country is very pleasant, with very attractive villages every few miles. The "locals" seem to be getting more friendly, perhaps now they see we mean business. They aren't anything like so poor looking as I had imagined them to be and at least here have quite a lot of farming stock left. It is funny to see the chickens and calves trotting around a farm yard whilst tags of ammo are flying around. I rather like to see it....

'The other day I came bang through a German-occupied village (unintentionally – just because I went down the wrong turning!) It was a funny feeling to see the German notices on walls and windows.'

Opposite: A British AVRE tank knocked out behind the sand dunes on Gold Beach. It has been restored by the French and now stands at Graye-sur-Mer, a few kilometres from Crepon.

Overleaf: The river Provence and the surrounding marshland, near the village of Crepon, which is the site of the memorial dedicated to the Green Howards.

Juno Beach

On 19th August 1942, in an action code-named Operation Jubilee, an Allied assault force of 6100 troops, of which 4963 were Canadians, attacked the port of Dieppe with the support of Allied naval and air forces. The operation was to take place under the cover of darkness and have the advantage of surprise. However, the approaching craft ran into a German convoy, resulting in a violent sea fight which alerted the German forces on the coast. Using their dominant positions on the cliff tops the Germans brought massive fire power to bear on the landing forces in a devastatingly effective counter-attack. Allied tanks were late arriving, leaving the infantry exposed and unsupported at the crucial moment. After a battle lasting nine hours, the assault force retreated, leaving behind 3600 men, a thousand of whom were dead and the rest wounded, missing or taken prisoner. The Germans

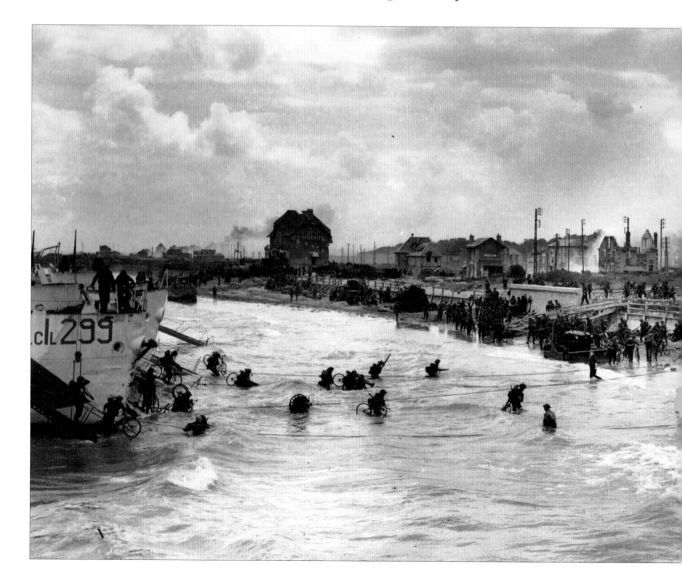

suffered only 300 casualties. The Allies failed to capture Dieppe, but valuable lessons were learnt which were to come into their own on D-Day.

The Canadians had borne the brunt of the Dieppe disaster, with 1946 men taken prisoner and 907 killed. It is hardly surprising, therefore, that they saw D-Day partly as an opportunity to avenge their comrades. However, their part of the invasion did not get off to a good start. The planned bombardment and bombing had not managed to reduce the German defences on Juno Beach, the area that had been assigned to the Canadian landings. Nearly all were still intact as the first wave of troops arrived on the beach. Moreover, armoured support from the 7th and 8th Brigade Groups was not forthcoming in the volumes planned, only a fraction of the tanks making it ashore. Even worse, the landing commenced later than expected, meaning that the lines of beach defences were covered by the tide. The water concealed the mines attached to the defences, increasing the risk for the landing craft approaching the shore. About a third of the landing craft at Juno were either destroyed or damaged by the beach defences, enemy fire and collisions.

The Canadian forces employed to assault Juno Beach included Le Regiment de La Chaudière, the Royal Winnipeg Rifles and the 1st Hussars (6th Canadian Armoured Regiment). The narrow strip of beach soon became a restriction as the tide came in. The success and speed of getting troops from ships in the Channel onto the beaches caused a virtual traffic jam, and the sea wall at Bernières was a formidable obstacle without the correct equipment. Nevertheless, a concerted push through the towns and villages behind the sea wall eased the congestion. Unlike other beaches, levels of resistance on Juno varied greatly. In some parts it was ferocious and had depth as well as organisation. In others it was non-existent.

At 2400 hours, the Canadians were the most successful of the Allied armies in terms of objectives achieved. They had established a beachhead which extended 6km (4 miles) inland from the beach and just 5km (3 miles) short of Le Carpiquet airport. They had chased off the majority of the Wehrmacht 716th Division, which was defending the area, and had landed over 21,000 men.

For fear of over-extending themselves and acutely aware that they had not managed to link up with their British counterparts on Sword Beach, the Canadians pulled back for the night to dig in for the expected counter-attack on their position. 7th Brigade had, however, successfully linked up with the British 50th Division at Gold Beach, the only such link-up of the Allied beachheads on D-Day.

Opposite: Second-wave troops of the Canadian army wade ashore at Juno Beach, some equipped with bicycles.

Luc-sur-Mer

Luc-sur-Mer was the boundary between Juno and Gold Beaches. This was the point that the only organised counter-attack of the day, by the 21st Panzer Division, reached to find the German beach defences intact. However, on the way to the coast from the area surrounding Caen, the Germans had suffered severe damage from the concentrated anti-tank fire of the British and Canadians on their flanks. It was also at this point that the 6th Airborne Division's follow-up glider force had landed and added their might to the defence of the area. This robust combination of forces destroyed 16 Panzers in as many minutes and caused the Germans to withdraw back towards Caen, unable to press home the advantage and throw the Allies back into the sea.

As well as witnessing this memorable action, Luc-sur-Mer had been the site of the first Commando raid in Normandy, which took place in 1941. Today there are a number of memorials in the area to troops who fought and died here, some not as well maintained as many throughout Normandy. The most notable of these are the ones dedicated to the 5th troop of Number 1 Commando, which took part in the 1941 raid, and also one to the French troops serving under General Le Clerc who participated in the liberation of their country on 6th June 1944.

Today Luc-sur-Mer is a small, quiet seaside resort. I was there on a cold but sunny October day. The sand blew inland from the beach and the place was not unlike many of its British counterparts. Despite the memorials to D-Day and even

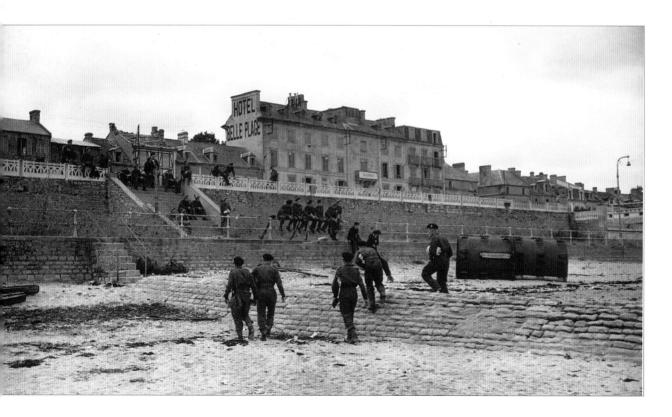

remnants of the old beach defences, the town does not seem to make as much of its war heritage as other places on the Normandy coast. No doubt this is different on 6th June each year.

Opposite: The Hotel Belle Plage, photographed shortly after the 1944 landings, was used as the rest club for the British 3rd Division which had landed at Luc-sur-Mer.

Below: When I arrived at this section of the beach at Luc-sur-Mer, it was bustling with recreational activities. Windsurfing, people walking their dogs, children playing made this beach one of the liveliest I visited in Normandy. It occurred to me that this peaceful scene was being enacted on a site where so many men sacrificed their lives in 1944.

Graye-sur-Mer

Graye-sur-Mer was the site where the 50th Northumberland Division landed. They used the complete range of Hobart's 'Funnies' (see page 113). The Royal Winnipeg Rifles, elements of the 6th Canadian Armoured Regiment and the 1st and 2nd Troops of the 26th Assault Squadron Royal Engineers were also involved in the landing. The first landing took place at 0755 hours. At the exit off the beach the Germans had dug an anti-tank ditch and to the right of this was a flooded culvert which led to the river Seulles. The ditch was crossed by an Allied fascine tank, which carried large bundles of wood for dropping into anti-tank ditches, enabling other tanks and troops to enter the defended area behind the dunes.

Today, a huge cross of Lorraine commemorates the site where General Charles de Gaulle landed on 12th June 1944. Churchill landed on the same spot on 14th June and King George VI two days later.

Below: A British AVRE tank coming down a narrow lane in the Graye-sur-Mer area.

Opposite: The stainless steel cross above Graye-sur-Mer commemorates the arrival of General Charles de Gaulle and is a symbol of Free France. It is also a memorial to all those who took part in Operation Overlord.

Bernières-sur-Mer

Bernières-sur-Mer was one of the four German strongpoints on Juno Beach. The 800 men of the Queen's Own Rifles of the Canadian Army landed there at 0800 hours with the task of disabling the big German guns. Despite strong opposition, the Canadians rapidly captured the towns of Bernières and Courseulles. With the belated help of tanks and armour Bernières was cleared of its German defenders by 0930 hours. By 1335 the Canadian Commander, Major-General Keller, was giving his first conference on French soil, in an orchard outside the town..

This assault was a triumph in terms of numbers of men landed and also in numbers of prisoners captured. The cost to the Allies was 304 dead, 574 wounded and 47 prisoners. In total the Canadians and British landed 21,400 men, 3200 vehicles and 1100 tonnes of supplies. In return they were the only one of the three Allied

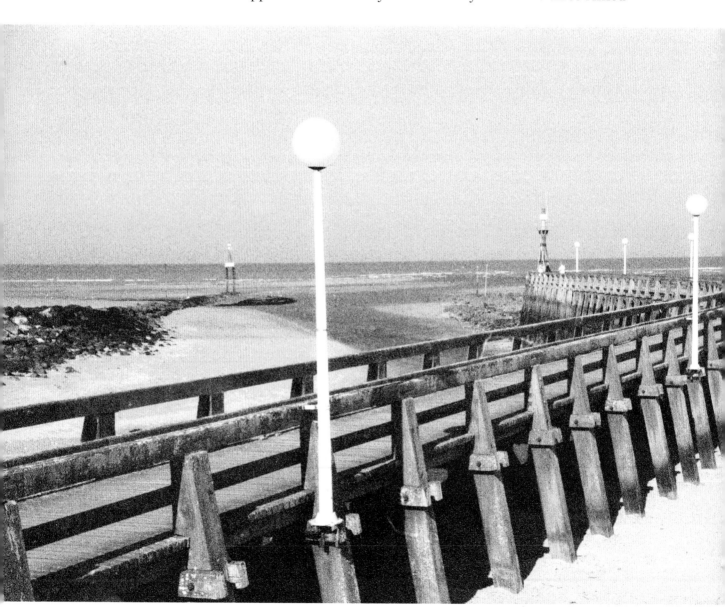

armies even to get close to their D-Day objectives. Caen was in sight, but its capture was to prove a more serious challenge.

Marine Reg Bettiss of the 46th Commando, Royal Marines, remembers the day: 'We moved into position in Southampton Water, to depart for Normandy, with HMS *Isis* as our destroyer escort at 1230 hours on D-Day. We arrived at anchorage Juno, off St Aubin-sur-Mer, at 1830 hours. One hour later, the ships proceeded to anchorage Sword off Ouistreham, to report to Flag Officer, Force S, where the LSIs [Landing Ships, Infantry] were to marry up with the rest of the naval force, for the decision as to which coastal battery was to be assaulted.

'At 2200 hours, the order was received that both operations were postponed, the reasons being:

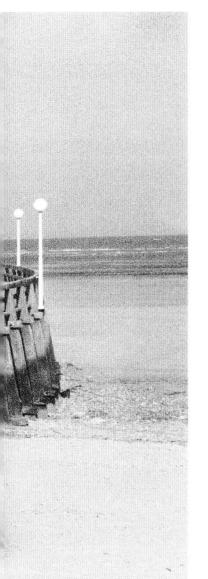

1. Neither battery was harassing our shipping:
2. The weather was considered unfavourable.

'On receipt of this order, the LSIs returned to anchorage Juno for the night.

'At 0600 hours, 7th June 1944, a signal was received that the Unit was to come under the command of I Corps, and would be landed at Bernières (The Canadian Division Sector) at all speed.

'Hasty adjustments and improvisations were made to equipment and personal loads, for going ashore at 0900 hours.

'Thus a unit of very angry young men were deprived of the assault on either of the two coastal batteries for which they had trained so hard, and the Commando was landed on Nan White Beach, to join up with our comrades in 4 S.S. [Special Service] Brigade.'

Left: Bernières-sur-Mer is rather overendowed with mementos of the Allied invasion: tanks on plinths, destroyed German guns made into street furniture.... I preferred to look out to sea, where the wall of the small harbour makes an attractive path for the eye to follow.

St Aubin-sur-Mer

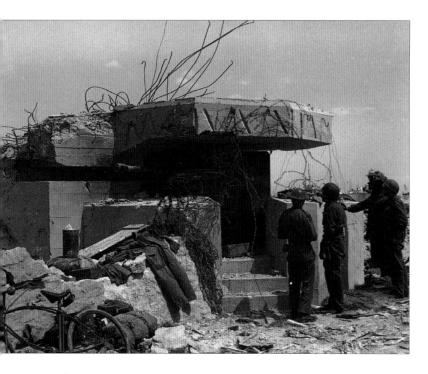

Left: A badly damaged German anti-tank bunker on the sea wall at St Aubin, photographed soon after D-Day. It has been carefully restored and still stands in its old position, as my own photograph (opposite) clearly shows.

St Aubin-sur-Mer was once a charming seaside resort, its coastline dotted with holiday cottages and beach huts. In June 1944 it was also the site of one of the four German strongpoints on Juno Beach. Naval bombardment up to the moment of the landings prevented the Germans from defending the beach effectively at these points. Coming ashore at 0845 hours, the Allies were supported by AVRE tanks and other heavy weaponry. Once British and Canadian forces had breached the defences, there followed a great deal of house-to-house fighting in the town itself. The Germans had been very resourceful in their defence, creating anti-tank blockades and siting their machine guns so as to produce effective killing fields. However, due to the superior numbers and weaponry of the invading forces, the Germans defending St Aubin capitulated by 1800 hours.

Now the fiercely fought-over stretch of beach at St Aubin has once more been colonised by holiday cottages. All that remains of the action on D-Day is the beach wall.

German resistance did not collapse so quickly in all areas. On 17th June, Captain Holden once again wrote to his wife: '… we are still in our little wood playing hide and seek with Jerry. It is getting quite a game – we are literally "dug in" and you walk along to see people's heads only above the ground! I think we shall be pushing on again soon; the Germans just can't make the grade at pushing us back into the sea now. They still think they are good, though – it's rather pathetic to see the chaps we bring in – some good-looking fellows and often they have some family

photographs with them, which makes it seem all the more hard. Let's hope they will learn soon that the war racket doesn't pay....

'It is a lovely country to be in. I have just been looking at a lovely sight – from where I sit I can see across a great field of barley an ideal village. At least it looks ideal from here – I'm afraid its being between us and Jerry doesn't help the architecture when you get up close. These villages are really picturesque, and in peacetime it must be a grand living around here.'

Below: A restored anti-tank bunker at St Aubin-sur-Mer.

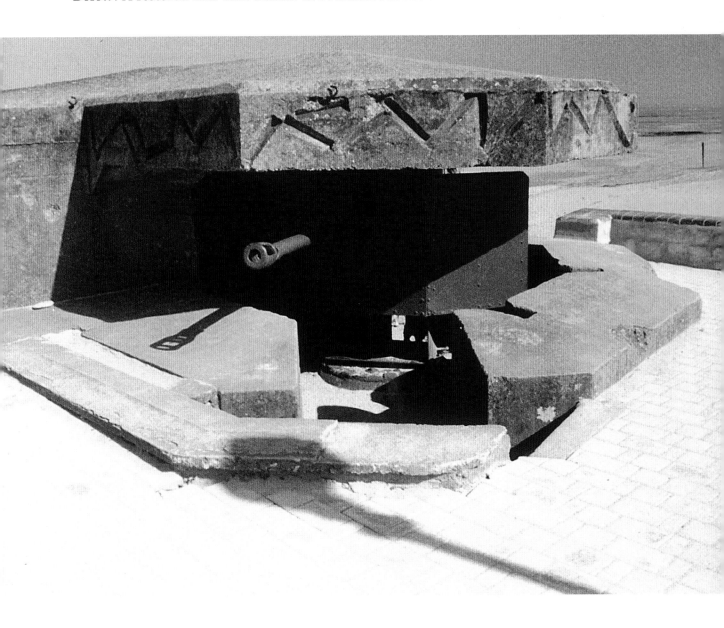

Douvres Radar Station

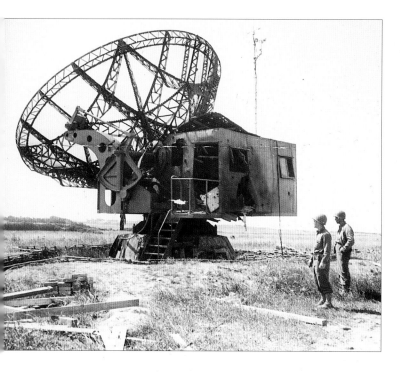

Prior to and immediately after the postponement of Operation Sealion (the German plan to invade Britain shortly after the fall of France in 1940), the Luftwaffe maintained a large presence in the north of France. All along the coast were many fighter and bomber bases, and also a number of radar stations in order to monitor the activity of British Bomber and Fighter Command. In the prelude to the invasion of Europe, Allied air activity was increased massively. As a part of the deception operation designed to make German High Command believe that the invasion would be in the Pas-de-Calais, for every bombing raid against the Calvados coast, two were launched against other parts of the Atlantic Wall. Douvres radar station was employed to detect such missions and direct what was by 1944 a piecemeal Luftwaffe air defence.

Such an installation included a garrison of around 200 men housed in the concrete bunkers around the radar dish. On the day I visited the station, the only residents of the site were two grey horses, blissfully unaware of the significance of their surroundings.

Douvres radar station was practically destroyed during the fighting. Today, as part of the movement for the preservation of Normandy's heritage, the site has been restored to its former glory.

Above: The radar station at Douvres-la-Délivrande in 1944.

Opposite: This radar station, photographed in 2003, is now situated at the Imperial War Museum, Duxford, Cambridgeshire, having been salvaged from a Normandy beach near Douvres.

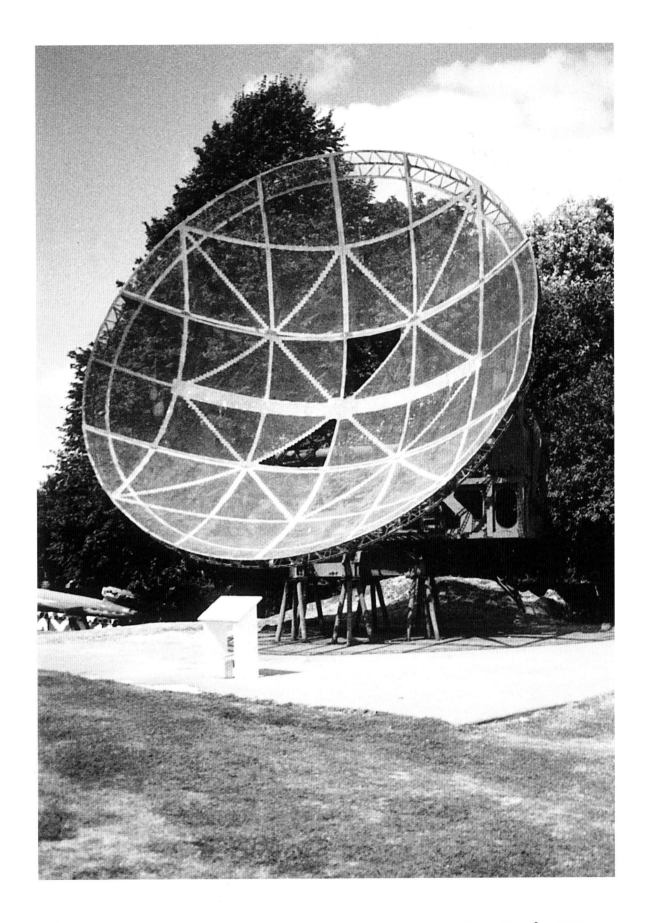

Douvres-la-Délivrande

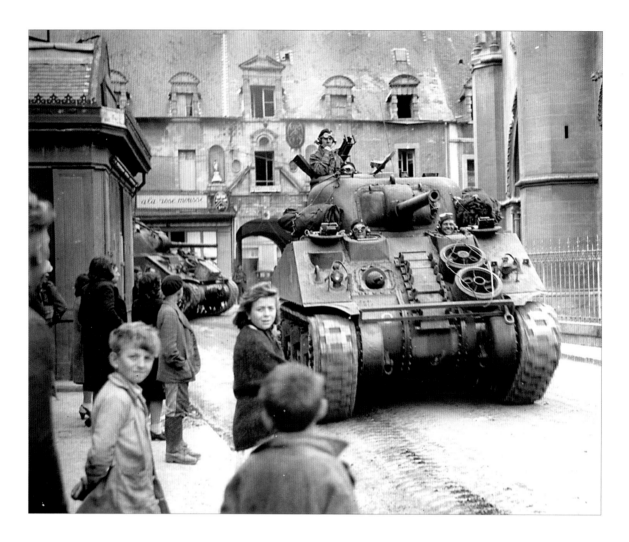

Situated amongst the rolling hills behind the British beaches, Douvres-la-Délivrande was a key town in the German logistical network in the region.

Brigadier Cass, Commander of the 1st Royal Engineers, gave an outline of the events of D-Day. He described how rough weather, including a strong onshore wind, combined with a higher tide than anticipated, slowed down the clearance of mines, tetrahidra (steel and concrete anti-tank defences) and other obstacles laid by the Wehrmacht in some sectors of the Second Army front. Yet, as the tide fell, these were quickly cleared.

Above: Sherman tanks passing in front of the church at Douvres, soon after the liberation of the town in June 1944.

At the close of D-Day the situation on the Second Army front was regarded as satisfactory. The XXX Corps controlled the area between Creully and the high ground in St Sulpice, Sommervieu and Vaux-sur-Seulles. A pocket of enemy resistance was reported at Douvres.

On D+1 operations ashore continued against stiffening German opposition. The capture of Bayeux was completed at 1645 hours. Port-en-Bessin, which was intended to be the joint Anglo-American petrol port, was captured by 47 Royal Marine Commando and the 1st Corps had made contact with the 6th Airborne Division. The weather, however, continued to be bad, hampering the departure of the landing craft from the beach and the removal of those that had been damaged during the assault.

Below: The twin Gothic spires of the church, rising over the rolling hills which surround the town of Douvres-la-Délivrande. The church is situated in the heart of the town.

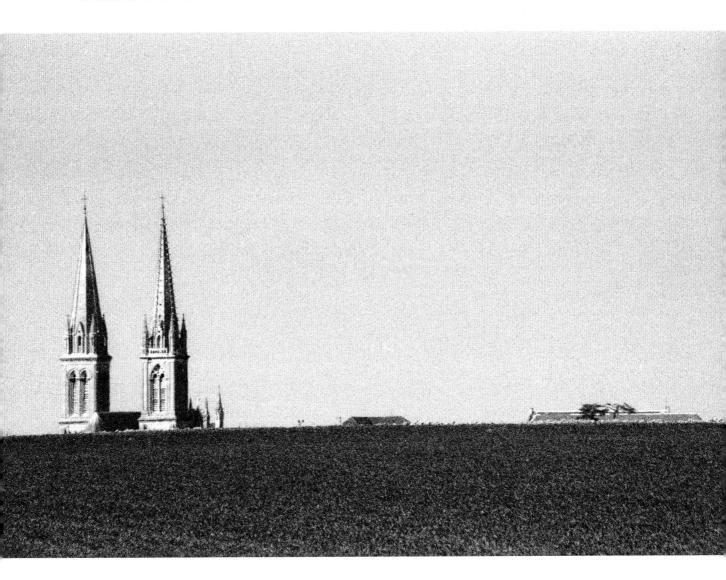

Courseulles

Juno Beach was allocated to the Canadian 3rd Division for the D-Day invasion. Their task was to land on the beach, penetrate the Atlantic Wall on a front which extended from La Rivière in the west to St Aubin-sur-Mer in the east, and then secure by force the numerous villages dotted along the sea front. Once this had been achieved the push was to be continued until the Caen–Bayeux road was reached.

The Canadian 3rd Division took its chance for revenge for the losses at Dieppe well; despite localised but strong opposition, it succeeded in achieving most of its objectives with relatively low casualties, even in some instances pushing further inland than had been planned.

Mr Guillotin, who was a young boy at the time, was much impressed by his first

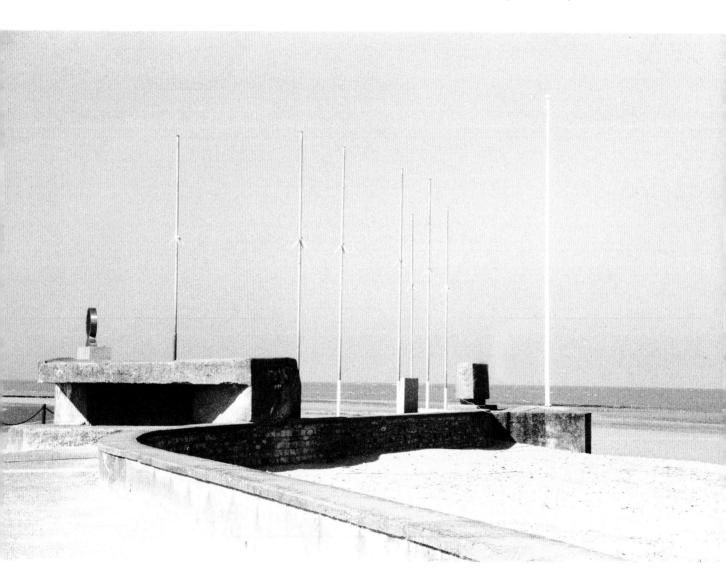

sighting of the advancing Allied troops: 'I was all eyes looking at and admiring the soldiers. They were sunburnt and their faces were blackened by dust and smoke. I was amused to see them apparently chewing the cud. I was soon to know well and taste for myself what was in fact chewing gum. I also would learn that the little packet they carried under their helmet nets was a personal emergency bandage. At the top of the sleeves of their khaki uniforms was a badge saying: Regina Rifles Regiment. It was a regiment from Saskatchewan, which in Red Indian language means Golden Earth. On average they were tall and solidly built. They didn't tremble apprehensively as the Germans did. Their quiet assurance and the personal strength and resolve which they showed indicated that they were fighting in a just cause which would lead to victory. What a contrast to the Germans! The truth hit us that things had changed and that these Canadian soldiers already carried an air of victory.'

As time passed and more and more towns and villages fell into Allied hands, German confidence was waning, as Captain Holden observed on 11th July: 'There is no doubt that the Germans are licked; I feel sure most of them have that idea to a small degree already. Our prisoners aren't half so cocky as they were a month ago.'

Captain Holden also noticed the good humour of the French civilians, despite the destruction to their homes: 'During our moving yesterday…I came to a very nice house lately left by Jerry in which were three charming old ladies. My bad French or something so amused them that they were emphatic I should accept a tin hat full of cherries and two eggs – they did it with such charm. There is a lot of courtesy and old-world manners about these people which I like very much….'

A few days later he witnessed people making their way back to their home, or what was left of them: 'To-day,' he wrote, 'has been marked by a sudden appearance on the roads of streams of refugees heading back towards their homes: whole families walking along behind carts laden with all their possessions and driving cows and horses. It is very pathetic to see them. And they are all cheery and take a very good view of us: much more so than the coastal people.'

Opposite: The Canadian forces which landed at Courseulles were as keen to avenge their losses at Dieppe as they were to free the French. The local population welcomed them particularly warmly as they were able to converse in their own language with many of them. The photograph shows an anti-tank bunker which is part of the sea wall. It is decorated with memorials to the Canadian troops who died here, and is topped with flag poles.

Port-en-Bessin

Another key point on the coast was Port-en-Bessin, which was to be attacked by the British 47th Royal Marine Commando. The Commandos were supposed to meet up with an American regiment coming from Omaha in order to link the two beaches. Unfortunately, the Americans were delayed by stiff German resistance and failed to make the rendezvous.

Despite fierce opposition the British forces broke through the German lines of defence with relative ease. The 79th Armoured Division made full use of Hobart's 'Funnies', including the Sherman Crab for clearing minefields, bulldozer tanks, bridge-carrying tanks, Churchills, Crocodile tanks with their flamethrowers, fascine tanks with their bundles of sticks and road-matting to be placed on the sand, giving better traction to following armour, and finally Sherman Fireflies with 17-pounder cannons.

The British troops encountered considerable fire from enemy gun batteries and mortars sited inland. This held up proceedings for a long time. But by 1000 hours, La Rivière was captured and, a couple hours later, Le Hamel too. The Commandos were able to reach within a kilometre (just over half a mile) of Port-en-Bessin after finding that the Longues battery had been destroyed in a gun duel with HMS *Ajax*.

Below: Walking along the beach at Port-en-Bessin.

Banville

On D-Day congestion on the beach slowed down the advance more than confrontation with the enemy. The 1st Hussars made their way forward, their Sherman tanks easily overcoming the German anti-tank guns and machine-gun posts. Their timely support enabled the Canadian troops to proceed towards Banville. Along the way, many German prisoners were captured and evacuated towards the beaches in small groups. They were, according to those on the scene, 'a sorry lot'.

The Canadian troops soon consolidated their positions in Banville and prepared to defend them against a counter-attack. In the process of expelling the Germans from the town in the initial assault, the Canadians had destroyed three large gun casemates and 12 machine-gun nests. They had also breached a major minefield with minimal casualties. The Canadian Army, supported by the Sherman tanks of the 1st Hussars, was now in a position to march forward towards their objective.

R. Neillands of C Squadron, Inns of Court Regiment, Royal Armoured Corps, landed with his unit somewhere along Juno Beach. These are his recollections of the day: 'The landings on the beach proved to be more difficult that [*sic*] had been expected, steel posts with mines on top could clearly be seen at the water's edge. At the time of our arrival the water was deeper than had been anticipated – we had been prepared for wading in about four and one half feet [1.5m] – the car

exhausts allowed only a few inches more than that. Our craft was the first to land but hit a mine which badly damaged the ramp and by the time that this had been dealt with the water was too deep for wading and we had to wait for the tide to recede. Our sister craft was able to unload…

'All that we could do was to watch. The Canadian infantrymen… were finding the opposition more than had been anticipated and were having considerable problems with anti-personnel mines which were…scattered in the sandhills either side of the beach exit. The mined areas were well marked…, but not the 88mm gun, which scored a direct hit on the first of our Daimler armoured cars to attempt to leave the beach. Here I could only sit and watch the driver, a very good personal friend, Trooper Dixon, burn to death.'

Overleaf: The beach at Banville.

Sword Beach

Sword Beach is situated on the far eastern flank of the invasion area. It extends for approximately 8km (5 miles) from Lion-sur-Mer in the west to Ouistreham in the east, at the mouth of the Orne river. In 1944, this area was largely dominated by half-timbered holiday homes. More importantly, the Orne and the roads out of Ouistreham and the surrounding area led to the medieval city of Caen, which was a key communication centre for the area, and its control was a major concern for both the Allies and the Germans, to allow transport and resupply for their respective armies. Caen in Allied hands would open the road to Paris.

The Germans strengthened the Sword area with beach defences and concrete gun emplacements in the soft sand. These defences were lighter than those of the Atlantic Wall at Omaha, so the heavy-gun batteries at Merville-Franceville and 30km (20 miles) further east at Le Havre were also crucial to resistance in the area. There were 75mm guns at Merville and massive 155mm howitzers at Le Havre, supported by 88mm guns behind the beaches and numerous machine guns and mortars. In addition, the landscape was significantly changed to facilitate defence. Anti-tank ditches were built, large areas were turned into minefields both on and behind the beach, and huge concrete walls were built in the streets of the towns and villages to impede tanks and infantry. In terms of manpower, the Germans had the 716th Infantry Division and 21st Panzer Division waiting on the cliff tops, looking out for signs of the invasion, whilst across the Dives river the 711th Infantry was in reserve. All of these troops were veterans and some had seen action on the Eastern Front.

Sword was one of the three beaches on which the forces of the British 2nd Army were to land. It was divided into four sectors designated, from west to east, Oboe, Peter, Queen and Roger. The plan was for the British 3rd Division to assault the beaches with French and British Commandos in accompaniment, beginning at 0725 hours on D-Day. Their prime objectives were to push across the beach, move on towards Caen and then to take control of Carpiquet Airport to the west of Caen. The Commandos were tasked with pushing towards the bridges over the Orne canal and river and meeting up with the 6th Airborne Division, who should by this time have captured the area.

German resistance on the beach was moderate. By 0800 most of the fighting was already taking place inland. Just after midday the Commandos had achieved their objective and had joined forces with the 6th Airborne Division at Benouville. However, not everything had gone the Allies' way. On the west of the beach the British had been prevented from meeting up with the Canadians, who had

landed at Juno, by a counter-attack launched by the 21st Panzer Division and designed to push the British back into the sea. After much fierce fighting the British gained the upper hand by excellent anti-tank tactics utilising anti-tank artillery, Allied airpower and Sherman tanks.

At 2400 hours on D-Day the British forces ashore numbered about 28,500. Casualties were surprisingly light – only 630. Some objectives had been achieved, but Caen, the most important in the eyes of General (as he then was) Montgomery, would not be attained until over a month later.

Below: HMS *Ramillies* bombarding shore targets on the eastern flank of the invasion zone.

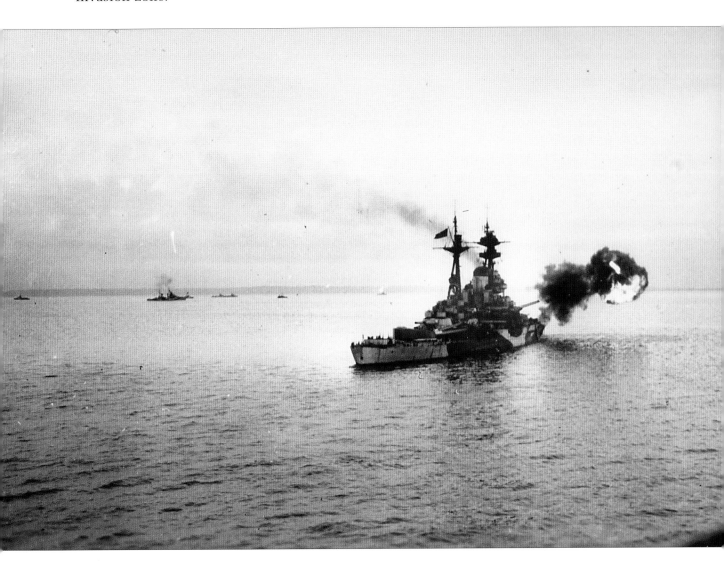

Pegasus Bridge

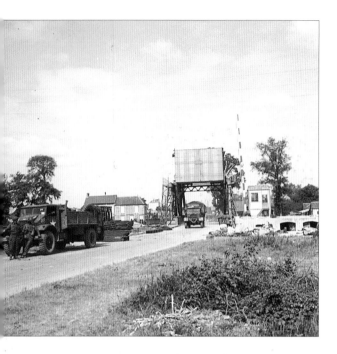

Left and opposite: These two pictures, taken shortly after the capture of Pegasus Bridge, show British troops being moved to and from the front line at Caen. In the picture on the left, the building visible to the left of the bridge is Café Gondrée, the first house to be liberated by the Allies (see page 162).

Pegasus Bridge (so called after the emblem of the troops who liberated it) is one of the bridges which cross the river Orne at Benouville and lead to Caen and Ouistreham (see page 172). For the purpose of the D-Day invasion this made it a key position in the plans of General Montgomery. If Rommel was going to repulse the invasion, he would need to introduce more and more troops and Panzer Divisions into the battle. Not knowing that all Panzers were now under Hitler's direct command, Montgomery thought they were being held in reserve in the Pas-de-Calais, to the east of the Orne. It was decided that elements of the British 6th Airborne Division would seize the bridges at Benouville (the other bridge being the one across the Caen canal, which runs parallel to the Orne river) in order to prevent the possibility of this happening.

Major-General Richard Gale, the Divisional Commander, sent an assault party of 181 men, comprising a specially trained team from D Company, 2nd Battalion Oxfordshire and Buckinghamshire Light Infantry, plus two platoons from B Company, 30 members of the Royal Engineers and six pilots from the Glider Pilot Regiment flying one Horsa glider each. Their objective was to land near the bridges (three gliders per bridge) and capture and hold them until they could be relieved either by more airborne troops or by the infantry landing on the beaches in the morning.

All but one of the gliders landed within metres of the bridges. Although many of the troops on board were knocked out by the impact of landing, they regained consciousness within seconds and those assigned to do so charged the Orne river bridge, taking the German sentries by surprise. The assault lasted only five minutes. The leader of the charge, Lieutenant Danny Brotheridge, was killed in the fire fight, making him the first Allied soldier to die in action during

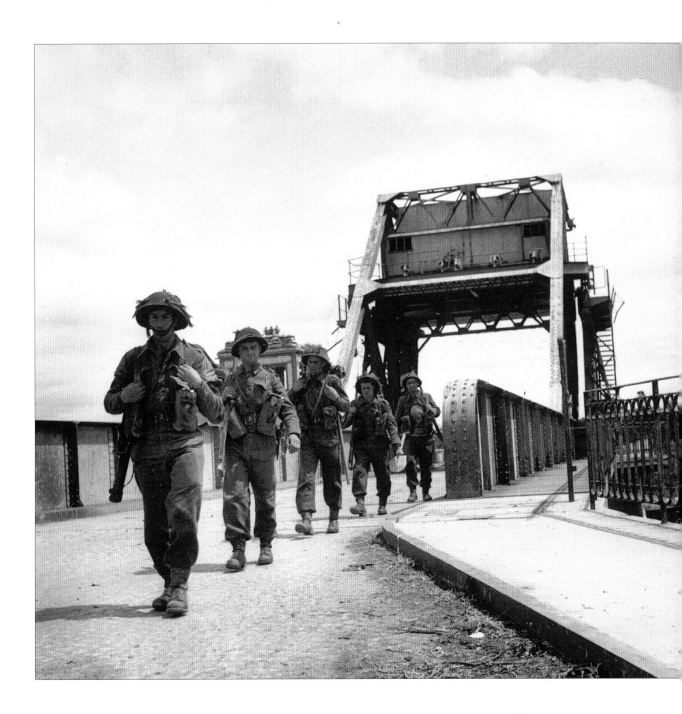

the Normandy campaign. The bridge crossing the Caen canal was found to have been deserted by those guarding it and was easily taken.

Overleaf: The new Pegasus Bridge. The old one, shown above, has been moved from its original site across the canal and re-established near the Benouville Museum.

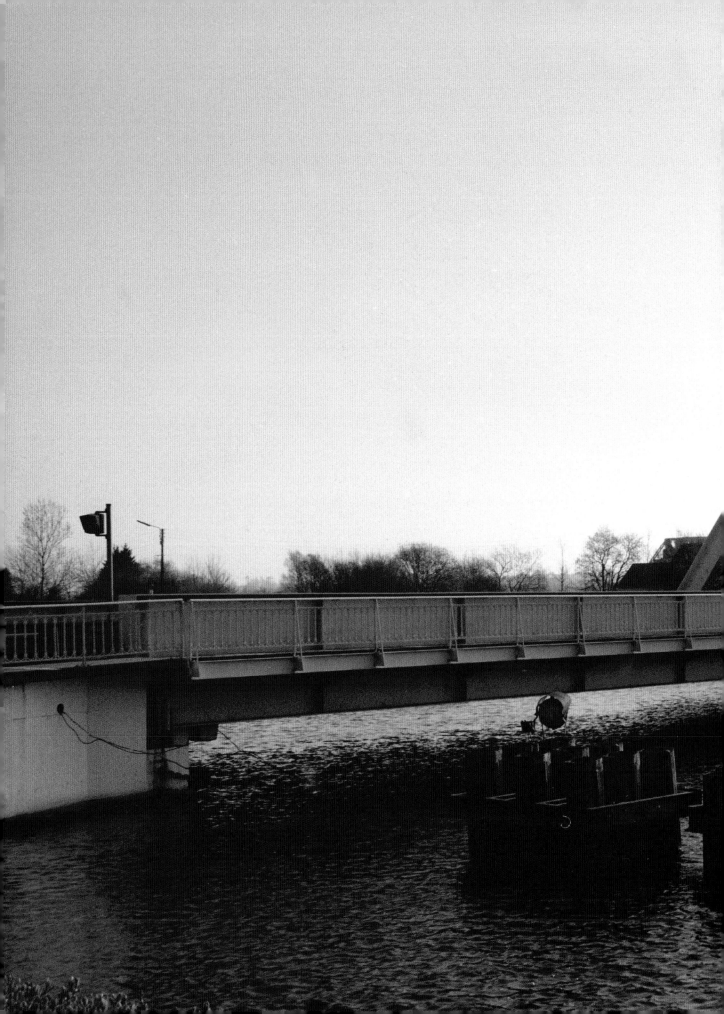

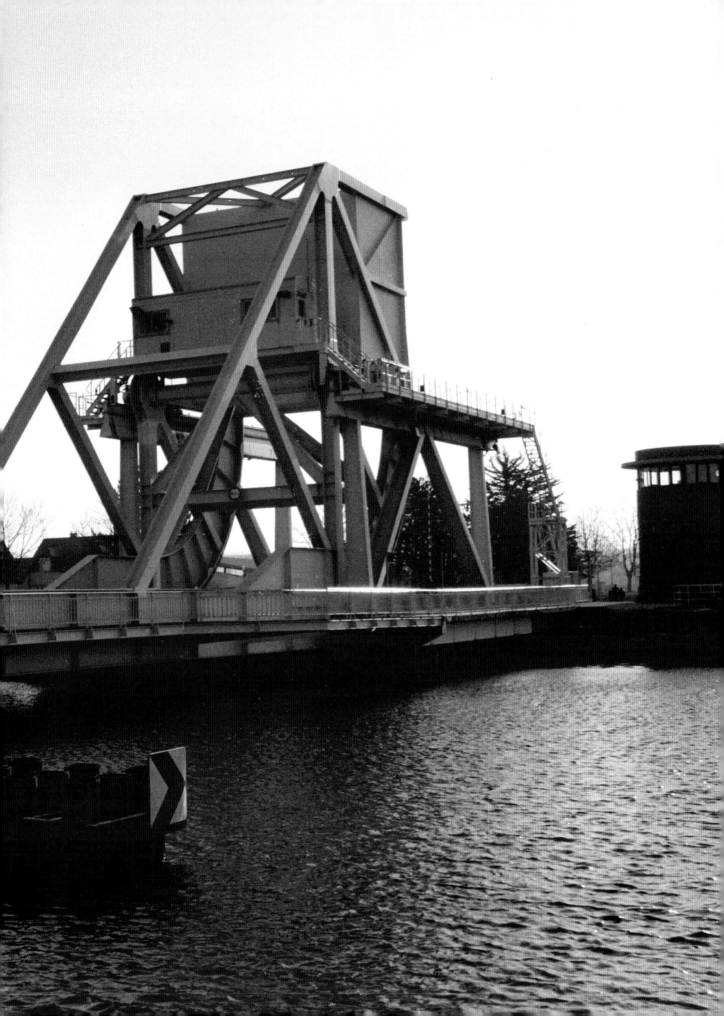

Café Gondrée

Opposite: Café Gondrée is situated next to Pegasus Bridge. It was the first building to be liberated and has become a centre of pilgrimage for D-Day veterans and enthusiasts alike. The present Madame Gondrée, a descendant of the original owner, provides her visitors with a good cup of tea and sells numerous souvenirs of the events that took place around the café.

Alex Savidge, who lived in London as a boy, witnessed the flyover of the airborne troops heading towards Pegasus Bridge and the surrounding area. It was mid-morning before the BBC radio news confirmed that the landing had taken place on the Normandy beaches, rather than along the Dunkerque–Calais–Boulogne stretch of coast, as people in Britain, not to mention the German army, had expected.

'After all these years,' he writes, 'I still wonder why that air armada that I watched in D-Day dawn, headed out across London, out across northern Kent and towards the Calais coastal area.

'Perhaps it was one of the decoy actions that drew the German divisions towards Cap Gris Nez. But, in retrospect, knowing more of the events of D-Day as history unfolds, it was most likely to have been the British 6th Airborne Division, on its way towards the left flank of the landing forces of Operation Overlord, the code-name for the Normandy landings. So, from the vantage point of the Woolwich Common, we watched the hundreds of aeroplanes, some singly, some towing the Hamilcar troop- and equipment-transporting gliders, [all marked with the characteristic three white and two black stripes] on each wing and on the fuselage, that were to identify the Allied aircraft from those of the enemy. The aircrafts were mainly American-built Douglas DC-3 Dakota transport planes, the air-workhorse of the war. But I think I recall many British bombers, converted to drop equipment canisters, amongst them Lancasters, Wellington bombers particularly. It is hard, now, to really accept what we saw. Aircraft spread overhead from the south and as far as we could clearly see to the north. The width of the flock was at least ten miles [15km] wide and it took at least a quarter of an hour to fly overhead. Even if the separation was 100 yards [90m] between aircraft there must have been close to two hundred aircraft abreast... One thousand bomber raids had become common by the Allies over Occupied Europe – but thirty thousand? No, it could not have been, although it certainly looked like it that morning.

'How the mind tricks one, as time passes.'

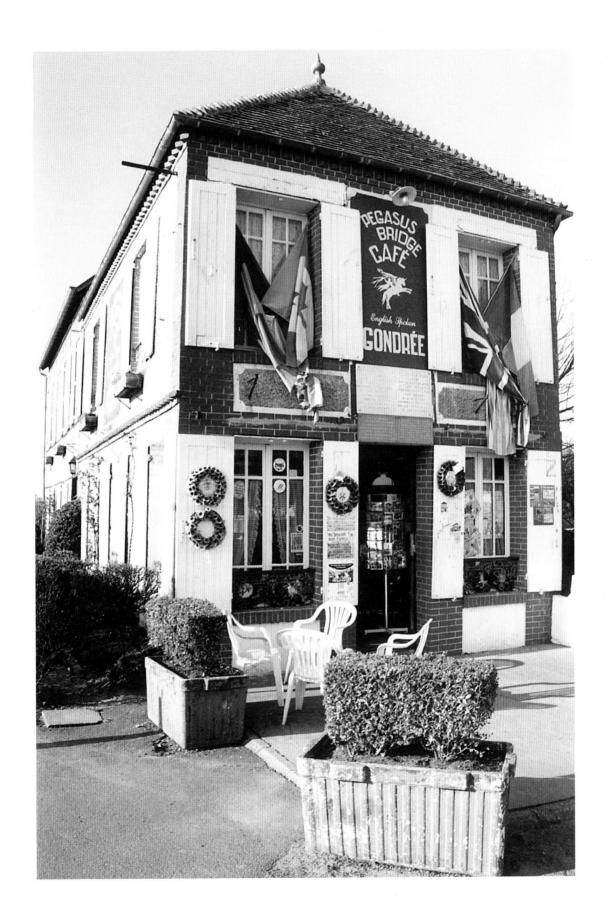

Benouville

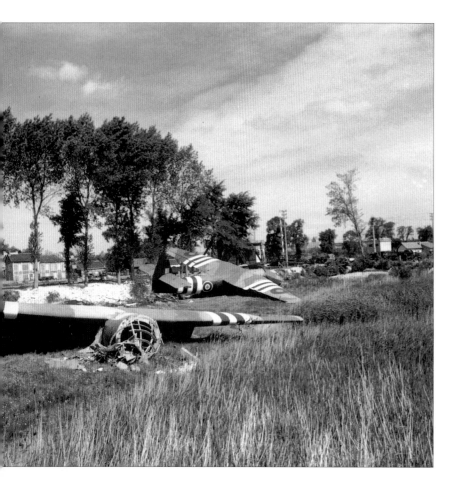

Left: These gliders crash-landed within sight of Pegasus Bridge, with troops from the British 6th Airborne Division on board. Their mission was to capture and hold the bridge until reinforcements arrived from the beaches, which they succeeded in doing. This was to be the first combat action of D-Day.

The pilots of the three Horsa gliders assigned to land next to the bridge over the Orne and capture it intact in a 'coup de main' operation were required to navigate from their release point to the bridge, in pitch dark, without markers and using only a compass and stop watch to guide them. The fact that two of these gliders landed exactly on target and the third not much more than a kilometre (less than a mile) away led Air Marshal Leigh-Mallory, the Deputy Supreme Commander of Operation Overlord, to call this the finest piece of airmanship of the war .

The Allied bombing prior to the landing struck many of the towns along the Normandy coast. Despite the danger to themselves and the damage to, if not destruction of, their homes, the French citizens welcomed the arrival of the RAF and the rest of the Allied forces as harbingers of their liberation. These are the recollections of one of them:

'I had been sleeping soundly until about three in the morning, when I was awakened by thunderous explosions. I flicked on the light switch, but there was no electricity. It took only a few seconds to realise that it wasn't Caen or the airfield at Carpiquet which were being bombarded. The noise was coming from the opposite

direction, that is, from the sea, and it appeared to be from somewhere very close.
'My parents dressed quickly, and my sisters and brother awoke in their turn.
My mother told us she had heard, around midnight, planes flying over and
the sound of bombing from Caen. I had also dressed and we went out of the house,
which was shaken so violently that the front door flew open and we were afraid
the whole place might collapse around us. There was no longer any doubt.
This was the long-awaited and hoped-for landing.'

Below: The landing site at Benouville as it stands today and the monument
to Major Howard, who commanded the operation.

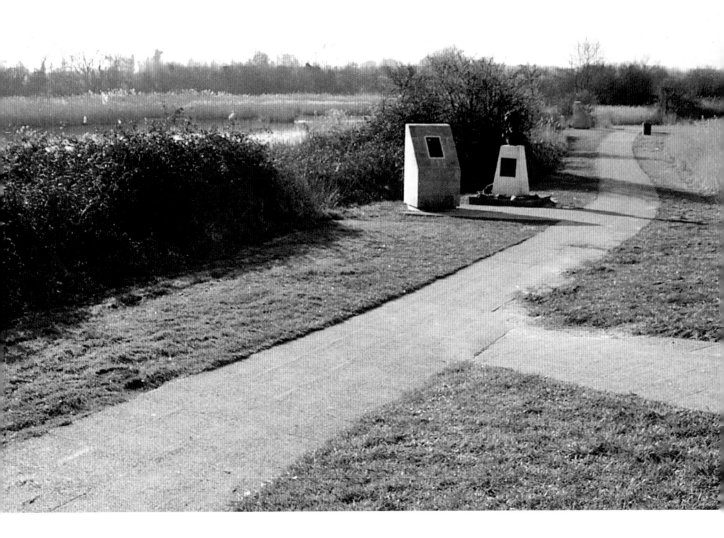

Ranville

Left: British Airborne recruitment poster

The village of Ranville, near the mouth of the Orne, was occupied by the command of the British 6th Airborne Division after it had secured the bridges over the river and the Caen canal. Headquarters were set up in the village church, next to which is the Allied cemetery, holding the graves of 2572 Allied soldiers and the remains of unidentified German soldiers.

On the day I visited it, the cemetery was bathed in bright sunlight. Beautifully tended by local gardeners, the white marble of its headstones and monuments shines starkly against the neatly trimmed, carpet-like grass. At the entrance, in common with many such cemeteries in Normandy, is a porch which contains the Roll of Honour.

As a boy who had lived for four years under German occupation, Mr Guillotin and his family were exhilarated by the prospect of the freedom the Canadians brought with them, especially as many of them spoke French: '... my mother came to tell me that some soldiers who did not look like Germans had been seen at the turning by the church. Very quickly I sorted myself out and after making myself presentable joined my father in the street. Three hundred metres away, coming round the church bend, some soldiers were advancing in Indian file. We were in no doubt that these were not German soldiers, who had become very familiar to us since 1940. The soldiers advanced slowly along the length of the stables at Mr André Lefèvre's farm. The first ones, arriving at the bottom of the hill, were hidden by it for the time being. My father and I decided to go towards them. While doing this we listened and looked to the right and the left, but we were sure that there were no more Germans in the vicinity. Since the morning we had seen everything that had gone on.'

Opposite page: Ranville church was used as the headquarters of the British 6th Airborne Division after its success at Pegasus Bridge. Today the small Allied cemetery is next to the church, at the centre of the village. It is one of the most handsome in Normandy.

Queen Sector

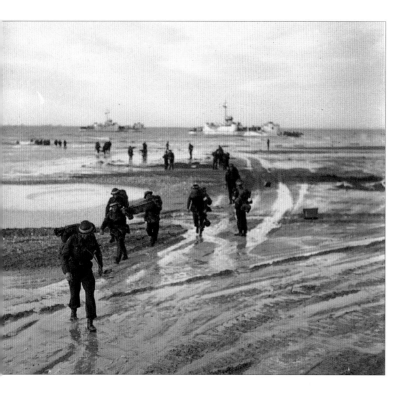

Left: British Army Red Cross personnel coming ashore on Queen Sector, carrying stretchers and medical equipment. In the foreground a medic carries a wounded soldier on his shoulders.

Overleaf: View of the beach at Queen Sector. Standing on the sea wall it was easy to imagine the hundreds of ships out to sea and the landing craft on the shore which made the D-Day landings possible.

This is Captain Frank Holden again, writing to his wife Peggie as he is waiting to embark for France. Captain, later Major, Holden was awarded the Military Cross in February 1945 for action in North-west Europe: 'Again we are on the water, and it still feels very much as though it is just an exercise. That feeling is increased by our being on the same craft as last time, and our party being precisely the same personnel (including the nice tank major).... The men are being very well looked after, quite a large number of free cigarettes are on board and Penguin books and newspapers for everyone....

'Just to embark and come out of harbour has taken up all today. Tomorrow should be more interesting, if we are to have the cross trip then. It is certainly going to be an experience – here's to *our* real journey across this stretch of sea!'

On 5th June he dashes off another letter to Peggie: 'Another day nearly over and ending with us in the Channel awaiting the great day tomorrow. It has been interesting this evening to watch the lines of ships of all sizes stretching away to the horizon, and I'm sure the Germans won't much like the look of it. The weather is proving better than we expected this morning and it looks as though we may have a good "run-in" tomorrow morning. Anyway, here we are – it is almost the day the Army has so long waited for, and we will see how soon the job can be finished.

'The day has gone quickly enough, with our moving up the Channel to link up with the convoy and a last look at maps and photographs.

'And so till tomorrow, my darling. You will be very close to me, bless you; come what may, I can be sure now of the constant happiness of knowing our love is all that matters.'

Captain Holden and his men landed in the Queen Sector of Sword Beach. From his letters, he makes it sound as though he had a comparatively straightforward landing, but it must be remembered that he was writing to his dear wife, whom he wanted to spare worry as far as was humanly possible – not to mention avoiding the censor's blue pen. His unit dug in inland and they soon established a routine.

A few days later another letter wings its way to England and Peggie: 'It has been another full and interesting day, and I have felt very fit as last night was the first real sleep I had been able to get since landing. and I slept from ten till nine this morning (followed by breakfast in bed!)...

'I was glad to help rather a sad case this morning. I was just visiting the old battalion when they made a push forward, and I was just in time to get a family out of a house, after they had been cut off from outside by war and Jerry firing for two days. They all kissed me, including the sons, so it was rather embarrassing.

'Life is getting much more pleasant, as what remains of the civilian population are, in large part, finding little facilities in the way of eggs, clothes washing and so on for us and you would laugh to see them looking at my glengarry [brimless Scottish cap] and nudging each other and saying so very knowingly something about "Ecossais"....

'Everything here continues to go well. This is lovely country, full of woods and orchards, with magnificent seventeenth-century farm buildings everywhere....

'C. [Captain Holden's batman] has been away all day in a house in the nearby very attractive village, doing my laundry! He is very good at making local contacts, and our meals are frequently helped up by local new potatoes, eggs, greens and bread. The war doesn't seem to affect some of the locals much, apart from the risk of having their house down about their ears any minute, they seem to carry on with farming just the same. And I don't think they care a lot either way – they had just about got used to Jerry when we came fussing in. And it won't be long before we can leave them alone, praise be.

'I hope you will never worry about me over here, my darling. Everything is fine, and I have been glad to find that I'm not at all frightened! I have you to thank for that.'

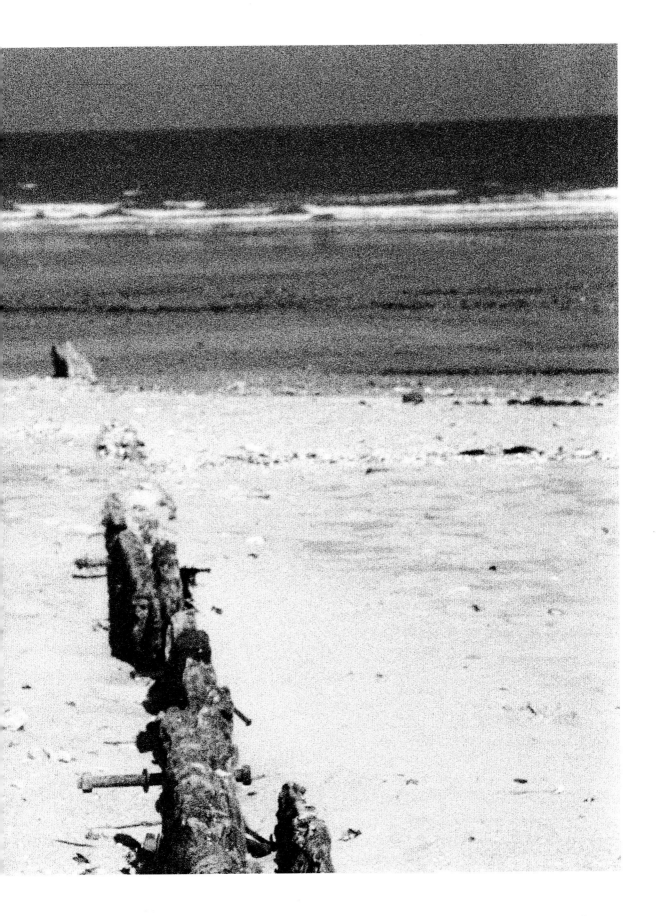

Riva-Bella and Ouistreham

Situated at the mouth of the Orne river, Ouistreham is on the far eastern flank of the D-Day invasion zone. Just next to it on the coast, Riva-Bella was and is a handsome and thriving seaside resort with beautiful sandy beaches. Parts of the beach still bear the marks of the war, the anti-tank defences known as dragons' teeth protruding through the white sand (see endpapers).

Here the 4th Commando Brigade, under the command of Lord Lovat, landed to the sound of bagpipes played by the now famous Piper Bill Millin. Defences at Riva-Bella, as in all sectors of the British/Canadian landing zones, were somewhat lighter than those on the American beaches. The British troops that landed here did so largely with the cover of tanks provided by the 79th Armoured Division (Hobart's 'Funnies') and, perhaps as a result, losses were much lighter than on US beaches.

D. Dewar supplies an eyewitness of the occasion: 'On Monday 5th June there was an announcement over the ship's tannoy system that we should be sailing that evening for the coast of France. What had seemed somewhat unreal, almost as though we were only engaged in training manoeuvres, now became a reality.

'No-one slept much, if at all, that night, many of us being up on the deck watching the flashes from the coast where our bombers were attacking the coastal batteries. I remember thinking that I ought to be frightened and that instead I seemed to be detached and observing myself as though I were watching a film. The feeling of unreality, the sub-conscious thought that this can't really be happening to me, was in some way a calming influence.

'Reveillé was sounded at 3.15 a.m. And we hastily went for breakfast. This being an American ship, the galley was equipped with the multi-course indented trays which I had not encountered previously. In one indentation was porridge and in another what must have been surely the most unsuitable of meals that could have been devised. We were served with minced liver (we were to see this for a second time after we had been at sea in the small assault landing craft for a few hours). We were also given a rum ration. For many years after the war I could not bear the smell of rum since, in spite of the thoughtfully provided vomit bags and the fresh sea air,

there was a pervading stench of wretched liver and rum in the boats, as we approached our encounter with Jerry. We were ordered to keep our heads down as we approached the coast to avoid enemy fire. However, our landing craft was disabled by some underwater mine or other obstacle and it became impossible to steer. One of the other boats was brought alongside, and although it was already fully loaded with a similar number of men, we had to clamber aboard and abandon our boat. We were now exposed to enemy fire as well as being grossly overloaded. From this position I was able to see more of the action, and one image which remains with me is of the rocket ships sending off volleys of rockets, very large numbers on each flight, at an angle of about forty-five degrees. Although there is of course no recoil from a rocket there was to me, an optical illusion of the ships or barges moving backwards, as each flight was fired.

'In the confusion of the hoards of other landing craft of various types, and due to the fact that some of the landmarks on which the battalion commander was relying had been destroyed by the bombardment, we landed about four hundred yards to the right of our planned beach position at 0815 hours, forty-five minutes after the leading troops.'

Below: A stretch of beach between Riva-Bella and La Brèche (see overleaf).

La Brèche

La Brèche was another German strongpoint on the Normandy Coast. It was secured as early as 1000 hours on the morning of D-Day by troops from the 8th British Infantry Brigade. News of the invasion as a whole was difficult to come by for the small units on the ground. The little information that did get through to unit commanders therefore had a tremendous effect on morale, as when the men of 8th Infantry heard of the success of the 6th Airborne Division in capturing the bridges over the river Orne and Caen canal.

The landing had not been a happy experience for the men of the 8th Brigade, so any scrap of good news was welcome. The beach was under heavy shell fire and in relatively deep water, which precluded a quick crossing to safety. One landing craft sank after receiving a direct hit that killed all on board.

The troops that made it late onto the beach, like the 185th Brigade, had to move off immediately to catch up with the forces already nearing Caen. The regimental diary of the 8th Brigade records how 'every officer and man had carried ashore a sandbag labelled with his name and [containing] gas masks, cardigans and some other items of clothing [these were dumped to lighten the load]. This was well worthwhile and 95% were recovered...the following day, the missing 5% having been destroyed by shelling. The [Sherman tanks]...supposed to advance on Caen were landing, but making little progress forward, owing to congestion on the roads.'

The divisional diary records how, as they moved forward, they got held up at 1315 hours by enemy posts in the fields beyond Périers Ridge, especially machine-gun posts which were firing from the right. The CO ordered W Company to move up to the right and take these machine-gun posts. By 1430 hours X Company was held up by accurate sniping from Beuville. By 1630 German tanks mounted a counter-attack which was successfully driven off and two of the tanks were captured, as reported in the diary: 'We bumped the first lot of Boche on the ridge overlooking the sea, where we had an unpleasant bout of shellfire and were held up for a bit by machine guns hidden in the corn. We then spread out...like a row of beaters through the crops and from time to time...despatch a small post of Boche.... We sent back several prisoners and killed several more...until we reached the village of Beuville. Up to this time we had lost 15 to 20 of our numbers, but the men were in grand heart and out for revenge.'

The Germans put up a spirited defence in Beuville, where the Allied troops were held up by snipers in the houses. These were eventually overpowered and Beuville fell into Allied hands.

Merville Battery

The Merville Battery was located on east of the eastern flank of the invasion area, in Merville–Franceville, across the Orne river from the landing beaches. Allied intelligence indicated that the battery contained a number of heavy artillery guns, 150mm calibre at least. These guns would be capable of bombarding the beaches at Ouistreham, thus providing a very serious threat to the landings at Sword Beach. They therefore had to be neutralised.

Lieutenant Colonel T. B. H. Otway, commander of 9th Para, 16th Airborne Division, was given this task. After intensive training in the Berkshire countryside using a life-size model of the gun emplacements, 9th Para were dropped in the early hours of D-Day into the pre-marked zones at Toufreville, Varaville and Ranville. With his men scattered far and wide by the drop, Otway could muster only 110 troops at the rendezvous point and between them they carried only one machine gun, Bangalore torpedoes (for clearing the barbed-wire defences), demolition charges for destroying the big guns and various small arms. Nevertheless, the guns had to be silenced before the landings at Sword began, so he gave the order to attack.

Otway led the attack and he and his paratroopers took the position at a cost of 70 men killed or injured, only to find that most of the guns had already been destroyed by the pre-D-Day naval and aerial bombardments.

Because Otway's naval radio link had not reached the rendezvous point, the only way he could let High Command know that the guns were inactive was by carrier pigeon. Pigeon on its way, 9th Para moved off the emplacement and headed towards the eastern flank positions.

When shelling on Sword began, High Command, which had not received Otway's pigeon, assumed that the German guns at Merville were still active and sent No 3 Commando to silence them. In the meantime, German troops who had been hidden in tunnels beneath the battery when Otway had occupied the emplacement re-surfaced to re-occupy their positions. No 3 Commando took the battery back at the cost of their leader, Major J. B. V. Pooley, only to be repulsed themselves by a counter-attack by 125th Panzer Grenadier Regiment. The Commandos then withdrew to Le Plain. The Allies did not take the Merville battery until August, although it had been put permanently out of action as an offensive station.

In 2003 half the battery is a tourist attraction which includes a museum and shop. A bronze bust of Lieutenant Colonel Otway stands guard near the entrance to the site

and a British 25-pounder gun serves as a monument to the achievements of 9th Para. As is often the case, the other half of the battery is used as a shelter by livestock.

Admiral Middleton was commander of the British battleship HMS *Ramillies* (pictured on page 157). As part of the Eastern Naval Task Force his and the other battleships off the British beaches, which included the famous *Warspite*, engaged the German shore batteries at Le Havre and Merville.

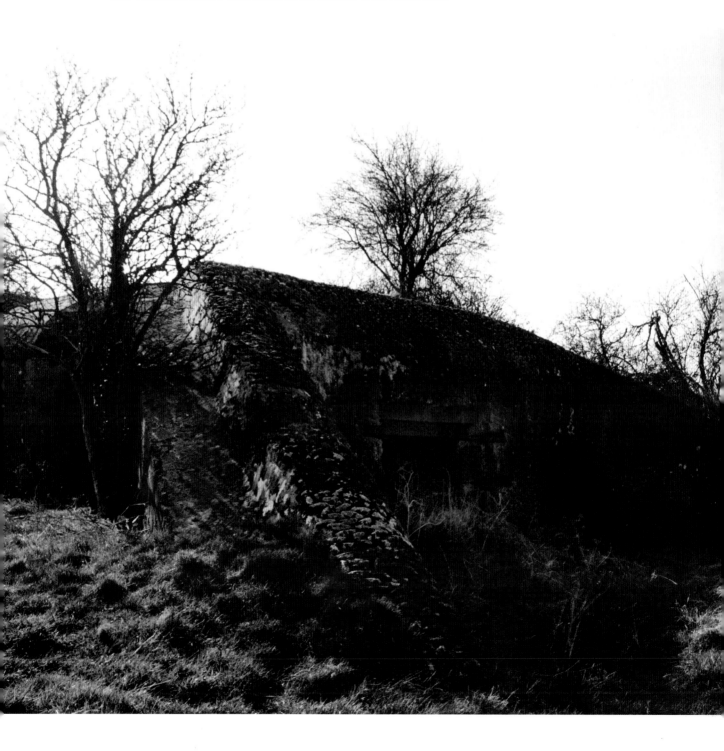

'And I am afraid we all felt a bit gloomy about the prospects – strong winds, and lumpy seas! Changing visibility and it seemed a desperate venture to try to make a landing on a defended coast under such conditions. However the decision was taken and early on Monday morning, June 5, I was able to broadcast to my ship's company. The die is cast, we are committed to the attack and now it must be driven home at all costs – here is the general plan and the part we are called upon to play. About 3.15 we had a brief lull, which enabled me to get a much needed cup of coffee from my thermos and a sandwich, but we were soon at work again on our particular battery. The trouble was that he was a new one with concrete casemates for his guns and only direct hits would do permanent harm. We settled down to a prolonged strafe and got many shells firmly into the battery area and we knew that we secured hits on at least two of the casemates. Early in the afternoon a follow-up wave went ashore and the RAF put a smashing bomb attack on top of our battery which added to our efforts.'

Left: Like many of the other large German gun batteries in Normandy, Merville has been preserved as a memorial to those who fought to capture it. It has its own museum, with a shop worth visiting. In a space near the battery which is now used as a car park, there is a memorial to men of 9th Para, 6th Airborne Division, who died here capturing the guns. In common with other batteries, some of the concrete casemates, such as the one pictured here, are to be found on farmers' fields.

Rommel's Beach Obstacles

Rommel's beach obstacles (see page 64), which had nicknames such as 'Asparagus', 'Belgian Gates' and 'Element C', were designed to combat the landing craft on the beaches by ripping the bottoms out of the craft or by exploding mines against the hulls. They were laid in long lines parallel to the shoreline at such a distance from the shore as to be concealed by the water at high tide (which is when Rommel expected to be attacked). During the invasion the steel defences were often used by landing troops as cover against the searing machine-gun fire coming from the cliff-tops. They were also sometimes used further inland as anti-tank defences.

Once the Allies had established a secure beachhead along the Normandy coast the invasion was slowed down by the terrain inland, which had not been as rigorously considered during the planning stage as the beach defences. Many GIs were surprised to find that the hedgerows surrounding fields in France were different from those found in England, where they had been stationed prior to the invasion. Reconnaissance photos did not reveal that in Normandy the hedgerows grew at the top of a bank of earth up to 6m (20ft) high. This meant that the attackers had to proceed down country lanes beneath the level of the defenders, who usually set up ambushes looking down from the fields. Although the Americans had the advantage of being supported by plentiful armour, this was useless against German troops dug into positions in the surrounding fields. A tank would have to climb up the side of a bank to get into the field, and then its unarmoured underbelly would be exposed to the defending troops. Many tanks were knocked out by German Panzerfausts in this way.

To combat this limitation, US engineers had the idea of adapting Sherman tanks to add a blade in front. Using the dismantled German beach defences and welding the steel spars into a tooth configuration, and taking advantage of the power of the Sherman's Cadillac engine, they created a machine capable of driving into the base of the hedgerow mound and cutting a hole in it. This enabled the assaulting troops to disperse through the gap, with armoured support, without being completely exposed.

Lieutenant L. E. Anderson of the Border Regiment landed at Gold Beach and had a significant encounter with a beach obstacle. He writes: 'D-Day 7.30 a.m. An assault craft heading for Gold Beach with some of my signallers and myself with a Naval Boatswain. The rule was that, as long as we were at sea, the Boatswain was in charge, but I was in command as soon as we touched the shore. We ended up on an underwater obstacle sticking up through the bottom of the boat, which made it

spin round like a roulette wheel in the rough sea. There then ensued what seemed to be a lengthy discussion between the Boatswain and myself as to whether we were at sea or shore. Ultimately, I won and he let down the ramp. With the famous cry of "Follow me, chaps," I ran off the ramp to find myself up to my neck in water.'

Below: US troops attempting to take cover behind some German beach obstacles. This photograph is one of only eight taken by Robert Capa during the D-Day landings to have survived the attentions of an inexperienced darkroom assistant.

Overleaf: These obstacles, also known as 'hedgehogs', were extensively used along the Normandy coast. They were designed to rip a hole in the bottom of landing craft and to immobilise them within range of German artillery and machine guns. The group I photographed has been placed in front of one of the beach museums. As I was walking through the dunes, it occurred to me that millions of mines had been placed around the obstacle field in 1944 and I caught myself walking rather gingerly over the soft sands.

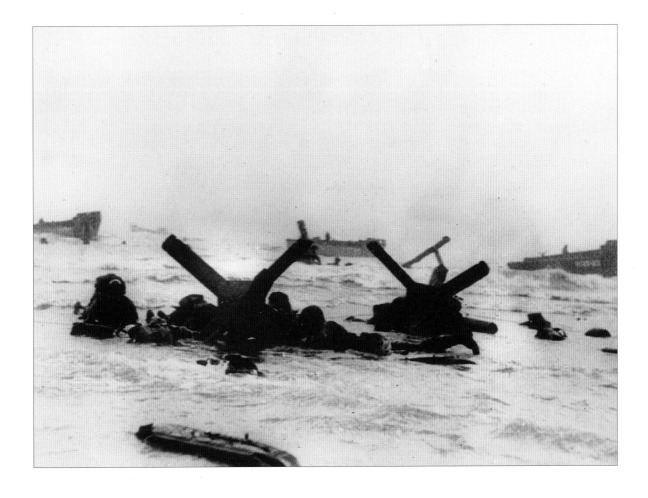

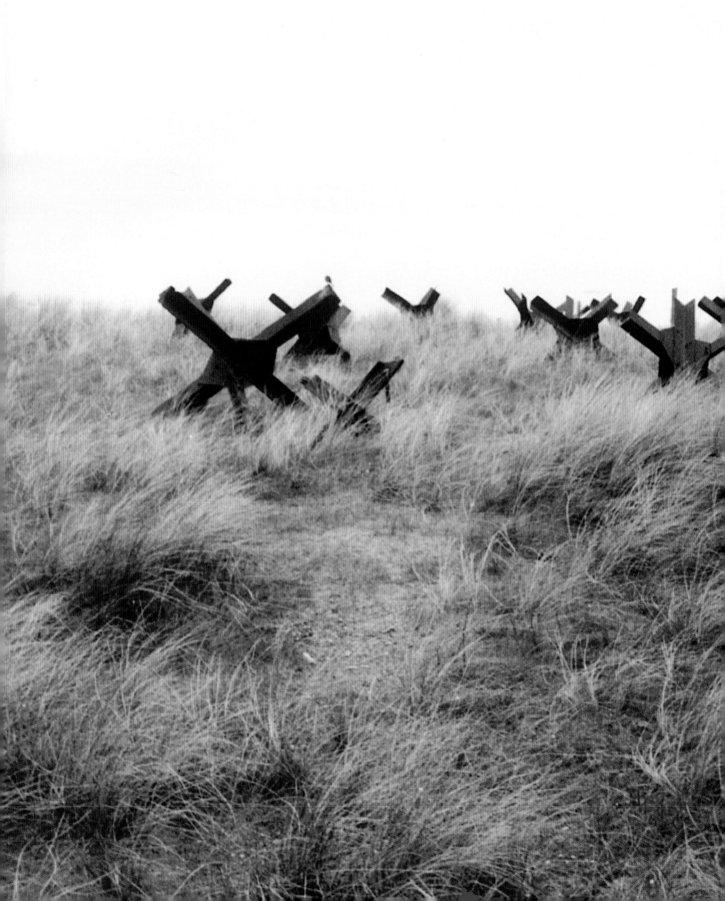

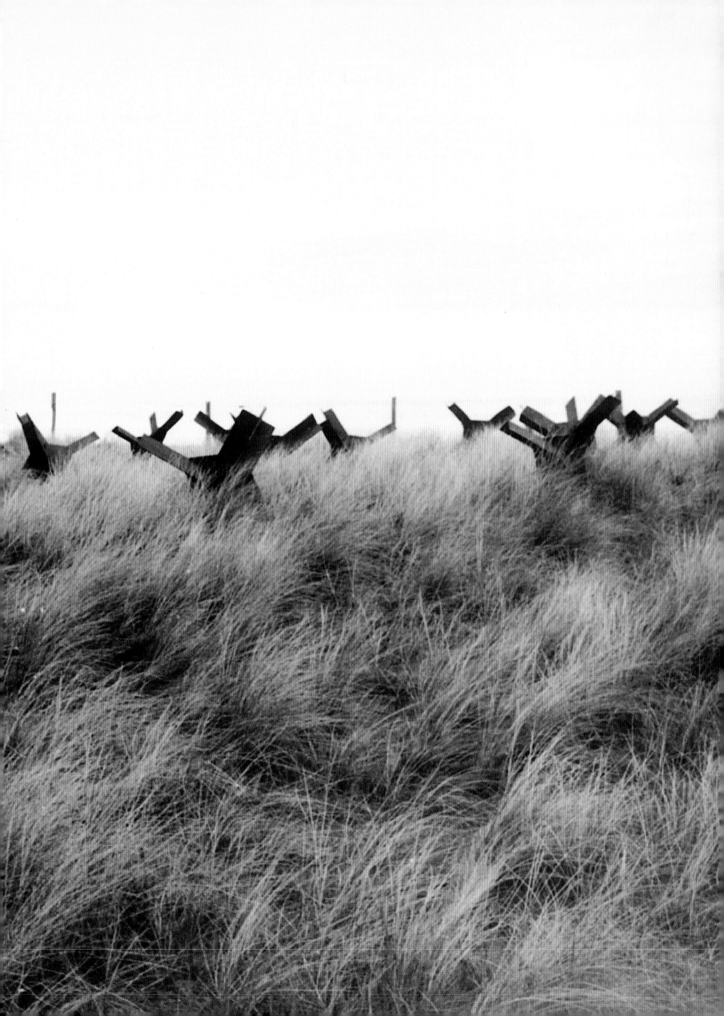

In Memoriam

During the celebrations of the fiftieth anniversary of the D-Day landings in 1994, President Clinton praised the sacrifice made by the Allied troops, so many of whom had lost their lives in the process. 'On these beaches,' he said, 'the forces of freedom turned the tide of the twentieth century...let us not forget that when they were young these men saved the world. Remember them.'

As I walked among the countless graves, it was a sobering thought to see that the great majority of the men lying under these stones had been my age when they lost their lives. It was very difficult to control my emotion and I hope that this book is a small tribute to them.

Below: The Memorial Cross at the centre of the cemetery at Ranville, Sword Beach, one of many British and Commonwealth cemeteries in Normandy (see also the frontispiece of this book).

Opposite: Some of the thousands of white marble crosses which fill the American cemetery at Colleville-sur-Mer.

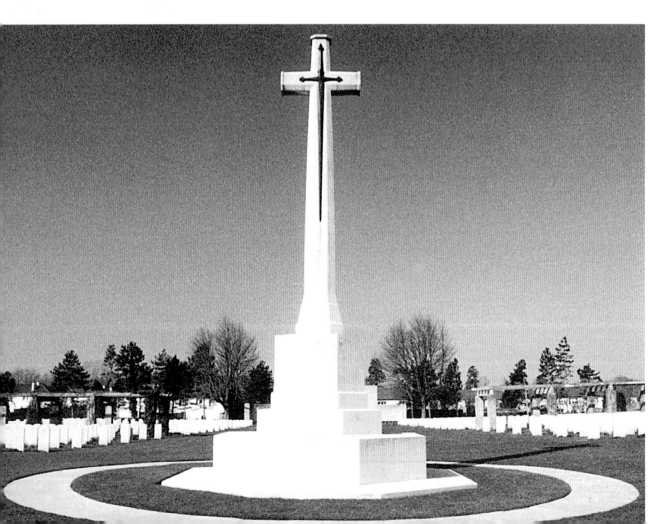

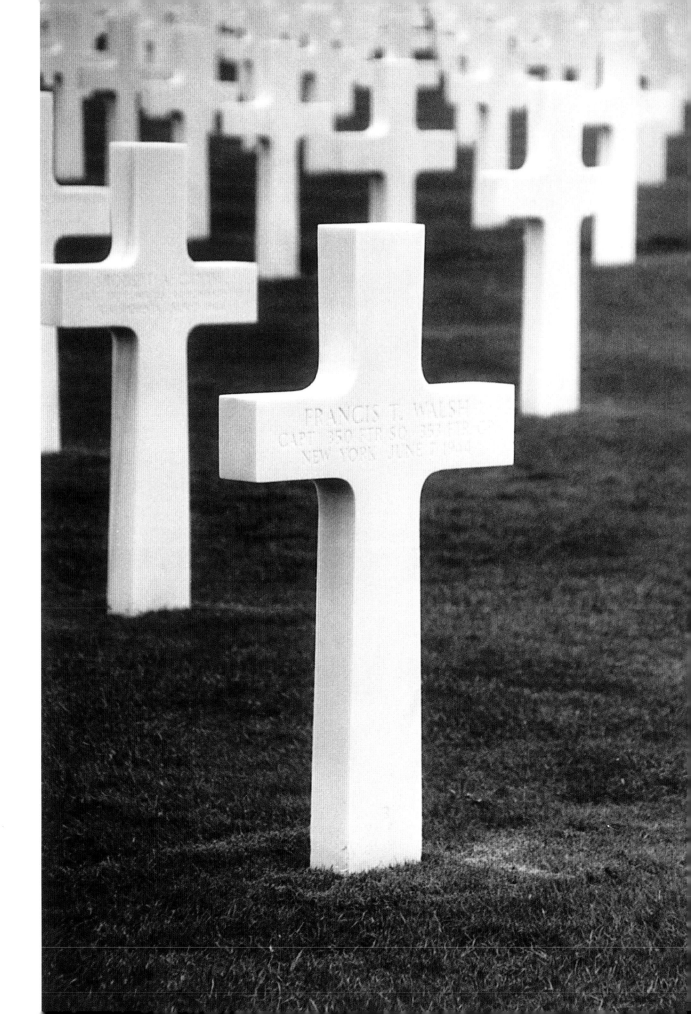

Opposite and below: The Canadian Memorial at Courseulles. On the day I was there, a group of Canadian veterans was also visiting the memorial. On their blazers they all displayed their medals and regimental badges. In the picture opposite, the white stone monuments on the left carry the names of soldiers who fell during the Dieppe raid and on D-Day.

It may seem surprising that no accurate figures for Allied casualties exist. This is probably because different armies had different methods of recording their casualties. Some are based on D-Day itself, others include a longer period and a wider area. Some sources give a total of 8443 casualties for the Allied forces, but this figure is probably on the low side. For instance the figures available for the 50th and 3rd British Divisions cover losses on the beaches only. Historians disagree among themselves, some British sources putting the figure closer to 10,865, while according to Canadian calculations Allied casualties might have totalled over 9000 men, of whom roughly one third lost their lives.

The number of soldiers buried in the Allied cemeteries is no guide either. The dead were often brought to them during and after the war, often from a long way off, and once the hostilities were over many families claimed back their dead and had them repatriated for burial in their homelands.

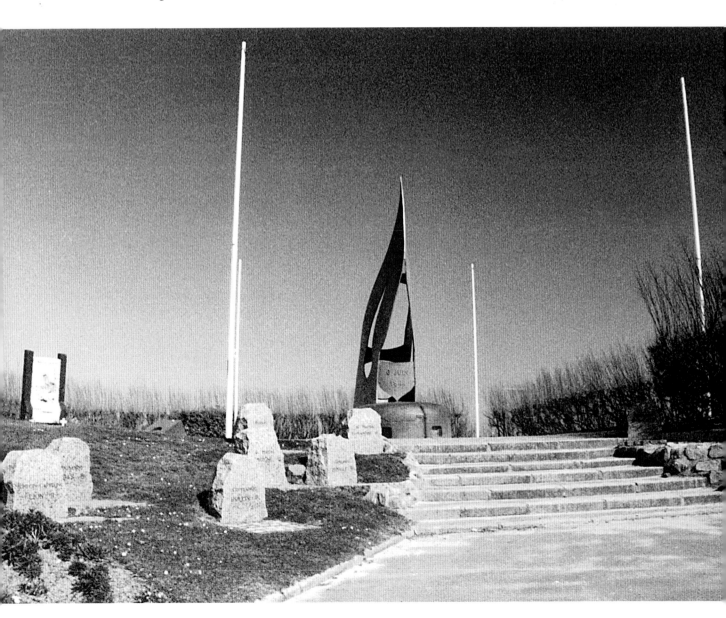

Opposite: The German cemetery at La Cambe. It contains the graves of 10,000 troops who fell during the Battle of Normandy and the subsequent retreat eastwards. Many of those who died were caught in the trap set by the American Army at Falaise, when the Germans were almost encircled with the river Seine at their back, unable to retreat or break through. The Allied air forces destroyed the vast majority of German armour and killed thousands of men. General Eisenhower, on witnessing the destruction, said that 'it would be possible to walk for hundreds of yards on nothing but dead and decaying human remains.'

The German cemeteries are immediately recognisable by the dark gravestones arranged in little groups, dotted among the trees, rather than the closely packed lines found in Allied cemeteries. The Allies tended to bury one body under each headstone, whereas a German grave often had two or more of the dead under a single stone.

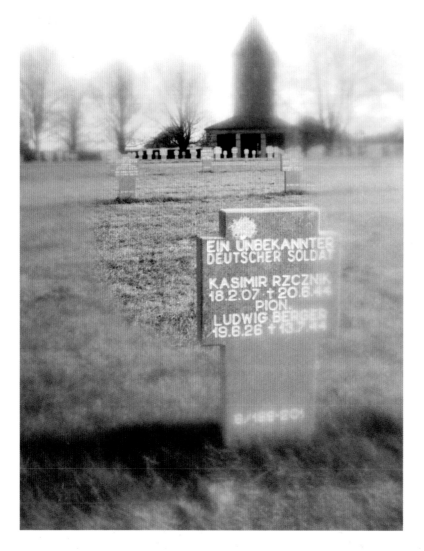

Left: This German grave is at Orglandes Cemetery, on the Cotentin Peninsula. It contains the remains of three soldiers, one of them unknown. They fell at different times and were probably reburied after the war. Immediately after D-Day, Orglandes was used by the Americans as a burial place for their fallen. After the war the American dead were moved to the US Cemetery at Colleville-sur-Mer, and Orglandes was converted into a burial place for German war dead.

Credits and Permissions

Passages from the late Major Frank Holden's letters to his wife Peggie are reproduced by kind permission of their children © The estate of the late Frank and Peggie Holden, 2004

The following archival pictures are reproduced by kind permission of the Imperial War Museum. The negative number appears in brackets.

Pages 14-5 (PL 27983), 34-5 (EA 26248), 43 (OWIL 26504), 48 (EA 29427), 55 (AP 26886), 58 (AP 26881), 61 (B 6382), 62 (PL 26752), 64 (PL 26536), 69 (PL 25623), 74 (KY 27285), 96 and back of jacket (PL26539), 98 (EA 26547 and EA 25980), 104 (RY 480722), 105 (RY 480704), 108 (HU 87653), 113 (MH 2021), 115 (BU 1024), 118 (B 7244 and A 24675), 124 (PL 54818 and MH 31512), 125 (MH 28249), 126 (KY 480722), 136 (A 23938), 138 (B 7352), 140 (B 5193), 144 (B 5252), 146 (MH 27454), 148 (B 5267), 157 (A 24459), 158 (B 5296), 159 (B 5290), 164 (B5233), 166 (D 13058), 168 (B 5009), 179 (AP 25724), 188 (B7203).

The extract of the poem, *Carentan O Carentan,* by Louis Simpson is reproduced by kind permission of Wesleyan University Press.

Below: Damaged section of Mulberry harbour.

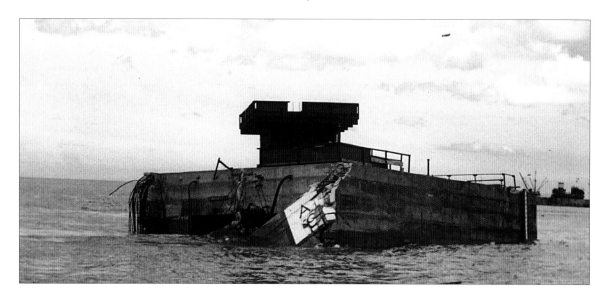

Bibliography

Ambrose, Stephen E., *Band of Brothers*. London: Pocket Books, an imprint of Simon and Schuster, 2001

Ambrose, Stephen E., *Citizen Soldiers, From the Beaches of Normandy to the Surrender of Germany*. London: Pocket Books, an imprint of Simon and Schuster, 2002

Amtrose, Stephen E., *The Battle for the Normandy Beaches*. London: Pocket Books, an imprint of Simon and Schuster, 2002

Badsey, Dr Stephen, *D-Day from the Normandy Beaches to the Liberation of France*. Colour Library Books Ltd, 1993

Cawthorne, Nigel, *Fighting them on the Beaches – The D-Day Landings June 6, 1944*. Arcturus Publishing Ltd, 2002

Collier, Richard, *D-Day 06.06.1944*. The Orion Publishing Group, 2002

Dunphie, Christopher & Johnson, Garry: *Gold Beach Inland from King – June 1944*. Leo Cooper, an imprint of Pen & Sword Books Ltd, 2001

Holt, Tonie & Valmai, *Major and Mrs Holt's Battlefield Guide, Normandy Landing Beaches*. Leo Cooper, an imprint of Pen & Sword Books Ltd, 2001

Keegan, John, *Encyclopedia of World War II*. The Hamlyn Publishing Group Ltd, 1977

Kilvert-Jones, Tim, *Sword Beach – British 3rd Infantry Division/27th Armoured Brigade*. Leo Cooper an imprint of Pen & Sword Books Ltd, 2001

Shilleto, Carl & Tolhurst, Mike: *A Traveller's Guide to D-Day and the Battle for Normandy*. The Windrush Press, 2000

Below: Commemorative gardens, Colleville American Cemetery.

Index